CARL FABERGÉ

Carl Fabergé

GOLDSMITH TO THE
IMPERIAL COURT OF RUSSIA

A. Kenneth Snowman

A Studio Book

THE VIKING PRESS · NEW YORK

in association with Debrett's Peerage Limited

With gracious permission, this book is dedicated to
Her Majesty Queen Elizabeth the Queen Mother.

Library of Congress Catalog Card Number: 79-63369

ISBN 0-670-20486-2

Printed in Holland

Produced by Edition, 25 Lloyd Baker Street, London W.C.1.
Designed by Ian Cameron.

Contents

Note on the Illustrations 8

Acknowledgements 9

INTRODUCTION 11

METALS, ENAMELS AND
 STONES 17

A RESTLESS IMAGINATION 47

STONE CARVINGS 65

FLOWER STUDIES 80

IMPERIAL EASTER EGGS 89

IN RETROSPECT 116

MARKS AND STANDARDS 140

WRONG ATTRIBUTIONS,
 PASTICHES & FORGERIES 146

APPENDICES

Chronological Table 152

Select Bibliography 156

Index 158

Note on the Illustrations

Throughout this book, when the maker of an object is known, the workmaster's initials are given after the descriptive caption thus: Signed HW.

Gold and silver marks in use before the *Kokoshnik* are identified by the mention of 'crossed anchors' for St Petersburg and 'St George and Dragon' for Moscow.

Although, as is noted in the Appendix on Marks and Standards, it is possible to divide objects bearing the *Kokoshnik* into two brief periods, the dating in this book has been confined to pre and post *Kokoshnik* markings unless the more precise date of a particular piece is of special interest. It has also been thought unnecessary to specify particular Inspectors' Hall marks.

If the purity of the metal exceeds the normal 56 *zolotniks* for gold, or 84 or 88 *zolotniks* for silver, this is noted by the qualifications, Gold mark: 72 or Silver mark: 91.

Where no acknowledgement is made below a description, it is to be assumed that the piece is privately owned.

Many of the objects illustrated in this book have already appeared, often in earlier photographs, in one or other of two books on the subject of Fabergé, they are: *Peter Carl Fabergé* by H. C. Bainbridge, Batsford 1949, and *The Art of Carl Fabergé* by A. Kenneth Snowman, Faber & Faber 1953. For the sake of brevity, these are referred to in captions as respectively HCB and AKS.

Acknowledgements

I should like to thank Her Majesty the Queen for graciously allowing me such generous access to the incomparable Royal Collections in order to plan and realize a completely new series of photographs.

I am deeply indebted to Her Majesty Queen Elizabeth the Queen Mother, whose delight in and knowledge of Fabergé's work is too well-known to need repetition here, for graciously accepting the dedication of this book. To His Royal Highness the Prince of Wales, to Her Royal Highness Princess Anne, Mrs Mark Phillips, to Her Royal Highness the Princess Margaret, Countess of Snowdon, to His Royal Highness the Duke of Gloucester and Her Royal Highness, Princess Alice, Duchess of Gloucester I am most grateful for allowing me to include examples from their collections. Geoffrey de Bellaigue C.V.O., F.S.A. of the Lord Chamberlain's Office has invariably provided unstinting help.

The photographing of the Royal Collections was carried out with the help of Gordon H. Roberton of Messrs A.C. Cooper Ltd and Prudence Cuming of Prudence Cuming Associates Ltd with all their characteristic patience and feeling for the various materials involved.

My thanks are due to the private collectors, whether acknowledged by name or not, whose objects are illustrated on the following pages; without their friendly co-operation this project would not have been possible.

Sincere gratitude must be expressed to Messrs Faber and Faber who readily welcomed the creation of this book, which is intended as a pendant to the more compendious work first published by them in 1953 and still happily alive and well in its current amplified edition. This essay is in fact offered as a sort of second helping, which I hope may be found palatable.

I am particularly grateful to the Director of the Kremlin Museums in Moscow, Mr Tsukanov, for permission to have new coloured photographs taken by Mr B. Kuznetzov especially for this book. In this regard I want to thank the enchanting and wise ladies, Mesdames Postnikova-Losseva and Nekrassova for their help.

The great collections in the United States are well represented thanks to the generosity of those in charge of the Forbes Magazine Collection, New York, the Matilda Geddings Gray Foundation Collection, New Orleans, the India Early Minshall Collection of the Cleveland Museum of Art, the Lilian Thomas Pratt Collection of the Virginia Museum

of Fine Arts in Richmond, and the Walters Art Gallery in Baltimore.

My thanks also to *The Connoisseur* and to Messrs Weidenfeld and Nicolson, who have allowed me to make use of material which I have produced for them in the past, and to Messrs Jonathan Cape, who have kindly permitted me to include a fascinating and relevant poem by William Plomer from their 1973 edition of his *Collected Poems*. The episode briefly referred to on page 137 involving a former governess of the Tsarina and a ghosted cry for help is told in full in *The File on the Tsar* by Anthony Summers and Tom Mangold, published by Messrs Victor Gollancz in 1976.

I was glad to receive a letter from Dr Erik Schmidt in Haldesleben about his father, the architect who rebuilt the palatial Fabergé premises in Bolshaya Morskaya street for his uncle.

Stefan Moses, Peter Macdonald and Selim Nahas have allowed me to include splendid examples of their colour photography on pages 94, 97 and 104 respectively.

I am happy to record my thanks to Dr Geza von Habsburg in Geneva, a notable scholar in this field, who, with his loyal collaborator Alexander Solodkov, has engaged me in long and pleasurable discussions in the Austro-Hungarian haven in the Chemin des Corneilles presided over by his charming Archduchess.

In one way or another, the following people have given me assistance which I very much appreciate: Luigi Bandini, Marina Bowater, John Donald, Ralph Esmerian, Jeffrey di Fonzo, Christopher Forbes, Charlotte Gere, Julia Harland, Henry Hill, Louise Irvine, Gwendolyn L. Kelso, Eugène Mollo, John Morgan, Sir John and Lady Pilcher, Paul and Peter Schaffer, Roland H. Smith, Matilda and Harold Stream, Marilyn P. Swezey, Tamara Talbot Rice, William J. S. Tallon, and the Yeoman of the Silver Pantry in Buckingham Palace.

My relations with my old friend Harold Brooks-Baker and his associates at Debrett's have always been of the happiest, and a natural accord has grown between the designer of this book, Ian Cameron, and myself; I think we have both enjoyed preparing it.

I am deeply indebted to June Trager who has, at all times, kept a watchful eye upon the development of my manuscript and to my colleagues David Edmond and Geoffrey Munn, with whom I invariably discuss any new object or scrap of information which comes our way.

Finally, I should like to thank my wife Sallie, not only for her encouragement and patience, but especially for her invaluable ability to conduct successful early morning telephone conversations with Moscow in fast Russian.

Introduction

It calls for, if not courage, at any rate a measure of self-assurance to embark upon yet more writing about the already much publicized Carl Fabergé.

The only acceptable justification must depend upon the merit of the subject, and in this respect, the St Petersburg master never lets us down.

The purpose of this book is to assemble a number of new and serviceable photographs of Fabergé's work in gold and silver, enamels, semi-precious stones and jewels and to explain as far as possible how and when they were designed and realized. If the resulting amalgam becomes more readily available to a wider public at an economic figure than earlier publications, the enterprise will not have been in vain.

It is the genuine surprise experienced upon the discovery that such an extravagant and restless talent was operating so far from the centre of Europe at the end of the nineteenth century which has, I feel sure, been the source of much of the current interest in him and his associates.

Another element which undoubtedly contributes to the world-wide respect in which his name is held is the virtual revolution which, in 1870, as a young man of 24, Carl Fabergé consciously and very courageously brought about when he took over the conventional jewellery business founded by his father Gustav. This revolution was firmly based upon the dictum that the worth of a piece should be reckoned by the skill expended upon its design and manufacture rather than by the opulence of its materials.

This hypothesis was a guiding principal throughout his entire career and 44 years later, in an issue of *Stoliza y Usadba* (*Town and Country*) dated 15th January 1914, we find the 68-year-old Fabergé giving a superbly disdainful interview which contains the following succinct summary of his credo.

'Clearly if you compare my things with those of such firms as Tiffany, Boucheron and Cartier, of course you will find that the value of theirs is greater than of mine. As far as they are concerned, it is possible to find a necklace in stock for one and a half million roubles. But of course these people are merchants and not artist-jewellers. Expensive things interest me little if the value is merely in so many diamonds or pearls.'

Now that we appear to be losing our grip on so many techniques in the decorative arts, it seems particularly appropriate for us to assess the loss we have sustained. Economics have, of course, played an important part in this decline; fewer and fewer people of an educated taste are in a position to acquire luxury articles that attract them.

The principal reason for the loss of manual cunning is the poor prospect offered to apprentices. Young people of talent, however enthusiastic they may initially be, are understandably reluctant to risk their time on the laborious training that is essential for a skilled craft. They can no longer look forward with any real confidence to a career which is both safe and fulfilling.

Running true to form, the trade union involved has exerted irresponsible and destructive pressure upon even this problem. By demanding too high a minimum wage for sixteen-year-old apprentices in, for example, silversmithing, they have effectively prevented youngsters who might have been willing or even anxious to sacrifice a few years fending for themselves, (some perhaps helped by their families) from entering the trade. Government support is minimal. Firms with imagination occasionally help in this regard when they can afford it, as do some public spirited City Companies, but the unsurprising fact remains that the number of recruits has dwindled alarmingly. In this way we are breaking essential links in the chain of wisdom which has always, by tradition, been handed on from generation to generation.

According to Fabergé's eldest son Eugène, men worked overtime almost all the year round, from 7.00 a.m. to 11.00 p.m. The overtime pay was good. On Sundays, work went on from 8.00 a.m. to 1.00 p.m. which was counted as a full working day. Hardly what we, today, would call social hours.

Slovenly standards of craftsmanship have inevitably contributed to the aesthetic permissiveness which so bedevils the arts of our time. We have come to accept, and—more dangerous—many artists themselves have come to accept, almost anything that they can get away with.

What is true of the decorative or applied arts is unfortunately just as true of what we used to call the fine arts. When the artist commands neither the technical vocabulary nor the grammar to say exactly what he wants to say, he tends to seek refuge in tricks and novelties. However, if the message he wishes to transmit is urgent enough (an unusual circumstance in itself), a language will clamour to emerge from his initial inarticulacy—we have only to recall two great painters, El Greco and Van Gogh, whose genius compounded for each of them a highly personal voice which later generations have gratefully heard and understood better than did their contemporaries.

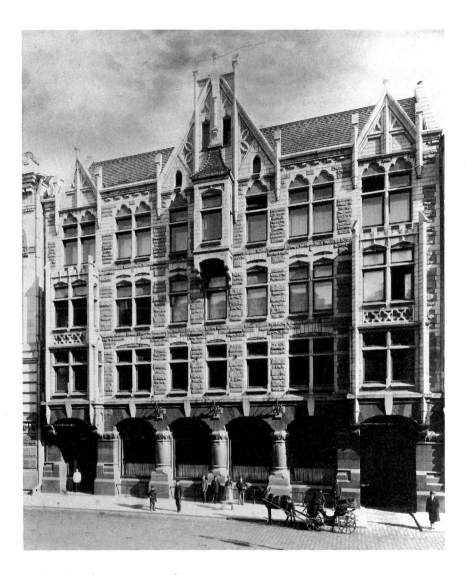

The St Petersburg House in Morskaya Street.

Such phenomena, however, are rare; nowadays we have been lulled into accepting practically anything that is offered. We are invited to gape open-mouthed before the most arbitrary nonsense which is put in front of us by cynical entrepreneurs who are happy to exploit the innocence of self-styled intellectuals and those of the rich who have no time to think for themselves.

Every time a pencil traces a mark on a piece of paper or a paint-brush leaves a patch of colour on a canvas, there is an increasing tendency to declare the result a work of art. We seem to have forgotten that there exist other perfectly valid and respectable categories into which many of these manifestations might be said to fall, particularly into that of interior decoration. Museums of contemporary art (especially in the United States) are packed with massive wall-to-wall canvases which seem to have been designed to fit in with the furniture and go well with the living-room curtains. Commercial art is another honourable activity which is confused with art when it turns up, as it often does, in art galleries.

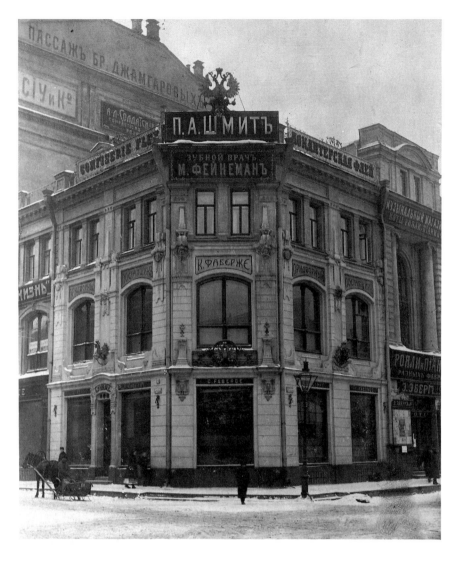

The Moscow shop – compare with an earlier photograph taken before modernization, *The Art of Carl Fabergé*, plate 9.

Discipline and order in the arts are less and less valued—ours is an age in danger of becoming characterized by minimal art put out by performers of minimal talent. As a result, we too often accept the second and third rate. Sadly we seem to have forgotten Sydney Smith's observation: 'Among the smaller duties of life I hardly know any one more important than that of not praising where praise is not due.' This is now no longer a small duty but a fundamental one. We have too much to lose by accepting mediocrity without question.

As far as the decorative arts are concerned, where technique is not optional but fundamental, the unhappy truth is that most contemporary goldsmiths and silversmiths, who may well be outstandingly talented, are obliged to concentrate their energies exclusively on questions of how cheaply, how many and how soon.

When, therefore, we are shown the splendid pieces produced in St Petersburg and Moscow by Fabergé and his craftsmen in the years between about 1870 and the outbreak of the Bolshevik Revolution, we are particularly susceptible

to their impact. It is not merely a nostalgia that we feel, though there must inevitably be an element of this too—we are quite simply overwhelmed by the quality of the wares. Indeed, it may be claimed that any object which is not immaculately made and highly finished in every detail cannot be by Fabergé at all. There may never again be the chance for such technical perfection to be triumphantly allied to an instinctive feeling for materials.

For some years, much of Fabergé's work was thought to be too perfectionist—somehow airless and even claustrophobic. We longed for evidence of more accidental and casual gestures in the arts. Fabergé appeared possibly too invulnerable, as though the struggle for perfect expression had been so completely won that it was hard to detect the humanity in work which, to some, seemed to have a quality of despair. It was as though the quest for truth had been abandoned and the achievement made possible with the help of newly perfected scientific machinery and methods had doused the fires of inspiration. We are now more inclined to applaud Fabergé's enthusiasm for any technical advance in his craft and rather mistrust a self-conscious archaism which can achieve only a spuriously primitive quality through deliberately ignoring the facilities available. Most of us today are so thankful to have such

Below :
The Odessa branch was opened in 1890 and flourished until 1918. Note the fashionable *art nouveau* lettering outside the shop.

Right :
The Kiev branch, founded in 1905, was closed down five years later as it was considered unnecessary in view of the existence of the older shop in Odessa.

a corpus of work well done that we readily accept it. The long queues which daily wound round the Victoria & Albert Museum in London during the four months' duration of the Silver Jubilee Exhibition of Fabergé objects in 1977 would seem to confirm this view; they also proclaim the urgent need for glamour felt by people of all ages and classes. As Terence Mullaly points out in a perceptive essay on this event, 'the real key as to why Fabergé answers a widely felt need lies in the fact that these objects are delightful toys. They are intensely pretty, a word of which, thanks to puritanical aesthetic theories and even what we imagine to be a social conscience, we have become frightened.'

In similar vein, we find Simon Harcourt Smith writing about Fabergé for *The Listener* in his characteristically rococo prose, as far back as January 1950: 'Blinkered and prudish in our way as any Victorian, we denigrate these days all the talents that serve no community, that delight at best a few. Would we for instance tolerate a second's length the genius of King Stanislas Lescinski's pastrycook, the Sieur Gilliers, who created puddings where a sugar Leda follied with her sugar swan among fountains of sherbert? Of course not. We would advance damning statistics on the poverty that generally prevailed in Stanislas's dominions at the time; flattering Macaulay's shade to the point of embarrassment, we would contrast the proletarian fortitude of Stanislas's peasants with the brittle charms of the doxies who ate up the puddings.'

Let us then put aside our fears and allow ourselves, in an uncomplicated way, to enjoy charming and stylish products which were designed simply to give pleasure.

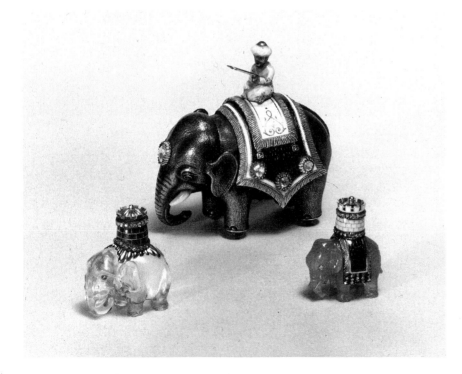

These objects from the collection at Sandringham are illustrated by gracious permission of Her Majesty The Queen.

Top :
Gun-metal automaton Indian elephant with cabochon ruby eyes and ivory tusks; an opaque white enamelled *mahout* (elephant tender) carrying an elephant-hook sits on a rose diamond set yellow gold rug enamelled translucent green and opaque white. One of the diamond collets may be moved aside and a gold key inserted to work the clockwork mechanism; when a tiny lever under the stomach is pressed, the elephant walks slowly along swinging its head and tail.
Length $1\frac{7}{8}$ inches No marks
AKS colour plate XXX

Left :
Rock crystal elephant with cabochon ruby eyes, bearing on its back a red gold rug on which sits a yellow and red gold tower enamelled with translucent rust-coloured bricks and set with rose diamonds. This model recalls the Royal Danish Elephant.
Height 1 inch

Right :
Carrot-coloured sardonyx elephant with rose diamond eyes. It bears on its back a gold tower enamelled with opaque white bricks and set with rose diamonds; a yellow gold rug underneath enamelled translucent emerald over a *guilloché* field has fringes set with rose diamonds. Probably also intended as a reference to the Royal Danish Elephant.
Height 1 inch

Metals, Enamels and Stones

Cigarette case in red gold engraved with winged horses, griffins and swans, a winged female figure, scrolling and foliage in Empire taste; set with a cabochon sapphire push-piece.
Length 3½ inches Signed МП
Mr Frank Sinatra

It is clear that the colour of the gold or silver Fabergé used, as well as the precise shade of the enamel or stone, was a matter of the most deliberate consideration.

Gold and other metals

There are two methods of obtaining coloured golds, and Fabergé employed both. The metal used by goldsmiths is generally an alloy because pure 24 carat gold, although chosen occasionally for small trinkets, is much too soft for ordinary practical purposes. In the gold most often used by Fabergé (56 *zolotniks*—see Appendix—corresponding to our 14 carat), the nature of the metal added to complete the alloy, 10 parts to 14 in the case of 14 carat gold, determines the final colour.

The colour of the gold alloy is determined by the precise proportions of pure gold mainly to pure copper and fine silver; for some special shades, other metals, such as nickel or palladium, may be introduced. Pure gold combined with fine silver gives a green gold, and with pure copper, a red gold.

The numerous variations of the alloy enable the goldsmith to produce yellow, green, red and white golds in very many degrees of intensity, as well as more *recherché* effects such as blue, orange and grey golds. In the main, however, Fabergé confined his attention to the more usual colours.

The other method of colouring gold, simply tinting the finished work, was less frequently employed in Morskaya Street. It is sometimes difficult to discern which technique has been adopted without disturbing the surface of the metal.

The *quatre-couleur* technique of eighteenth-century French goldsmiths was developed to a surprising extent in the St Petersburg workshops and was often combined with the use of enamels or stones to give increased point to the subtle variations between the differently coloured golds.

Fabergé very effectively combined dull or matt golds with polished gold of another colour; for instance, a chased swag would be executed in matt green gold with the small bows and ties in polished red gold.

As well as making a great deal of polished silverware, mostly in the Moscow House, Fabergé was one of the first to

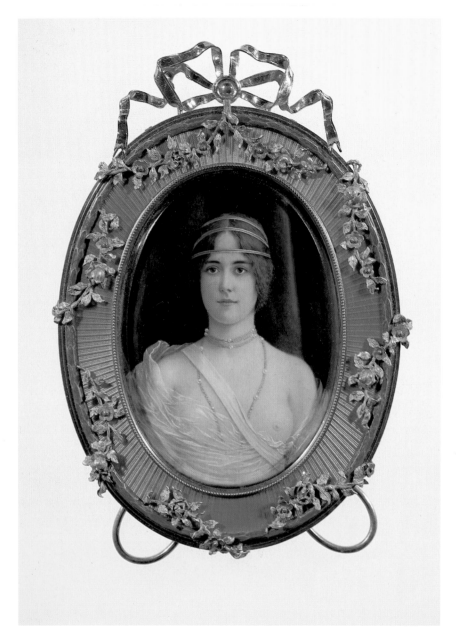

Oval strut frame. Silver-gilt. Surmounted by a yellow gold bow-knot, enamelled translucent deep yellow over a radiating engine-turning within a raised border of green translucent enamelled leaves over engraved veining, each leaf reserved with a gold outline. The frame is richly decorated with trails of roses chased in green, red and white gold. An unusually early example of Fabergé's work in this genre. It contains a highly finished painting in tempera of a young girl, partly clothed in a diaphanous veiling and wearing a pearl and gold chain necklace and a triple bandeau of hoops. Presumably the framed portrait was privately commissioned by an admirer.
Height 5¼ inches Signed К.ФАБЕРЖЕ and dated Moscow 1896
Madame Josiane Woolf, France.

make extensive use of oxidized silver, and produced a large quantity of *surtouts-de-table, bratini*, bowls and samovars in this medium.

Enamels

Fabergé's superb enamelling techniques are perhaps the most important aspect of his work. Enamelling is a complex process, fraught with difficulties, and some explanation of these technical problems is necessary to show how the Russians exploited several different methods to achieve the effects they wanted.

Enamel in the simplest sense is a semi-opaque glass, applied by fusion to metallic surfaces. The word 'fusion' is the key to the whole operation. For enamel to become soft,

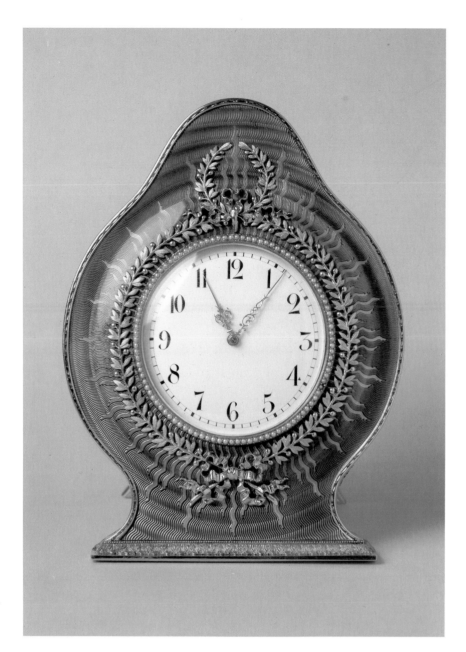

Strut clock of grenade form, engraved in red gold, standing upon a square foot decorated with chased green gold acanthus, enamelled translucent blue-grey over a sun-in-splendour *guilloché* ground which rises gently towards the dial. This is framed by half-pearls and surrounded by a chased green gold wreath of leaves and berries, applied above and below with red gold ribbon tied in bows. The hands are of pierced red gold. An example of Fabergé's mature work in coloured golds. Height 4¾ inches Signed HW

it has to be heated to a certain temperature, and it is precisely this heating that creates the problems that so consistently defeat modern craftsmen. The finest translucent enamel has to be brought up to a heat of about 600° Centigrade—Fabergé's enamellers normally worked at temperatures varying between 700° and 800°; at such tremendous heat, any slight error or miscalculation in the preparation of the enamel or flux, or the use in the metal plate of an alloy that is not entirely suited to the enamel covering it, will undoubtedly be followed by disaster, swift and sure.

In practice, it is astonishing just how much heat 14 carat gold, for example, can withstand without coming to grief. Enamel usually has to be applied to a part of an object already worked by the goldsmith, yet even if the temperature inside

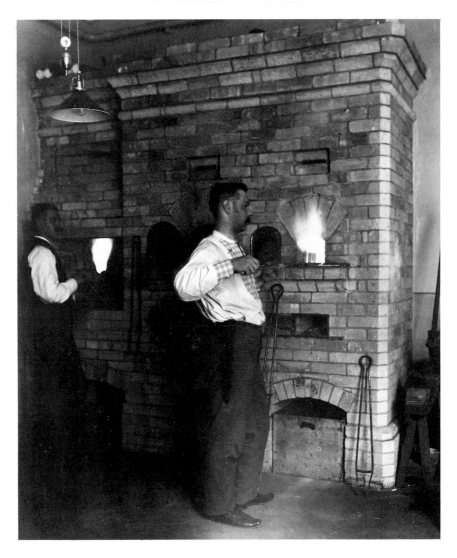

Gold cigarette case decorated with opaque white enamelled lines with a brilliant diamond push-piece and borders of leaves enamelled translucent emerald with rose-diamond ties and, at the centre, a basket of flowers in rose diamonds over an opaque enamelled background.
Height $3\frac{3}{16}$ inches Gold mark 72
Signed HW
HCB plate 107
Her Royal Highness, the Princess Margaret, Countess of Snowdon.

the 'muffle' of the kiln were raised to 1,000° Centigrade, the metal would emerge from its ordeal by fire unscathed—about 1,200° would be needed to affect 14 carat gold. It is not necessary to risk passing gems through the fire; the raised settings are cut out in advance, then, when the enamel has been applied, the stones are inserted and the settings closed to secure them.

Characteristics of Fabergé enamelling are the even quality and the smoothness of its texture. He specialized in what is known as *en plein* enamelling, the smooth covering of comparatively large surfaces or fields. This type of work allows for no margin of error. But perhaps the key to Fabergé's use of enamel is his subtle combination of techniques. Rather in the way that he used matt and burnished coloured gold surfaces together, so he contrasted opaque and translucent enamel, the latter with patterns engraved underneath.

Opaque enamel usually requires a lower temperature than translucent, about 300° sufficing. This low temperature firing is known as *petit feu*, as opposed to *grand feu*.

Translucent enamelling involves firing transparent layers of enamel, each of carefully matched fusibility, on a prepared metal surface. In Fabergé's work, this area is generally engine-turned (or sometimes engraved by hand), and is known as a *guilloché* surface. Each layer of enamel, and there may be as many as five or six, has to be baked separately. Sometimes gold leaf patterns known as *paillons* or painted decorations or scenes appear beneath the surface of such enamels; this lovely effect is obtained by applying and firing the gold leaf or the enamelled image on an already fired enamel surface before the top sealing layer of enamel is in turn applied and fired. The man who specialized in decorating enamel with these paper-thin gold *paillons* was a Czech named Trassak. When the enamel has been baked, it requires careful polishing with a wooden wheel to smooth down any irregularities on the surface; this is a highly skilled and extremely laborious operation without which the finished article will lack the distinction that we have come to connect with Fabergé. The enamel is finished off with the buff.

Silver-gilt and *cloisonné*-enamelled vase, with, on one side, a painting of Fabergé's Moscow shop showing his name-board under the Imperial Eagle, and, on the other, an inscription reading: 'xxv To the highly esteemed Carl Gustavovich in gratitude F. I. Ruckert 1912'. This presumably indicates that the Moscow German had worked for Fabergé since 1887. The vase itself is decorated with stylized flowers and fruit in the pastel colours characteristic of the maker's work.
Height 4½ inches Signed ФР
A la Vieille Russie, New York.

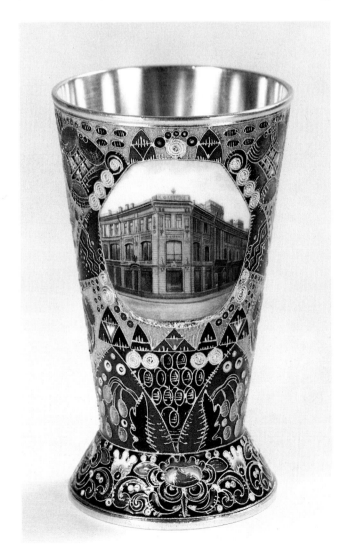

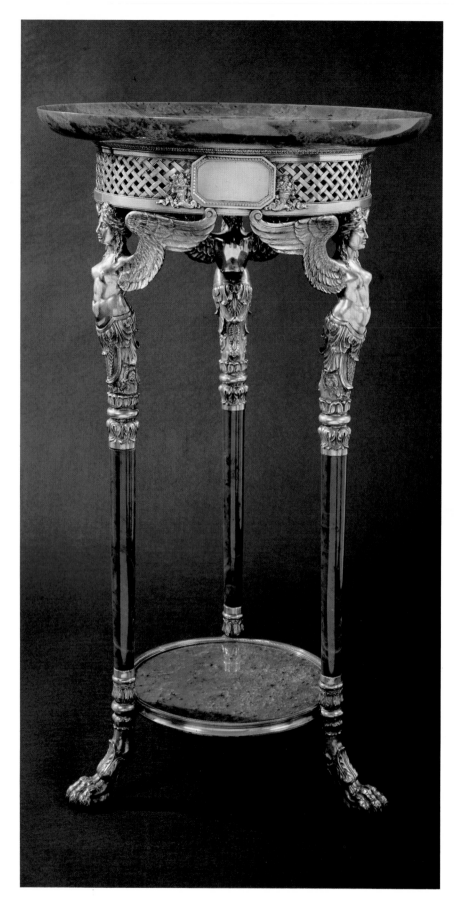

Silver-mounted *guéridon* in Louis XVI taste. Carl Fabergé made very few items of furniture, and this present example, composed of jade and silver, must be regarded as unique. A large shallow circular jade dish rests upon a broad pierced silver basketwork frieze, surmounted by a boldly chased laurel border and applied with a chamfered rectangular and two circular cartouches, each flanked on either side by a chased cornucopia filled with fruit and flowers. The whole is supported upon three tapering cylindrical jade legs which descend from elaborately chased silver winged caryatids and terminate in lion's feet similarly chased, enclosing a jade shelf in a beaded silver mount.
Diameter of top dish 22½ inches
Height 37 inches
Signed ЯА
Wartski photograph

Twelve spoons in silver-gilt each of a different design and *cloisonné* enamelled in a different pattern in a range of pastel colours. These spoons are a good example of the muted palette preferred by Fabergé in favour of the more garish colours, such as a piercing sky blue, used by contemporary Russian enamellers. The lid lining of the spoons case is of interest indicating where the firm was in business. Not only are Moscow, St Petersburg, Kiev, Odessa and London listed but also, Nijegor Yarmar (abbreviation of Nijegorodskaya Yarmarka). This was the commercial section of Nijni Novgorod where a vast annual fair was held and in which Fabergé presumably took part.
Lengths ranging from $4\frac{9}{16}$ inches to $4\frac{3}{4}$ inches
Signed ФР and overstruck К. ФАБЕРЖЕ
Mr and Mrs Edward Joseph, Tehran

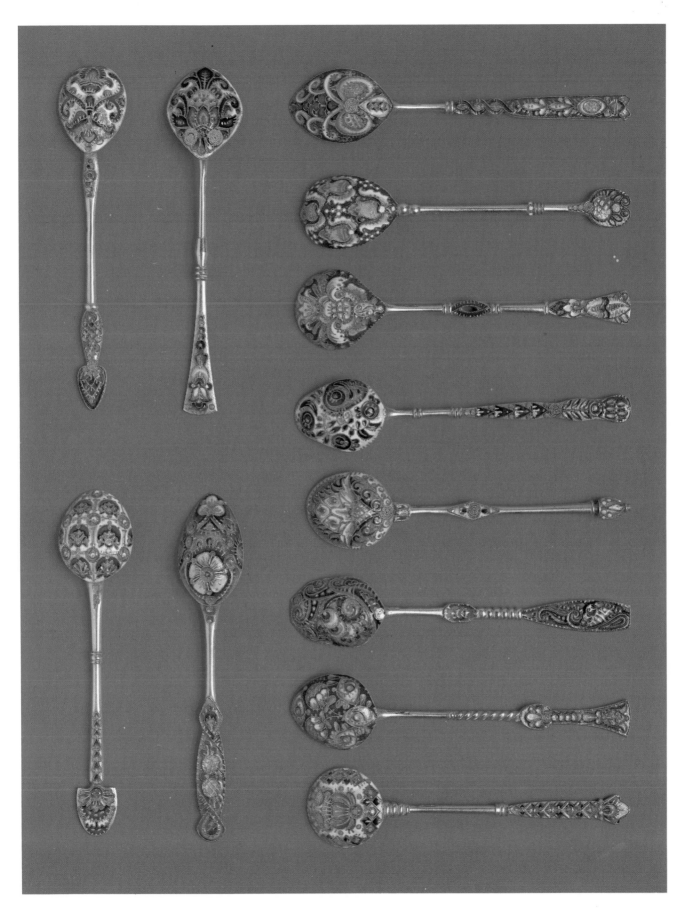

The characteristic milky quality of some of the translucent enamels, especially the white—a rich fullness difficult to describe on paper but easy to recognize in reality—was obtained with a mixture in the proportion of four to six parts of transparent to one part of opaque enamel, producing a semi-opaque enamel that is generally described as opalescent.

Another feature of some of Fabergé's enamel pieces is the way the colour appears to alter as the object is turned very slightly; this effect was brought about by simply varying the colours of the layers of enamel. A pale flame-coloured layer of semi-transparent enamel beneath one or more layers of white transparent enamel imparts a particularly enchanting lustre—the round box in the Sandringham Collection (page 27) is an excellent instance of this technique. Also, the effect of the light on the separate crystals of which the enamel is composed often gives the impression of a second colour. This variation in colour combined with painting beneath the top surface of enamel is illustrated very well in an Easter Egg made for Barbara Kelch (page 115). Add to these variations in colour the engraved pattern and the colour of the gold *guilloché* field—the carcass of the Egg itself, which can be seen through the layers of warm semi-transparent enamel, sometimes indistinctly, at other times very clearly, depending upon the angle of vision and the light, and we begin to get

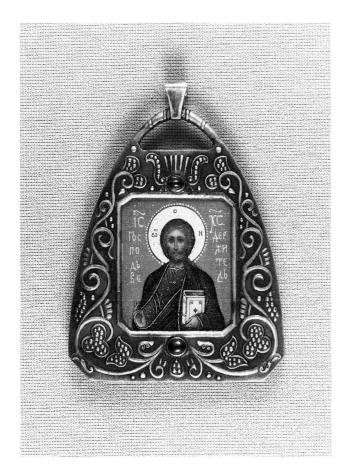

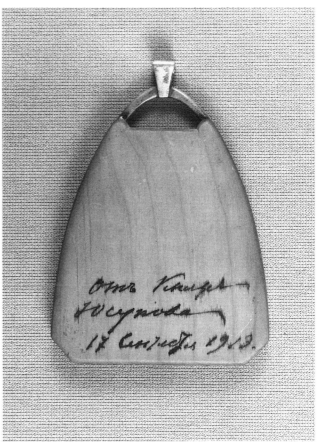

Painted icon of Christ Pantocrator in an oxidized silver pendant frame, decorated with repoussé scrolling and foliate motifs in the Old Russian style and set with two cabochon sapphires. The wooden back inscribed 'From Prince Youssoupov 17th September 1913' in his own hand.

Height $3\frac{3}{16}$ inches Signed K. ФАБЕРЖЕ

Wartski, London.

some conception of the thought and careful planning that went into the creation of such an object.

Cloisonné enamel was used in numerous designs prepared by the House for enamelled silver objects, but none were made by it. Fabergé commissioned Theodore Rückert, the firm of Saltykov and others to carry out this work. He preferred a pastel palette to the cruder blues and reds chosen by most Russian nineteenth-century silversmiths. A network of raised metal enclosures is soldered to the body of the object which is to be treated. The enamels are poured into these *cloisons*, the metal tops of which remain exposed, allowing the different colours in each one to be distinctly shown, like jewels in separate settings.

Champlevé enamelling was often employed, especially for opaque white-enamelled borders on the panels of boxes. For this technique a deep groove is cut and filled with enamel. The surface is then polished so that the accumulation of enamel becomes level with the surrounding area—hence its name.

The Fabergé enamellers occasionally used the *plique à jour* process, which gives the effect of a stained glass window in miniature. The enamel is not backed in any way; when held up to the light, an object treated in this manner, coruscates with an astonishingly vivid fire, as each individual small

25

Top:

Red Cross Egg with Resurrection triptych, presented to Alexandra Feodorovna by Nicholas II. Dated 1915. In white opalescent enamel on an engraved silver-gilt ground, this gold-mounted Egg is emblazoned with a bold red translucent enamel cross on either side. The centre of each cross is set with circular painted miniature portraits of respectively the Grand Duchesses Olga and Tatiana in Red Cross uniform. The front cross with the portrait of Tatiana serves as a clasp securing the double-opening doors, which reveal within a triptych painting of the Resurrection of Christ by Prachov in the centre, with the Saints Olga and Tatiana painted on the side panels. The two remaining panels of the doors are inscribed one with the crowned monogram of the Tsarina and the other with the year 1915. The indifferent painting of the two unsigned exterior miniatures does not prepare one for the rather impressive triptych concealed within the Egg, thus, in this case, the 'surprise' is a double one. In order to save the Emperor money, the cost of this war-time 'austerity' Egg was kept down to about £200.

Height 3⅜ inches Gold mark 72
Signed HW AKS plates 378–381

Left:

Miniature salt chair of chased gold, designed *à la reine*, the flowered upholstery painted in enamels to simulate brocade, set with two cabochon rubies and rose diamonds. The seat forms the lid of a receptacle the hinge of which is cleverly concealed.

Height 4⅛ inches Signed К. ФАБЕРЖЕ
AKS colour plate LI

Right:

Miniature salt chair of chased dull gold, in Louis XVI cabriolet style designed as a bidet. The hinged seat is carved from Siberian jade and is set with a panel simulating silk in opalescent oyster enamel with painted flowers, scrolls and leaves in pale sepia over a *guilloché* ground. The back of the bidet is set on both sides with oval panels similarly enamelled with trophies and entwined foliate borders, the front panel rimmed with half-pearls.

Height 3¼ inches Gold mark 72
Signed HW
HCB plate 38 AKS colour plate LII

Bottom:

Miniature teapot carved in bowenite and decorated with chased *repoussé* gold rococo scroll motifs. The cover with a finial designed as a *flambeau*.

Overall length 4¼ inches Signed МП
Gold mark crossed anchors
The India Early Minshall collection of The Cleveland Museum of Art, U.S.A.

Opposite page, below:

Circular box in red gold with chased green gold laurel mounts and set with twelve small cabochon rubies. The entire surface of the box is enamelled pale opalescent oyster with sepia motifs of simulated moss-agate on the base, the sides with lakeside scenes with boats and trees and the cover with the Wellington Arch, which stands opposite Apsley House, Number One, London, and was erected to celebrate the victory of Waterloo.

Fabergé designed a number of boxes incorporating English architectural monuments for the collection at Sandringham. It is probable that it originally formed part of this Royal Collection. It is fully signed Fabergé and bears the initials of the chief workmaster Michael Perchin. In addition the floor of the box is stamped with the initials of Henrik Wigström who took over this position when Perchin died in 1903, thus effectively dating this box.

Diameter 1⅞ inches Signed МП and HW

Opposite page, right:

Photograph frame in Siberian jade. The circular pearl-bordered aperture is surrounded by a chased garland of roses in four colours of gold. It is surmounted by a bow knot of gold ribbon which threads through the flowers to descend in two streams culminating in tassels set with rose diamonds and two cabochon rubies.

Height 4¼ inches Signed ЯА

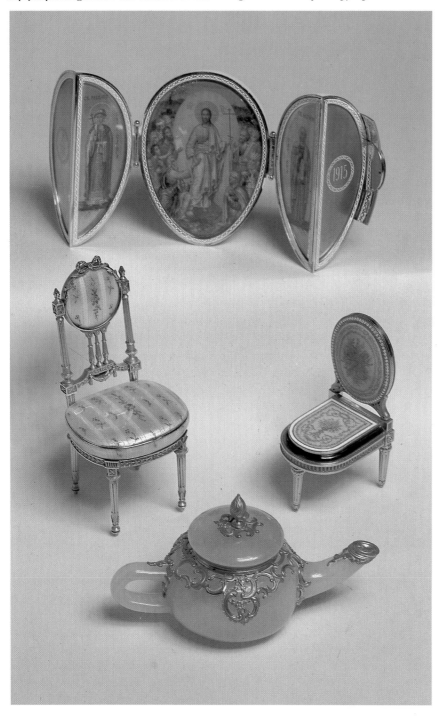

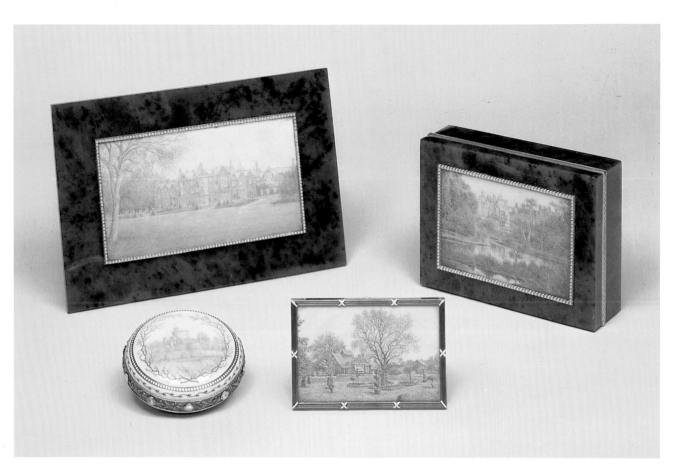

The objects shown above are from the collection at Sandringham and are illustrated by gracious permission of Her Majesty The Queen. Caption on page 29.

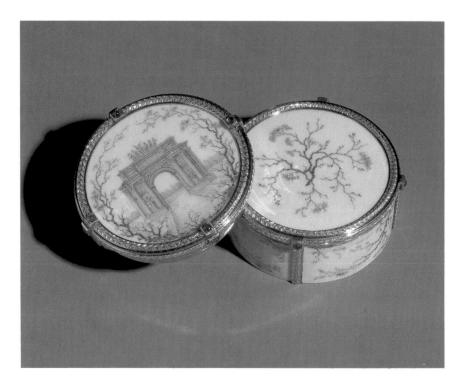

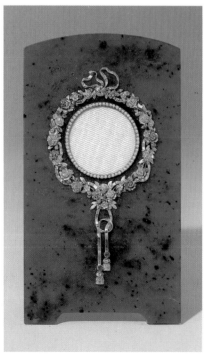

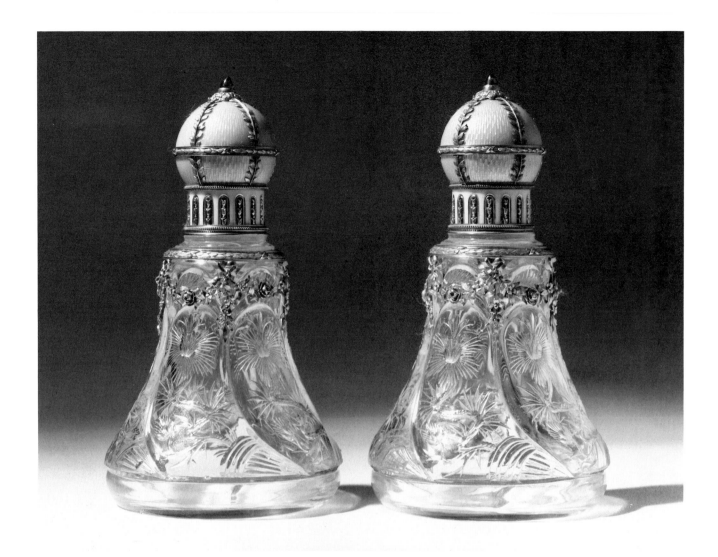

segment, which forms part of an elaborate skeletal frame-work, takes on the intensity of a gem-stone.

The Clover Egg in the Armoury Museum at the Kremlin (page 104) provides an excellent example of this difficult technique.

Stones

The lapidaries working in Russia found everything in their favour: the richest imaginable variety of natural resources was, practically speaking, on their doorstep, from vivid Siberian emeralds to the grey jasper of Kalgan. The astonishing abundance of minerals available from the Urals, the Caucasus, Siberia, and elsewhere must have been a source of great satisfaction to Fabergé. Time and time again, he is able to transmit to us his own pleasure in some particularly choice stone by means of an animal carving, or a dish or box.

He rarely used precious stones unless the purely decorative demands of the particular object called for them. Sapphires, rubies and emeralds were most frequently used *en cabochon*,

Pair of gold-mounted rock crystal toilet bottles, engraved with floral motifs and hung with chased bow-knots, garlands and swags in red, green and white golds. The globular chased gold stoppers enamelled opalescent rose and oyster, each with a cabochon sapphire finial. Compare with a similar pair of bottles in AKS plate 184.
Height 5½ inches Signed КФ
Her Royal Highness, the Princess Margaret, Countess of Snowdon.

Riding crop, with a carved Siberian jade handle, the collar enamelled translucent strawberry over an engraved wavy ground and mounted with chased green gold laurel borders.
Height of handle 1½ inches Signed HW
Her Royal Highness the Princess Anne, Mrs Mark Phillips.

Page 27, top picture:
Top left:
Rectangular strut frame. Nephrite, mounted in red gold with a border of half-pearls, containing a gold panel with a view of Sandringham House, painted in warm sepia enamel over a pale opalescent rose background.
Length 5$\frac{15}{16}$ inches Signed HW

Top right:
Rectangular box. Nephrite, mounted in red gold with a chased green gold foliate border with, on the hinged cover, an opalescent sepia enamel painting framed with half-pearls of a lakeside view of Sandringham House and grounds.
Length 4 inches Signed HW
HCB plate 89

Bottom left:
Bonbonnière in engraved yellow gold, of circular *bombé* form, the box and cover enamelled with wreathed paintings of Balmoral and Windsor Castle respectively, in warm sepia against opalescent backgrounds. Both paintings are bordered by opaque white-enamelled pellets and the box is encircled by an elaborate frieze composed of painted enamel roses and translucent green leaves with rose diamonds.
Diameter 2¼ inches Gold mark 72
Signed HW
HCB plate 91 AKS plate 91

Bottom right:
Rectangular strut frame in red gold. Enamelled translucent emerald green over an engraved ground with, at intervals, white opaque enamelled ties. It contains an opalescent rose-sepia enamelled painting on gold of the Dairy at Sandringham where the wax models for the Sandringham animals were assembled for the inspection of the King and Queen.
Length 2$\frac{13}{16}$ inches Signed HW
HCB plate 89

Circular eighteenth-century Chinese marriage cup, carved in mutton-fat jade and mounted in oxidized silver by Fabergé very much in the manner later to be associated with George Jensen. The rim is engraved with a pattern of lines and dots and the two handles are overlaid by chased stylized jaguar heads, each revealing within open jaws formed of leaf motifs three cabochon amethysts.
Length 4¼ inches Signed КФ
Silver mark crossed anchors
Wartski, London

and nine times out of ten the diamonds he used were rose-cut; he confined his use of brilliant diamonds to specially commissioned and Imperial pieces. Rose-cut diamonds set next to enamel or stone become part of the whole, whereas there is sometimes a danger that brilliant-cut stones, being so much brighter, might appear out of tone unless they have specially designed settings.

Semi-precious gemstones were used a great deal, especially moonstones, *cabochon* garnets, olivines, and stained chalcedonies which, cut *cabochon*, are known as Mecca stones.

The other hardstones to which Fabergé seems to have been most attracted for carving were jade, bowenite, rhodonite, rock crystal, agate, aventurine quartz, lapis lazuli and occasionally pale green flecked and opalescent amazonite.

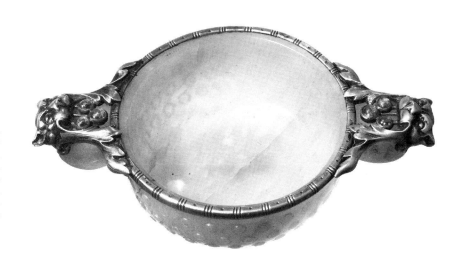

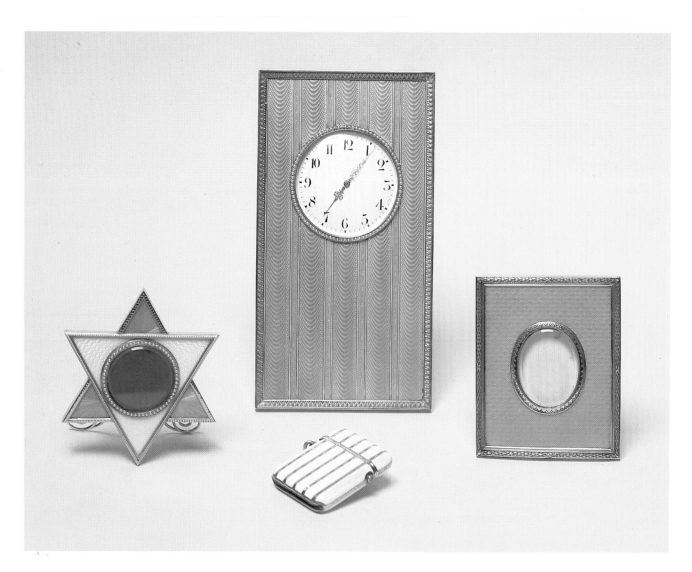

Left :

Miniature frame of chased and engraved red gold, designed as a Shield of David enamelled opalescent oyster and translucent peach over *guilloché* backgrounds. The circular aperture is bordered by half-pearls.

Height 3 inches Signed МП

Gold mark crossed anchors

Centre :

Rectangular strut clock. Red gold with chased green gold acanthus border, enamelled pale mauve over an engraved moiré ground with four narrow stripes within opaque white enamel borders enamelled translucent pale green over engraved lines and a trail of leaves. The white enamelled dial is bordered by half-pearls and the hands are of pierced red gold.

Height $6\frac{1}{8}$ inches Signed HW

Bottom centre :

Match-case. Silver, enamelled opalescent oyster over a *guilloché* ground with pellet and dot engraved stripes and a moonstone push-piece, and a gold ring.

Height $1\frac{3}{4}$ inches Signed A * H

Right :

Rectangular frame. Engraved red gold with chased foliate borders in green gold enamelled translucent sulphur.

Height $3\frac{1}{8}$ inches Signed МП

Gold mark crossed anchors

All items on this page: Wartski, London

Left :
Rectangular cigarette case in nephrite with an engraved yellow gold bezel and narrow opaque white enamelled borders, with a broad central band finished matt with deep flutes and enamelled overall with a thin wash of transparent flux. This band is applied with four stylized gold rose-heads one of which serves as a push-piece.
Height 3⅛ inches Signed HW
Gold mark 72
Stamped for the English market
Wartski, London

Top :
Oval box. Nephrite, with red gold mounts and a chased green gold laurel border within lines of opaque white enamel. The hinged cover inlaid with an oval plaque of moss-agate with a tree-form inclusion and a rose diamond thumbpiece.
Length 3¼ inches Signed HW
Gold mark 72
Formerly in the collection of His Royal Highness the Duke of Gloucester.
Wartski, London

Centre :
Elephant, skilfully carved in nephrite, set with rose diamond eyes, in the form of a miniature egg pendant, with a gold ring held by the trunk.

Right :
Imperial *kovsh.* Nephrite in an engraved red gold mount with, at its tip, a chased Romanoff double-headed eagle. The exceptionally thin gauge of this carving allows the light to reveal very clearly the natural variation of texture in the jade.
Length 3⅝ inches Signed HW

Bottom :
Ladle made of nephrite, with a long flat handle mounted in frosted yellow gold and chased with conventionalized scrolling, strapwork and foliage over granulation.
Length 6½ inches Signed МП
Formerly in the collection of Fabergé's son Agathon.

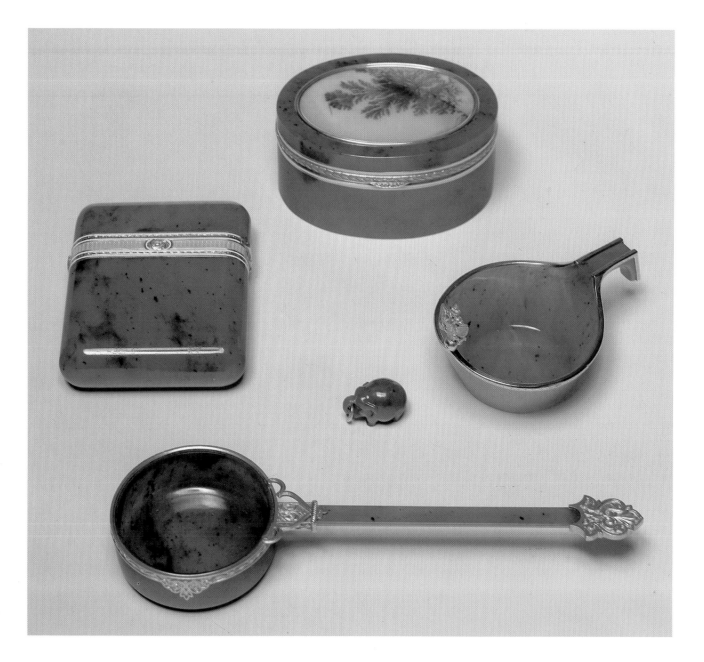

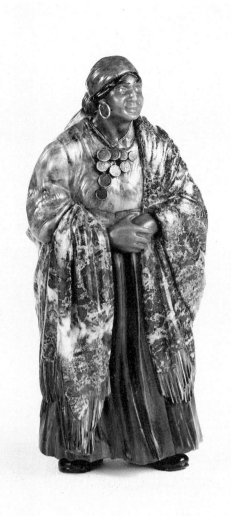

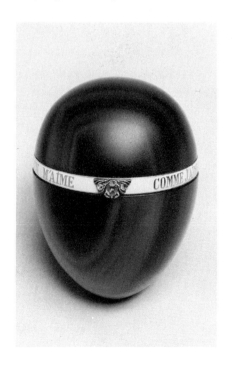

A word or two about the special properties of some of these
stones might be useful in this context. There are, strictly
speaking, only two varieties of jade, nephrite and jadeite;
both were used by Fabergé, nephrite a very great deal, jadeite
rarely. The nephrite he used was the dark green stone
found in Siberia. The pale yellow-green stone sometimes
described as pale jade is not a jade at all, but a hard form of
serpentine known as bowenite—known, that is to say, since
1822 when G. T. Bowen published his findings in the Ameri-
can Journal of Science. Until that time, the stone had been
erroneously thought to be jade. Apart from Rhode Island,
USA, where Bowen found it, this form of serpentine also
occurs in Afghanistan, the source from which Fabergé
doubtless had the stone imported.

Rhodonite or *orletz*, to give it its Russian name, is one of the
most beautiful of all natural stones. It was mined at Ekaterin-
burg and is characterized by its warm rose colour.

Rock crystal, a transparent glass-like quartz, was used for
numerous carvings of animals and birds, for the pots which

Nephrite carving of a *Tyrannosaurus*, a rare example of a prehistoric subject by a Fabergé sculptor.
Height about 4 inches
Wartski photograph

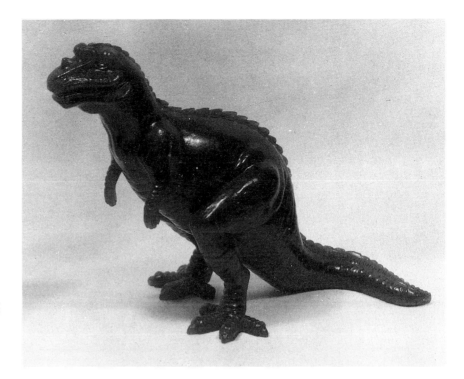

Covered jar of baluster form in green jasper; the carrot-coloured inclusions, the characteristic of bloodstone, are here particularly marked and vivid. Mounted in yellow gold in the eighteenth-century German rococo manner with reeded borders, the hinged cover chased with an elaborate scrolling border with balustrades and a peacock, over a granulated field. The floral thumbpiece is composed of rose diamonds set in silver leaves and a central cinnamon-coloured brilliant diamond and two rubies all set in gold in imitation of rose petals.
Height 1¾ inches Signed МП
Gold marks crossed anchors and 72
Wartski, London

hold the flower studies, and the ice floes upon which sprawl obsidian sea lions, some of the most original of the Imperial Easter Eggs and too many of the House objects of vertu to specify in detail.

Agates are a very large group of varicoloured stones which provided the material for the majority of Fabergé's animal carvings; they include cornelian, sardonyx, chalcedony, onyx and jaspers of many subtle shades and markings.

Aventurine quartz, a tawny material mined in the Altai Mountains is particularly attractive, with gold spangles which may be seen below the surface.

Obsidian, a natural volcanic glass of a grey-black colour which takes on a soft velvety sheen when polished, was peculiarly suited for carvings of some animals.

Kovsh in Siberian jade designed as a swan, the head set with two cabochon rubies, and neck with carefully chased and engraved feathers in green and red golds, the tail, which serves as the handle, reeded in the same golds framing a gold five rouble piece of 1898 partly enamelled translucent strawberry.
Length 4 inches Signed HW
Gold mark 72
Bentley, London.

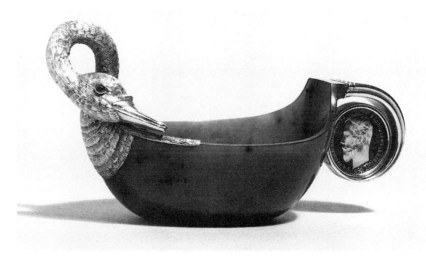

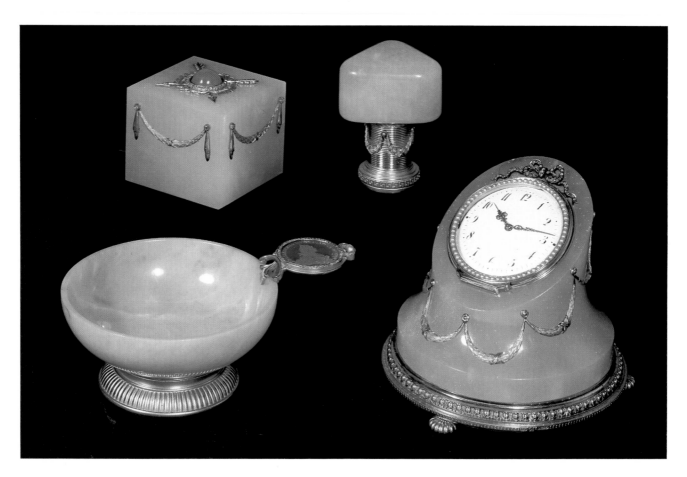

The objects shown above are from the collection at Sandringham and are illustrated by gracious permission of Her Majesty The Queen.

Top left :
Bell-push, composed of a solid cube of pale green bowenite decorated with dull green gold foliate mounts and red gold arrows set with rose diamonds. A pink-stained Mecca stone forms the push within a gold border chased with leaves, berries and roses.
2 inches square Signed MΠ
AKS plate 146

Top right :
Hand seal, the main column in reeded red gold decorated with Greek key and Vitruvian scroll borders and foliate swags in yellow and green golds, the top composed of a heavy block of bowenite carved in triangular form. Set with an agate sealing stone.
Height 2¼ inches Signed MΠ
Gold mark crossed anchors

Bottom left :
Kovsh of shallow circular form, carved in bowenite, supported on a dull yellow gold fluted base; the gold handle, mounted with a

single pearl, is inset with a Catherine the Great rouble dated 1766 enamelled translucent strawberry colour and bordered by rose diamonds.
Overall length 4¾ inches Signed EK
Gold mark crossed anchors
HCB plate 101

Bottom right :
Table clock of hoof form, on bun feet, in carved bowenite, mounted in red-gilt silver with red and green gold foliate swags. The plain white-enamelled dial, fitted with pierced red gold hands, is bordered by half-pearls set in red gold and is surmounted by a rose diamond bow.
Diameter without feet 3⅞ inches Signed MΠ

Oval snuff-box. Dark grey dappled agate mounted in red gold chased with green gold laurel and set with a briolet-cut diamond thumb-piece. The hinged cover is emblazoned with a green gold Imperial Romanoff Eagle, partly tinted red and enamelled opaque black with painted enamel ribbon and shields. Kenneth Blakemore writes in his book, *Snuff Boxes* (Frederick Muller, London, 1976): 'We see the essential Fabergé in an oval snuff box, produced presumably for the Tsar, for it has a green gold Imperial eagle in the centre of the lid. This box is an example of Fabergé's love affair with decorative minerals and of his ability to use them with unrivalled felicity. The lid and body of this box were carved from a dappled grey agate that has an effect that looks

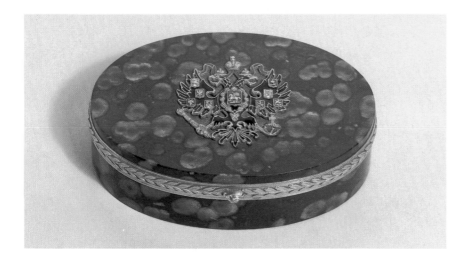

like the first raindrops on a pavement . . . a thumbpiece set with a single diamond is a final touch of opulence to what must be the most exquisite snuff box made in the late nineteenth century.'
Length 3⅛ inches Signed AH
Gold mark crossed anchors AKS plate 129

Marine chronometer. Red gold and chocolate-coloured agate. The movement by Brinkman, London, is balanced on gimbals and the hinged cover opens by means of a button, with glazed interior. The main opening, also hinged, locks with a small gold key, the key-hole being in an opaque white enamelled gold disc on the front, inscribed in black enamel C. Fabergé, St Petersburg. Two gold free-swinging handles are on the sides of this simply designed scientific instrument and the key for the movement is accommodated inside. Height 4 inches Signed HW

In addition to the many natural stones available to the firm, a deep crimson material known as purpurine was frequently used with great effect. A worker in the Imperial Glass Factory in St Petersburg, named Petouchov, discovered the secret of its manufacture. A similar process was known in the eighteenth century to the lapidaries of Murano, near Venice, to whom also must go the credit for the invention of aventurine glass or 'goldstone'.

The purpurine-like substance found in Italian work, however, is considerably lighter both in colour and weight, probably because it contained a smaller proportion of lead. than that used by Petouchov.

The manufacture of purpurine appears to have involved the crystallization of a lead chromate in a glass matrix. The intensity and depth of its *sang-de-boeuf* colour and its

spangled glassy texture make it a material of great beauty. The Fabergé workshops seem to have had the exclusive use of it.

Maquettes
Before starting up with the wheel on a freshly ground piece of stone, the sculptor would generally have before him a wax or plaster model of the subject from which to work. The lapidaries would not necessarily carry out their own ideas;

Shaped bell-push, intended as a panel for the wall, in holly wood with silver-gilt mounts in Louis XVI style and with a moonstone push.
Length 5 5/16 inches

Rectangular bell-push, designed as a wall panel in palisander wood, applied with chased oxidized silver mounts, an arrow with a moonstone push at its centre in a gadrooned border and two intertwined trails of berried leaves, all within a chased border.
Length 8 3/16 inches Signed BA
Silver mark crossed anchors
Dr Edwin I. Radlauer, New York.

Two views of a silver cigarette case decorated with niello work.
Length 3¼ inches Signed К. ФАБЕРЖЕ
HCB plate 116 AKS plate 94

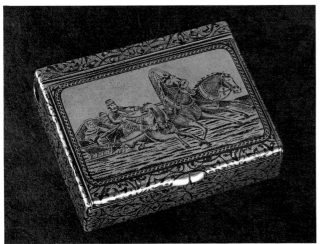

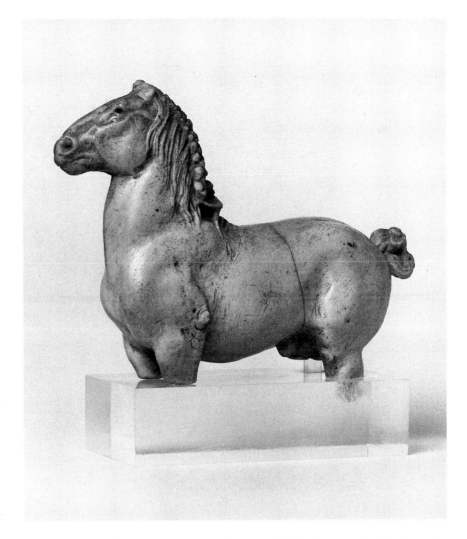

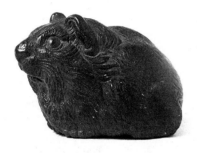

Two Fabergé wax figures, a stallion and a hamster, which are typical of the models from which the St Petersburg sculptors carved the hardstone animals. They were a gift to the author from H. C. Bainbridge.
Length of stallion $5\frac{1}{8}$ inches
Length of hamster $1\frac{3}{4}$ inches

there were about twenty artists and designers in Fabergé's drawing-studio, and it was here that these preliminary wax figures were usually modelled.

In some cases—the Sandringham series is an obvious example—the original modelling from nature would be done on the spot and the carving carried out in the St Petersburg workshop.

Woods

Fabergé had a nice appreciation of the different woods to be found in and around Russia. Karelian birch, palisander, and holly wood in particular were used for a variety of objects including cigarette cases, miniature frames, and even bell-pushes.

The boxes in which Fabergé pieces were delivered were generally made of wood—for the most part, polished white holly wood; they were beautifully made and provided a worthy setting for a precious gift. Fabergé set up his own special workshop in Moscow where he employed fifteen people to make these boxes.

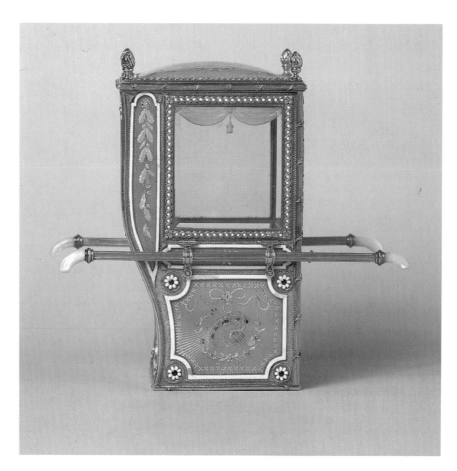

Miniature sedan chair. Chased, engraved and granulated gold, the panels enamelled opalescent rose over sunburst *guilloché* fields with coloured gold *paillons* sealed between the layers of enamel depicting the arts of painting and music together with horticultural and amatory motifs and trails of flower heads and leaves. It has Vitruvian scroll and pellet borders of opaque white and translucent emerald green and similarly enamelled rosettes. The carved rock crystal windows are engraved to simulate curtains. The door, which opens when the handle is turned, is flanked by two reeded gold columns embellished with single enamelled leaves applied at intervals, and the roof is similarly framed and is mounted at each corner with a chased gold pineapple. The two reeded gold bearing poles are mounted with carved mother-of-pearl handles and the interior of the chair is lined with the same material.
Height 3⅝ inches Gold mark 72
Signed МП
See AKS for a very similar example on colour plate L
Wartski, London

Pianoforte in the *Retour d'Egypte* style. Siberian jade and red gold, meticulously engraved and chased with green gold mounts with lyres and rosettes and two sphinxes. The borders are chased with acanthus and the piano is supported upon four reeded bun feet. The top jade panel is hinged and forms the cover of a box.
Length 2¹⁵⁄₁₆ inches Signed МП

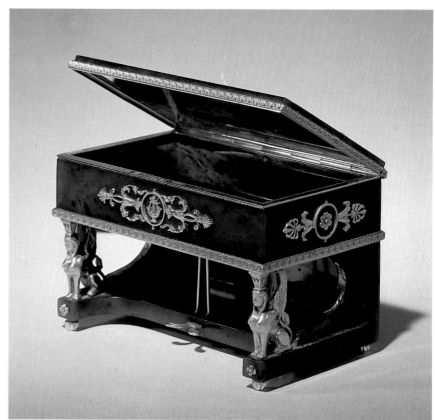

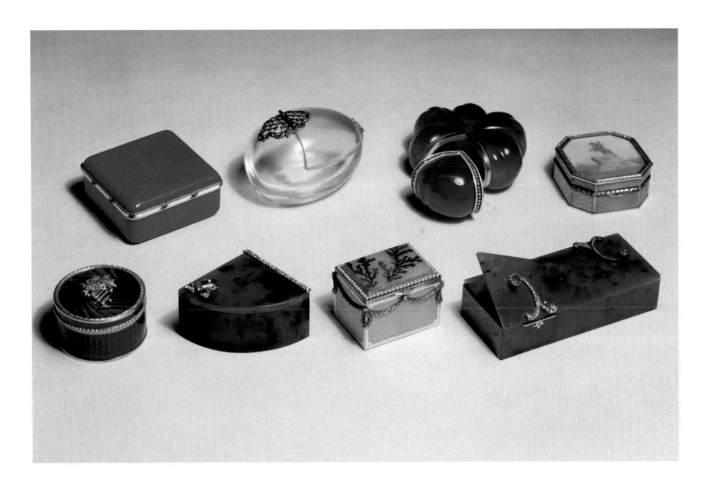

Top row, left to right :

Box. Purpurine mounted in red gold, the hinged lid with a rounded opaque white-enamelled border crossed at intervals by translucent emerald-enamelled leaf ties.
$1\frac{7}{8}$ inches square Gold mark 72
Signed HW
AKS plate 188

Box in the shape of an egg. Rock crystal with red and green gold *repoussé* clasp and hinge in rococo taste set with rose diamonds.
Length $2\frac{3}{16}$ inches Signed МП
AKS plate 188

Box. Red-brown carved cornelian mounted in yellow gold in the form of a pumpkin, the removable segment with a border enamelled opaque white and set with rose diamonds.
Diameter $2\frac{1}{8}$ inches
Gold mark 72 and crossed anchors
Signed ФАБЕРЖЕ
Any workmaster's initials there may originally have been, are now worn away.
AKS plate 128

Square box with canted corners. Silver with red and chased green gold laurel borders and a rose diamond thumb-piece. Sides and base enamelled translucent grey-blue, the hinged lid with a sepia enamel painting of the Peter the Great Monument over an opalescent background.
$1\frac{1}{2}$ inches square Signed ФА

Bottom row, left to right :

Circular box, in engraved red gold enamelled translucent royal blue over an engraved ground, with green gold chased borders, the cover applied with a rose diamond basket of flowers set with three cabochon rubies and two emeralds.
Diameter $1\frac{1}{2}$ inches Gold mark 72
Signed HW
AKS colour plate XXX

Hinged box in nephrite. Designed in the shape of a segment of cheese, mounted in yellow gold and set with *fleur-de-lis* motifs in rose diamonds, that on the cover with an elongated oval cabochon ruby.
Length $1\frac{7}{16}$ inches Signed МП
AKS plate 128

Small rectangular comfit box, in engraved yellow gold enamelled translucent pale pink over wave-patterned engraving, bordered by opaque white-enamelled lines and decorated with chased green gold swags set with rose diamonds. The hinged cover inset with a moss-agate panel within a frame of half-pearls, with a rose diamond thumb-piece.
Length $1\frac{7}{16}$ inches Gold mark 72
Signed HW
AKS colour plate XXX

Rectangular stamp-box in nephrite opening at the top by means of two lids meeting diagonally. The hinges are mounted with yellow gold arabesque motifs set with rose diamonds and two cabochon rubies, and the interior of the box divides into three compartments, the floors of which slope gently to enable the stamps to be more easily removed.
Length $2\frac{15}{16}$ inches Signed МП

The objects shown above are from the collection at Sandringham and are illustrated by gracious permission of Her Majesty The Queen.

39

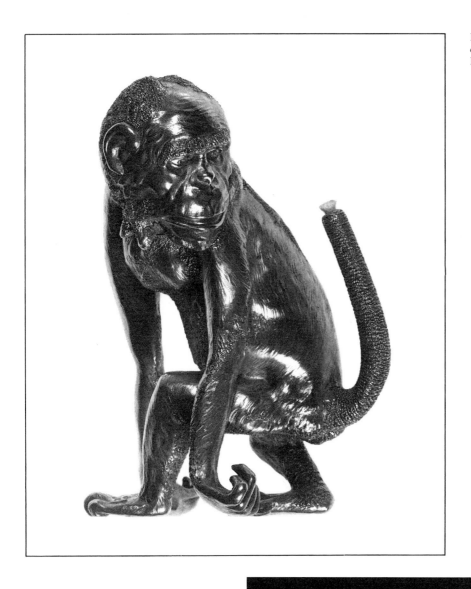

Engraved silver table lighter designed as a crouching monkey.
Height $4\frac{7}{16}$ inches Signed К.ФАБЕРЖЕ

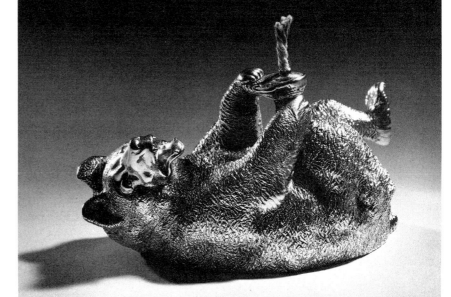

Silver table-lighter realistically modelled as a bear lying on its back. One paw may be removed by means of a bayonet-fitting to allow spirit to be poured in to impregnate the wick which emerges from it. Possibly a model of Mishka the Bear, a much-loved figure of Russian legend whose exploits are chronicled in the stories of Krilov.
Length $4\frac{3}{4}$ inches Signed IP
His Royal Highness, The Duke of Gloucester.

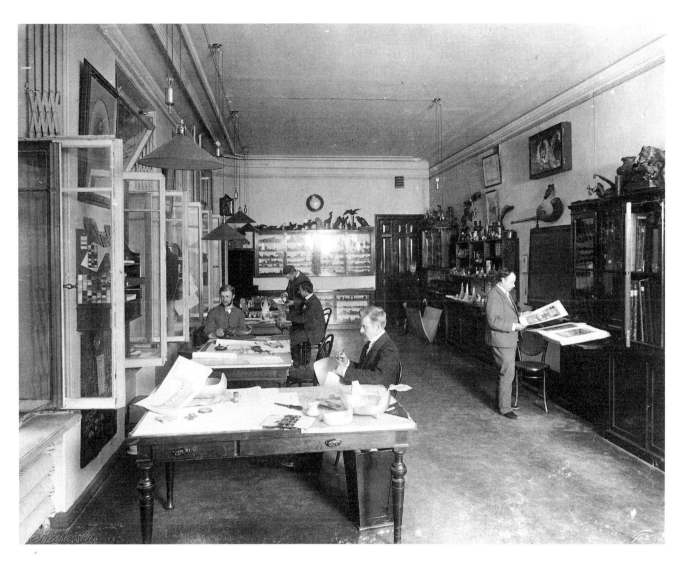

The Studio (photographed by Nicholas
Fabergé), where most of the twenty-five or
so designers worked. Alexander Fabergé is
seen on the extreme left, Eugène stands at the
back of the room, Oscar May is seated in
front of him. In the case at the back are seen
the original wax models used for the animal
carvings.

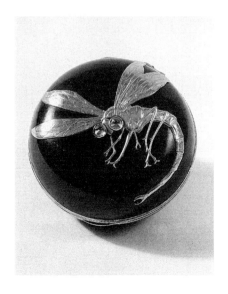

Circular steel-blue papier-maché bonbon-
nière with the signature of the Lukutin Factory
in gold painted on the usual sealing wax red
interior. Mounted in yellow gold by Fabergé
in imitation of Japanese gold *takamakie*
work on lacquer. The hinged cover is applied
with a dull and softly chased dragonfly set
with protruding moonstone eyes.
Diameter $2\frac{3}{8}$ inches
Gold mark crossed anchors Signed МП
A la Vieille Russie.

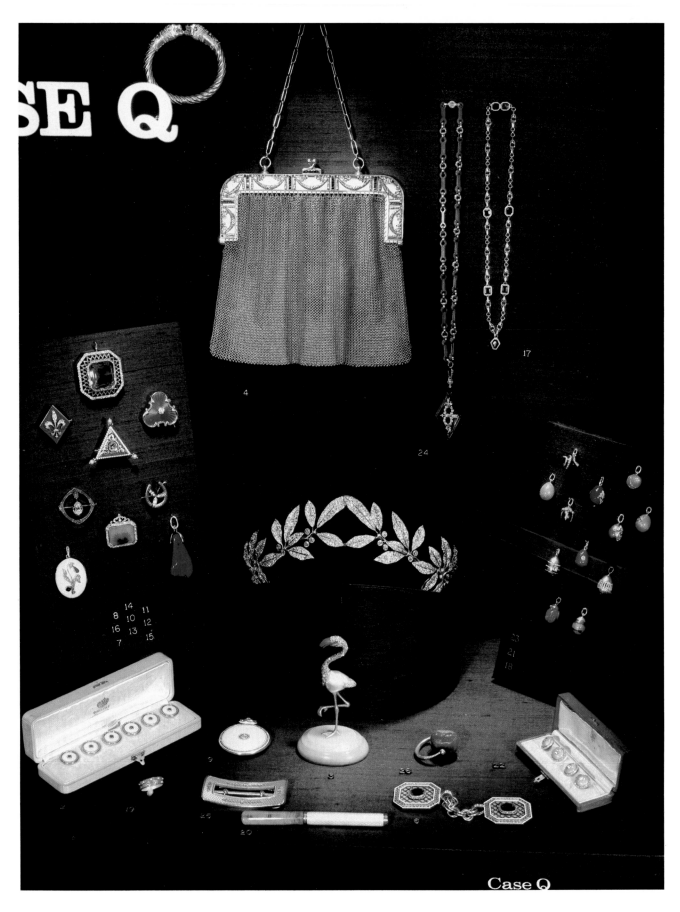

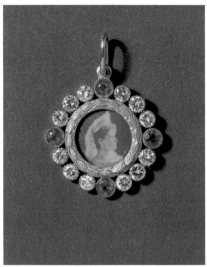

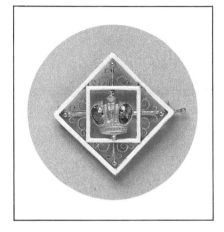

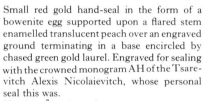

Circular miniature pendant frame. Gold with chased green gold foliate border framed by four rubies of fine colour and twelve brilliant diamonds, containing a tiny contemporary photograph of Alexandra Feodorovna wearing a pearl and diamond tiara in the form of a *Kokoshnik*.
Overall height $1\frac{3}{8}$ inches
Signed ФАБЕРЖЕ

Small red gold hand-seal in the form of a bowenite egg supported upon a flared stem enamelled translucent peach over an engraved ground terminating in a base encircled by chased green gold laurel. Engraved for sealing with the crowned monogram AH of the Tsarevitch Alexis Nicolaievitch, whose personal seal this was.
Height $1\frac{7}{16}$ inches Signed ФА

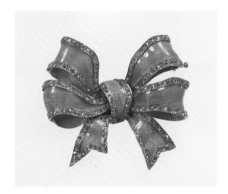

Brooch of openwork gold, enamelled opalescent oyster over an engraved ground with, at its centre, an Imperial Romanoff crown set with two sapphires. Fitted in the original case, the base of which bears the inscription '10.12.1912 from the Tsarina Marie Feodorovna of Russia'.
Height $1\frac{7}{16}$ inches Signed A * H
Mr Elton John

Gold brooch in the form of a knotted bow of broad ribbon enamelled translucent pink over a moiré ground and bordered with rose diamonds set in silver.
Length $1\frac{9}{16}$ inches Signed МП
Wartski, London

A view of the showcase of Fabergé jewels in the Jubilee Exhibition held at the Victoria & Albert Museum, London, in 1977. Detailed descriptions of these pieces and the objects shown on page 138 are given in the catalogue entitled *Fabergé 1846–1920* which was published by Debrett for the Exhibition.

Flamingo standing upon one leg in chased dull green gold, the body composed of a single baroque pearl, with feathers and neck of massed rose diamonds and the head with cabochon ruby eyes set in gold, the half-opened beak enamelled a deep coral with dark brown tip and marking. The feet are webbed and the bird stands on one leg on an oval bowenite base.
Height $4\frac{5}{16}$ inches No marks
This piece has its original wood case.

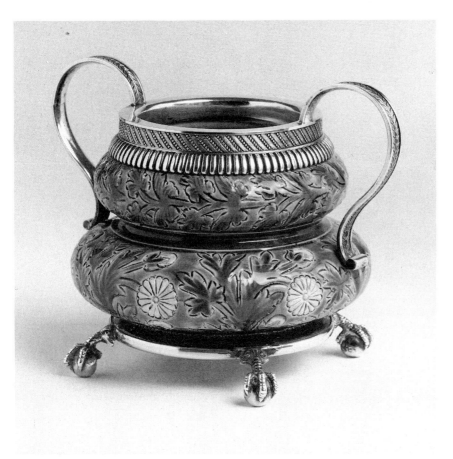

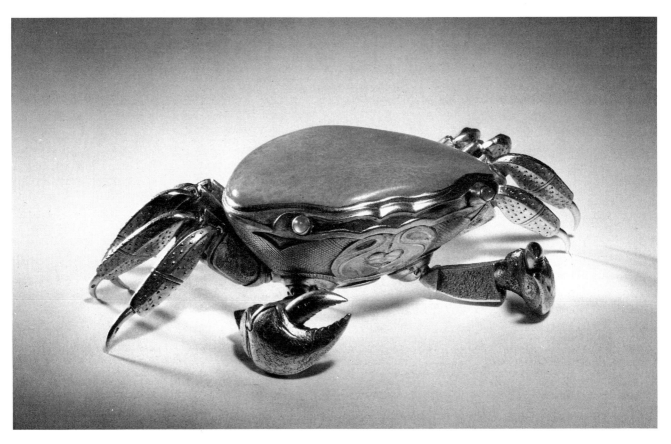

Waisted pottery bowl with incised floral decoration painted in ochre, blue and green glazes, and mounted with a two-handled chased and oxidized silver rim, raised on a silver base, supported by four claw and ball feet. The bowl is incised with the Doulton of Lambeth mark for 1879.
The decorator's initials AG are those of Annie Gentle, senior assistant until 1882, and the monogram IM that of Isabella Miller, then a junior assistant, but later to become senior from 1882 until 1912.
Height 4¾ inches Signed К. ФАБЕРЖЕ
Silver mark St George and Dragon
Wartski, London.

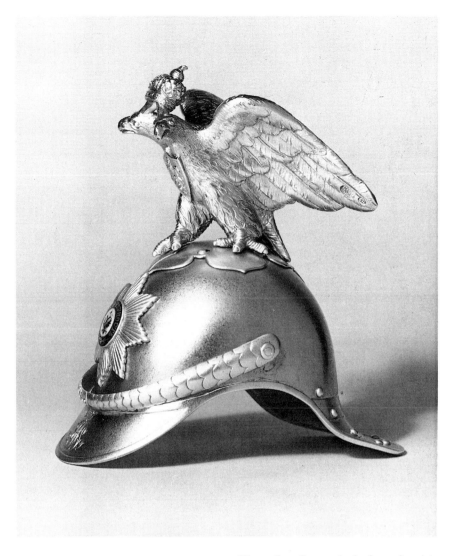

Silver double bell-push designed as a crab, carefully chased and engraved with scoring and pitting, the legs and claws naturalistically articulated. The shell is represented by carved blue chalcedony and the protruding eyes, each set with a moonstone, serve as pushes. Underneath, a segmented plate, similar to that found in these creatures, may be removed in order to connect the electric wire.
Overall width 5 inches Signed HW
Stamped for the English market.

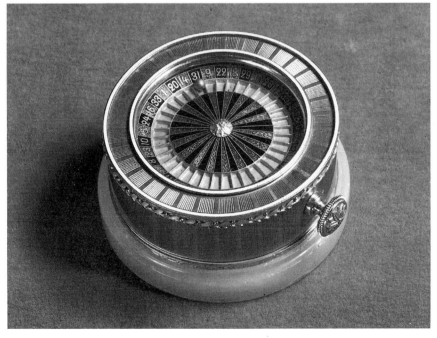

Silver-gilt vodka cup, in the form of a miniature helmet of the Imperial Chevalier Guard with the enamelled silver Badge and Star of the Order of St Andrew, surmounted by a chased silver crowned Imperial Eagle.
Height 5⅜ inches Signed AH
Silver mark crossed anchors

Miniature working model of a roulette wheel, enamelled translucent grey-blue against a *guilloché* ground with two-colour gold mounts, the main bezel chased with husks, and supported on an onyx base.
Diameter 2¾ inches
AKS colour plates LVIII and LIX

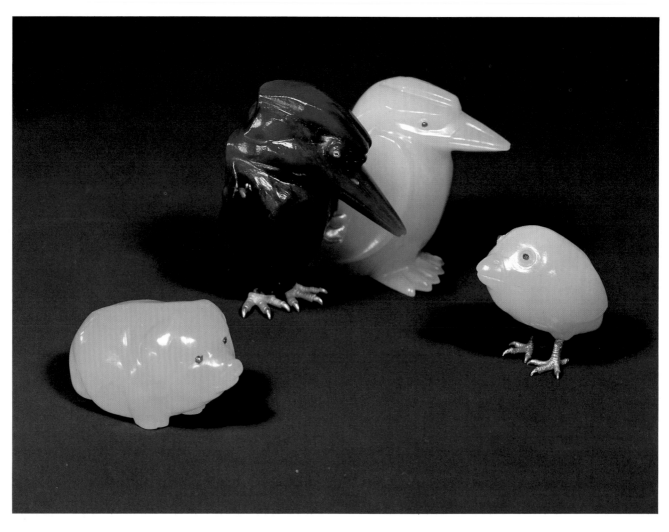

The carvings shown above are from the collection at Sandringham and are illustrated by gracious permission of Her Majesty The Queen.

Match-holder in the form of a brick, with oxidized silver handles in the Etruscan taste, composed of reeded loops with beaded bosses at either end and with the heads of bearded satyrs also within clusters of granulated beads.
Impressed on the base with the name of the Moscow brick factory of A. Gusarev.
Length of brick 3¾ inches Signed EK
Silver mark crossed anchors

A Restless Imagination

Opposite page :
Centre, right :
Kingfisher in bowenite with cabochon ruby eyes. This and the example in nephrite are characteristic of Fabergé's humorous treatment of his subject.
Height $2\frac{1}{16}$ inches

Left :
Pig. Bowenite with cabochon ruby eyes.
Length 2 inches

Centre, left :
Kingfisher in dark siberian nephrite, with rose diamond eyes and chased gold claws.
Height $2\frac{5}{16}$ inches Gold mark 72
Signed HW

Right :
Chick. Bowenite with cabochon ruby eyes and chased gold legs. This chick is carved in a manner that recalls the paintings of Bosch.
Height $1\frac{5}{16}$ inches Gold mark 72
Signed HW

It is easy to forget that Carl Fabergé was not just a creator of prettified confections based on the applied arts of eighteenth-century Paris. He also embarked upon many adventurous sorties into styles and manners which he made quite his own. As a matter of fact, even the neo-Louis XVI pieces have, despite their original inspiration, a strong Russian accent which sets them quite apart from their models. This is also the case with his essays in the manner of the craftsmen of the Italian Renaissance and the South German goldsmiths. Rather than treating these exercises as mere pastiches, I prefer to regard them as paraphrases—not on quite the level of Liszt's *Don Giovanni*, but paraphrases none the less. Some of the most intriguing objects made by this Diaghilev of his craft are seldom discussed.

Erik Kollin, one of Fabergé's first workmasters—he opened his workshop in 1870, the year that the young Carl Fabergé took over the firm—had a natural aptitude and enthusiasm for fashioning precious metals in the antique taste. At the

Fantastic bird in a fine-grained sandstone with chased silver mounts and carbuncle eyes. Designed as a holder for matches to be struck on the stone, this curiosity by Fabergé appears to have strayed from Hieronymus Bosch's 'Garden of Delights', a forerunner of so many dreaded seaside tourist souvenirs.
Length $5\frac{1}{2}$ inches Signed IP
Silver mark crossed anchors
AKS plate 55
Mr Robert Rush, Los Angeles.

suggestion of Count Gregory Stroganov, he made faithful replicas in dull gold of objects from the Scythian Treasure discovered near Kerch in the Crimea. Alexander III found it difficult to distinguish these replicas from the originals. An interesting Sassanian swivel dome-seal in banded agate mounted in silver by Kollin in the Old Persian style is shown on the right.

Pieces which, at first glance, one would assign to the 1930s in Scandinavia or France, turn out to have been designed and made in St Petersburg nearly half a century earlier. Consider, for example, the rectangular cigar-box composed of reeded stripes in red and green golds (page 53). This boldly conceived box has an austerity which, at the time of its manufacture, must have been astonishing—here Fabergé has even eschewed the idea of setting the usual rose diamonds in the thumb-piece, rightly judging that the chastity of his design would have been thereby impugned. One hardly needs to be reminded of the excesses that were being perpetrated in the name of the Decorative Arts at the end of the nineteenth century, and the appearance of this box, of the bowenite hand-seal (page 52) and of similar pieces must have served as a refreshing draught to a society parched of simplicity.

Because it was pure, this new style by no means lacked sparkle. Some of the animal and bird carvings which made

Swivel seal in banded brown agate, the stone a Sassanian intaglio seal engraved with two stags. The silver shank, authentically fashioned with ringed shoulders in imitation of the Old Persian manner of 400–500 AD, is the work of Erik Kollin who specialized in pastiches of this sort.
Height 1½ inches Signed EK
Silver mark crossed anchors

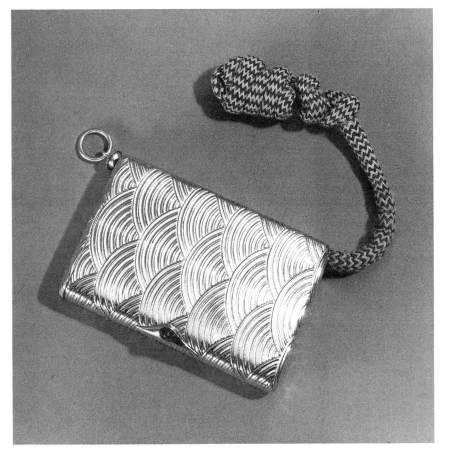

Cigarette case in red gold embossed with an all-over pattern of scallops, with a tinder attachment and match compartment, mounted with a thumb-piece set with a cabochon sapphire.
Length 3¹³⁄₁₆ inches Signed GN
Gold mark crossed anchors
HCB plate 106

Tazza in Siberian jade. The circular dish is supported by two addorsed nude girls, carved in a manner anticipating Maillol, as caryatids with cascades of water flowing over the rims of two pitchers between them, suggesting *La Source* as subject. The silver-gilt base is reeded and stands upon four chased and granulated feet. An early example of an 'art work'.
Height 8½ inches Signed MП
Silver mark crossed anchors

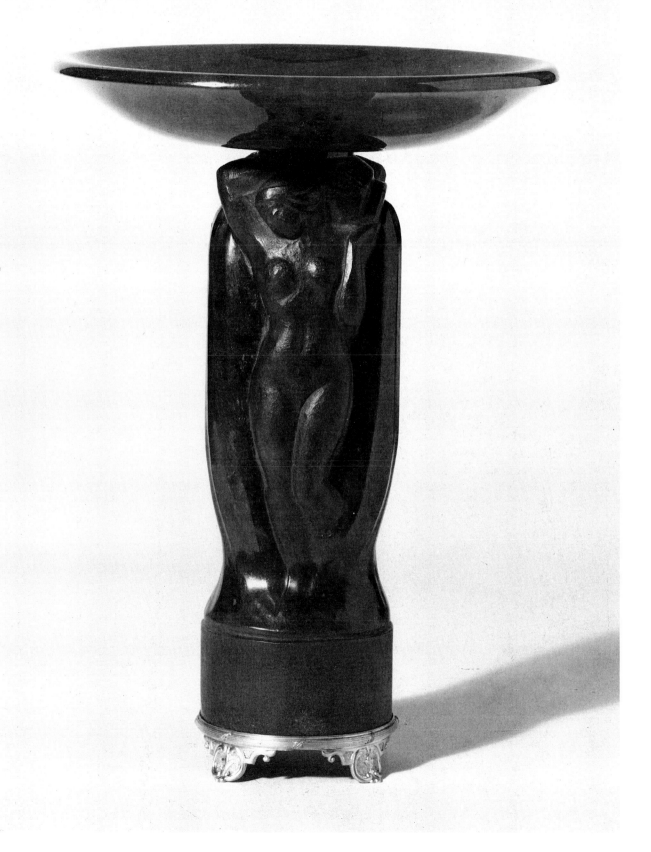

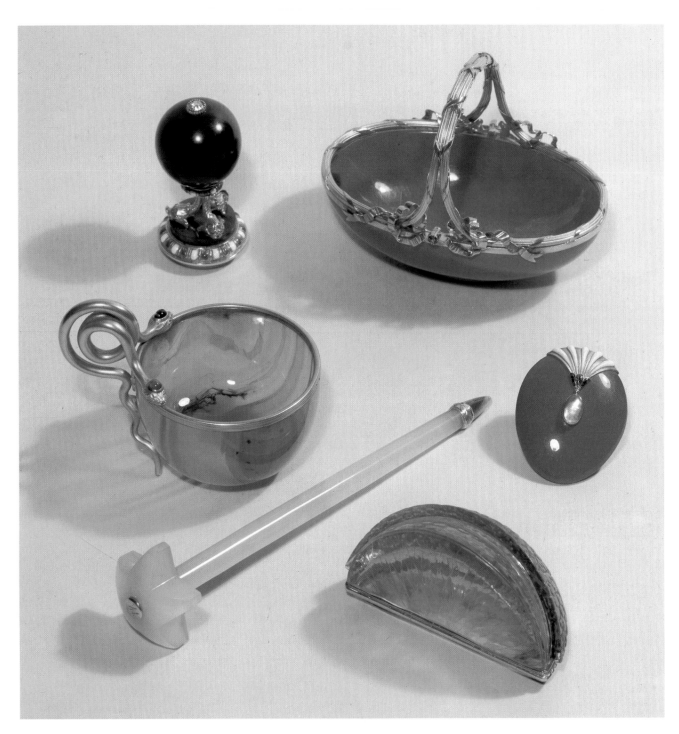

Top left :
Hand seal in red gold, composed of a nephrite
sphere with a crown rose diamond set in the
top, supported by three chased yellow gold
dolphins set with cabochon ruby eyes, resting
on a circular nephrite platform. Above and
below are borders of alternating pellets of
opaque white and translucent strawberry
enamel, the latter over engraved backgrounds.
The matrix is of pale grey chalcedony.
Height $2\frac{3}{16}$ inches Signed MΠ

Top right :
Oval bowl. Purpurine with dull yellow reeded
gold handle and bezel with burnished red
gold ribbon and bow-knots and set with two
green garnets.
Length $3\frac{1}{2}$ inches Signed EK
HCB plate 101
Mr and Mrs Peter Thornton, U.S.A.

Centre left :
Cup. Carved striated agate, mounted with
a handle composed of two snakes in dull gold,
their heads set respectively with a cabochon

ruby and a cabochon sapphire.
Length $2\frac{15}{16}$ inches Signed MΠ
Gold mark crossed anchors

Centre right :
Oviform paper-clip. Purpurine, with an
engraved gold mount enamelled opaque
white and translucent emerald and set with a
moonstone.
Height $1\frac{9}{16}$ inches Signed MΠ

Bottom left :
Swizzle-stick. Carved bowenite mounted in

Double-opening cigarette case. Red gold enamelled royal-blue over a *guilloché moiré* ground, encircled by an inlaid snake composed of rose diamonds set as scales in pale green gold. An elliptical diamond forms the push-piece. This imaginatively designed case was given to Edward VII by Mrs George Keppel. After the King's death, Queen Alexandra generously returned it to the donor as a keepsake. In 1936, Mrs Keppel, in turn, gave it to Queen Mary 'to place with the Russian collection of Fabergé things at Sandringham'. A note in Queen Mary's hand, setting out this history, is enclosed inside the case, which is so reminiscent of Beardsley. Height 3$\frac{11}{16}$ inches Signed К. ФАБЕРЖЕ
HCB plate 69
This object is from the collection at Sandringham and is illustrated by gracious permission of Her Majesty The Queen.

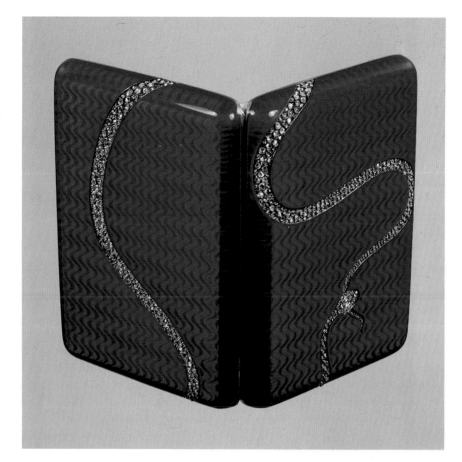

(continued from page 50)
chased red and green gold and engraved on an applied gold plate with the monogram of Victoria Melita, Grand Duchess Cyril, beneath the Imperial crown and set with a cabochon amethyst knop. The Grand Duchess was known affectionately as Ducky.
Length 5$\frac{1}{2}$ inches Signed HW
Mr and Mrs Oscar Getz, Chicago.

Bottom right:
Bonbonnière carved in smoky quartz in the form of a slice of crystallized fruit, the gold bezel decorated with translucent strawberry enamel over engraving and a band of rose diamonds.
Length 2$\frac{9}{16}$ inches Signed МП
AKS plate 143

Rectangular powder box in green gold, engraved and reeded with three hinged lids, enamelled overall an elusive shade of translucent aubergine over a *moiré* ground. Each panel has an opaque white enamel border, applied with chased green gold laurel borders, swags and leaves with pink gold rosettes and a bow knot. The largest central compartment is set with a looking-glass in the cover.
Length 4$\frac{1}{4}$ inches Gold mark 72
Signed HW
Stamped for the English market.

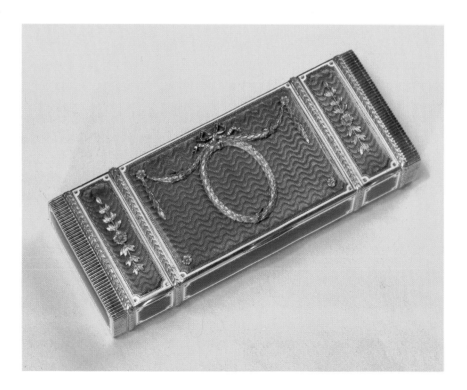

their appearance in Fabergé's *ateliers* at this period are among his most engaging productions. The two kingfishers from the collection at Sandringham (page 46) certainly do not suffer from any of the laboured overworking that we see in so many carvings of the period. The sculptor (for the modeller of these startling creatures must be recognized as such), was clearly determined to retain the original feeling of the pieces of stone selected and has achieved this here with outstanding success.

The small chick which appears in the same photograph comes straight out of the Garden of Delights in Madrid, as does another Bosch bird (page 47). This last creature was an early warning of horrors to come, and its descendants in the form of seaside souvenirs are clearly here to stay.

Being a man of unbounded curiosity, always receptive to new ideas, Fabergé took an active part in the Art Nouveau movement which was launched in Europe in 1893. The *minaudière* (page 53) is characteristic of several items in this style which have come down to us.

Fabergé anticipated many technical innovations which were to dominate the work of European goldsmiths and jewellers well into the twentieth century. A fascinating example is provided by the cigarette case composed of strips of red and green golds and platinum, woven together to give the effect of basket-work (page 54). This design, introduced in the opening decade of this century, was to provide, and for that matter still provides, a pattern which many successful French and Italian jewellers have exploited *ad nauseum*.

Fabergé was not afraid of thinking afresh and was never prepared merely to accept the traditionally accepted, recognizing that many of life's 'immutable truths' undermine revelation of new ideas.

Thus we see Fabergé as a pioneer in his field.

Another facet of his repertoire which has not, to my knowledge, been explored is represented by one or two objects he

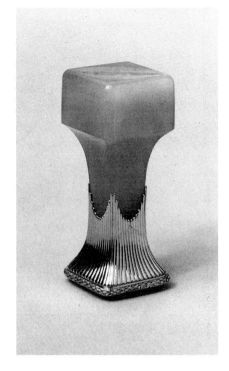

Hand-seal in bowenite with a simple reeded red gold mount bordered by chased green gold laurel.
Height 2½ inches Signed МП
Wartski, London

Bird in part-coloured agate, details not known.
Length 3½ inches

Carved bowenite miniature *bourdalou* in an engraved gold mount with a chased foliate border, set with rose diamonds, rubies and cabochon sapphires in the handle, supported on a crimson translucent enamelled base. Marks not known, but thought to have been designed by Hugo Oeberg.
Length 3¼ inches

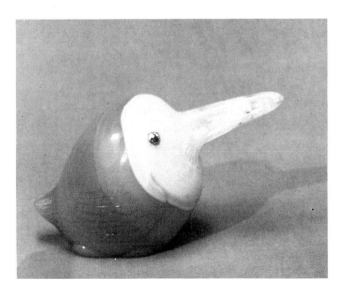

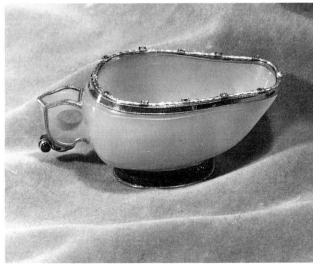

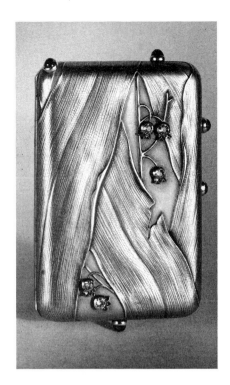

Green gold *minaudière* in an Art Nouveau design, with compartments for powder and rouge on one side, and a clip for notes on the other, divided by a mirror backed by an ivory writing panel. The four thumb-pieces are set with cabochon sapphires, as is the finial of a gold pencil which slides down the back of the case. The exterior is decorated with an elaborate pattern of lily-of-the-valley leaves in green gold, two of which are torn, relieved by flowers in brilliant diamonds set in silver against a background of red-tinted gold. Doubtless the *minaudière* was originally suspended from a gold chain.
Length $3\frac{1}{16}$ inches Signed К. ФАБЕРЖЕ
AKS plate 60
Lady Cox.

made of a mildly racy nature. I imagine he never embarked upon anything approaching the erotic, for, as his eldest son Eugène informed me some thirty years ago in Paris, '*Papa était plutôt solide.*' A model of a *bourdalou* (shown opposite) provides an amusing reminder of the introduction of these invaluable receptacles for the relief of ladies under stress in church when subjected to the interminable sermons of the seventeenth-century Jesuit priest whose name they now bear.

The Cleveland Museum of Art owns a miniature salt-chair in the Louis XVI cabriolet style which is designed as a bidet (page 26). Some of the most skilful craftsmanship has been lavished upon this object in chased gold, painted and opalescent enamels and carved Siberian jade and pearls.

Just as he was unwilling to be tied down to one or two styles that had served him well, Fabergé also refused to be restricted when it came to the actual materials he used. Disregarding the merely valuable, he gladly incorporated various woods, pottery (frequently imported from England), brass, copper, and gun-metal in the wares which proudly bore the signature of the House.

Strands of asbestos were brought in to help simulate the delicate gossamer of a dandelion clock. He even tried his hand on one or two occasions at decorating silver with niello, a technique with a long tradition of success in Russia. In all, his was a restless imagination which expressed itself in many styles, materials and techniques. In common with most other people who have ever had anything to contribute to the arts, his curiosity and excitement never abandoned him. This was his greatest strength.

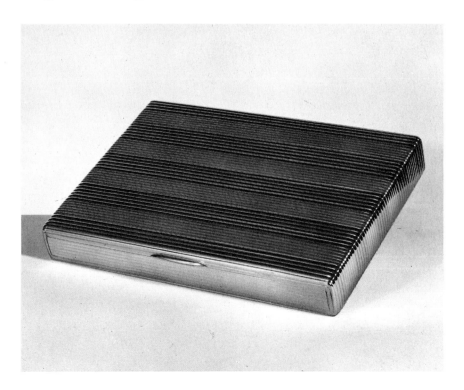

Cigar box in red and green ribbed gold with a plain thumb-piece without jewels.
Length $5\frac{3}{4}$ inches Signed К. ФАБЕРЖЕ
AKS plate 135

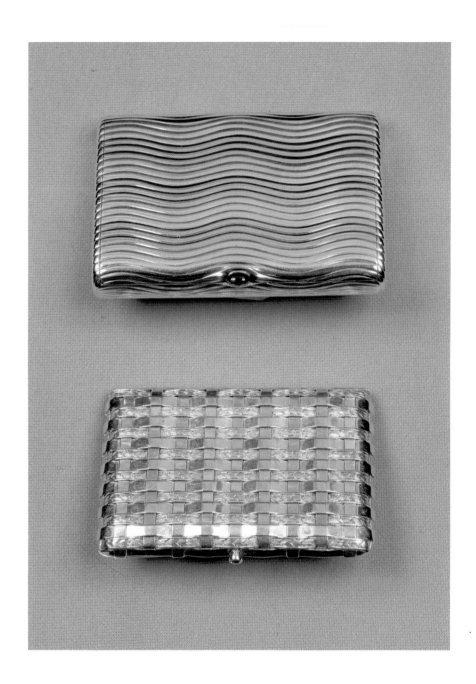

Top :
Cigarette case in pink and green ribbed gold
in an ingenious wavy pattern with a cabochon
sapphire thumb-piece.
Length 3¾ inches Signed A * H
AKS colour plate VI

Bottom :
Double-opening cigarette case composed of
plaited strips of red gold, platinum and green
gold deeply chased with laurel and set with a
brilliant diamond push-piece. An interesting
forerunner of a design later to be widely
exploited by the leading Paris goldsmiths.
Length 3½ inches Goldmark 72
Signed A * H

Cigarette box. Red gold, reserved with panels enamelled translucent emerald green over *moiré* engraving edged with opaque white enamelled lines and pellets, the main outer borders in granulated yellow gold overlaid with chased green gold leaves and red gold rosettes and ribbons.
Length 3⅝ inches Gold mark 72
Signed HW

Left :
Bowl of mustard-coloured pottery with chased silver foliate swags depending from a reeded bezel.
Width 3¾ inches
Signed by the unidentified workmaster AR
Mr and Mrs Jack Hartley, U.S.A.

Right :
Cigarette case in palisander wood, with match compartment and tinder attachment, the cover applied with an elaborate chased, green, yellow and red gold mount with a Catherine the Great rouble in a laurel frame with bows, ribbons and tassels and set with six cabochon sapphires.
Length 4⅛ inches Signed ЯA

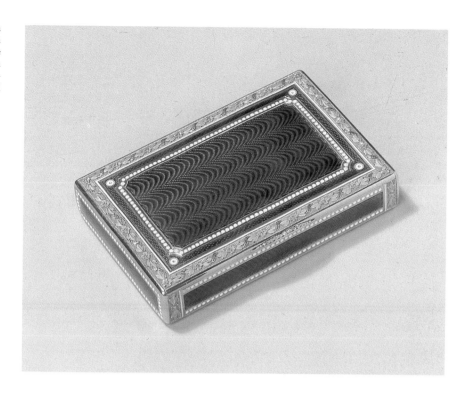

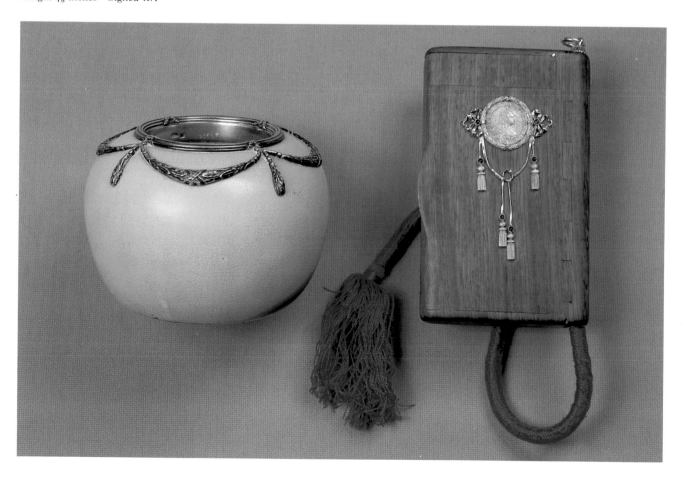

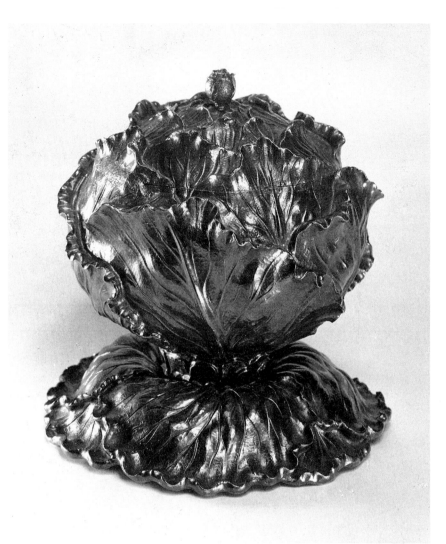

Oxidized silver tureen in the form of a cabbage, the leaves naturalistically chased, the top surmounted with a miniature cabbage finial. Designed to hold enough *borscht* for two.
Height about 5 inches Signed К.ФАБЕРЖЕ

Red gold folding screen of six rectangular miniature frames, each with a chased green gold beaded border of Vitruvian scrolling and rosettes. The screen closes up into a portable block set with ten sapphires polished in a pointed cabochon form; it is opened when one of the stones is pressed, releasing the handle.
Height of block $1\frac{5}{8}$ inches Signed МП
Width of screen extended $7\frac{1}{4}$ inches
Wartski photographs

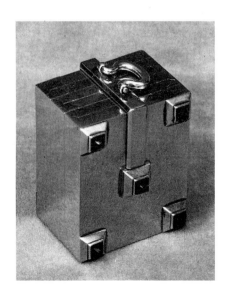

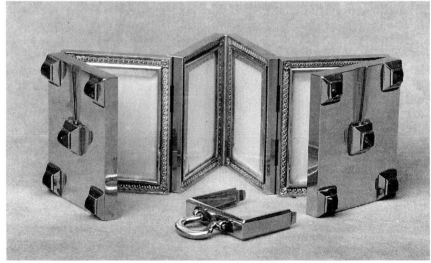

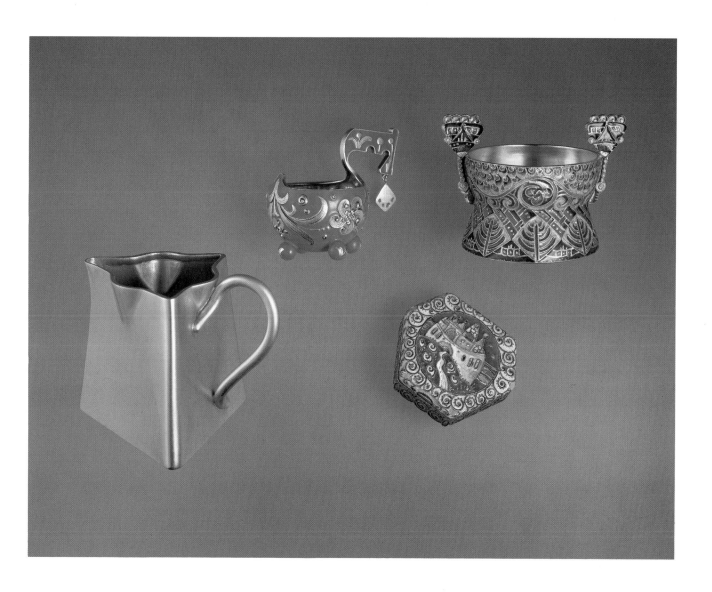

Top left:
Unusually heavy miniature cast silver *kovsh* with pendant attached, designed in the Old Russian style, enamelled opaque blue reminiscent of Wedgwood jasper-ware. It is decorated overall with raised oxidized chased silver flowers, leaves and scrolled bosses deriving from stylized motifs to be found in Russian silver and textiles of the fourteenth and fifteenth centuries, supported upon three ball feet and gilt within.
Length $2\frac{5}{16}$ inches
Silver mark: 91 (1899–1908)
Signed К. ФАБЕРЖЕ

Top right:
Two-handled *bratina* in silver-gilt, enamelled *cloisonné* in pastel shades. The general form and the scroll and tree motifs derive from Norwegian folk art.
Height 2 inches Signed ФР
Mr and Mrs S. P. Sher

Bottom left:
Jug. Heavy silver-gilt in *art nouveau* taste. Of triangular design, the sides are lobed at the top and a gentle forward curve at one corner forms the lip. The twisted handle recalls the stalk of a flower. An early example of this style, dated 1896.
Height $2\frac{9}{16}$ inches Signed К. ФАБЕРЖЕ
Silver mark St George and Dragon
Wartski, London

Bottom right:
Six-sided box, silver-gilt, enamelled with *cloisonné* scrolls in pastel colours, the hinged cover reserved with a circular area showing a stylized interpretation after Bilibin of a Pushkin fairy tale concerning Tsar Saltan and the miraculous appearance of a city on a remote desert island.
Length $1\frac{3}{4}$ inches Signed ФР
Her Majesty Queen Elizabeth the Queen Mother.

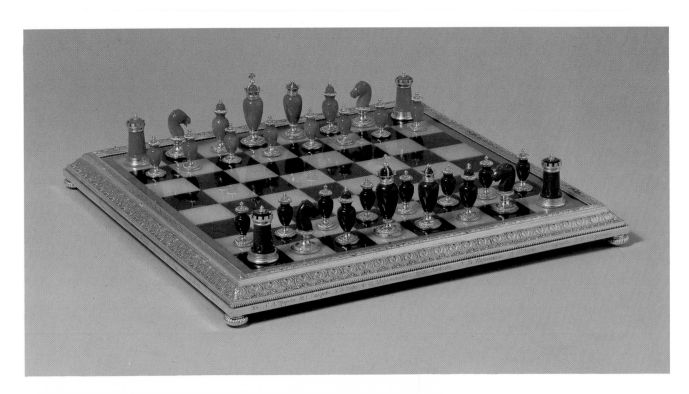

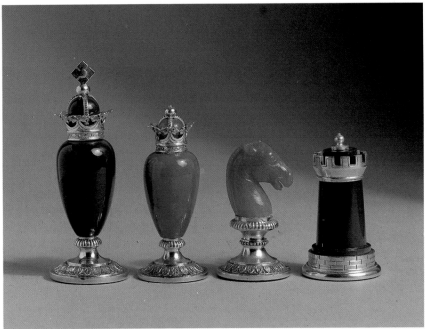

Chess-set. Silver and hardstone, the pieces of one side formed of tawny aventurine quartz mounted in silver and set on circular silver feet, the other side of grey Kalgan jasper similarly mounted, the board with nephrite squares alternating with pale apricot serpentine with silver frame mount moulded with acanthus and laurel borders, a bun foot at each corner, the sides inscribed in Russian: 'To warmly beloved and dear Commander General Adjutant Alexei Nikolaievitch Kouropatkin in memory of Manchuria 1904–1905 from those devoted and grateful to him'. Board 25 inches square Signed ЯА
AKS plate 185

Strut clock. Red gold with a dot and pellet engraved border and pierced red gold hands. Enamelled opalescent rose over an engraved sunburst field. The restraint of this design provides a striking contrast with the elaborate example shown below.
$2\frac{5}{16}$ inches square Signed HW

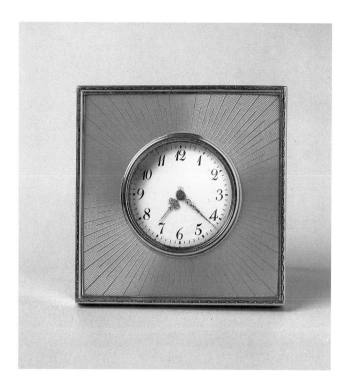

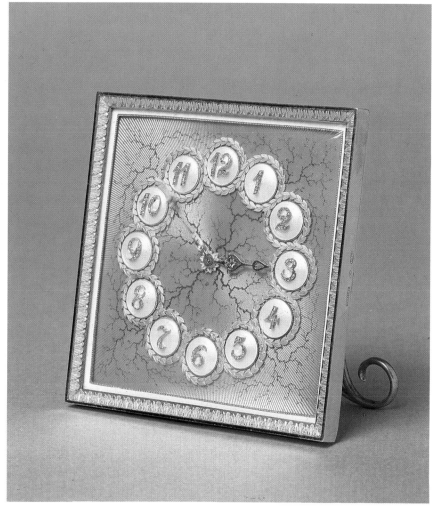

Strut clock. Red gold with chased green gold acanthus and laurel borders. Enamelled opalescent peach, painted with simulated moss-agate motifs over an engraved sunray field. The rose diamond numerals applied over concentric circles of opalescent oyster enamel and the hands in pierced red gold.
$3\frac{1}{2}$ inches square Signed HW
Mr and Mrs J. Bloom, Johannesburg.

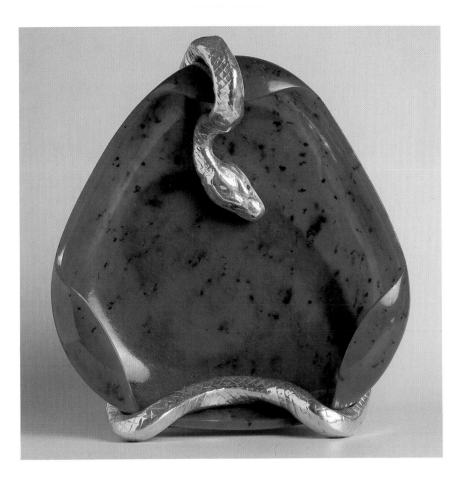

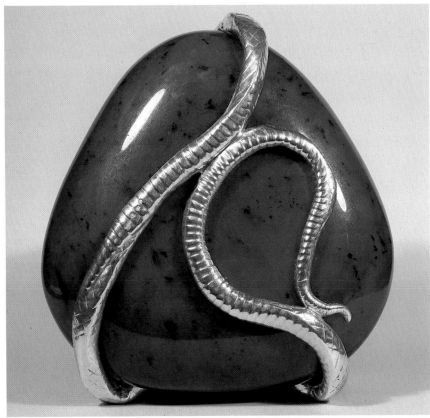

Triangular dish of carved nephrite, the corners furled over, entwined by a skilfully modelled snake in silver with naturalistically engraved markings heavily polished to increase the authentic effect. The head resting on the floor of the dish, is set with cabochon garnet eyes.
Length 7¼ inches Signed ЯА

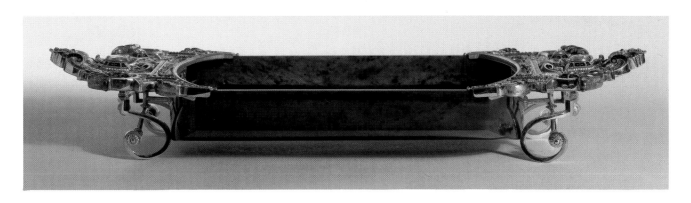

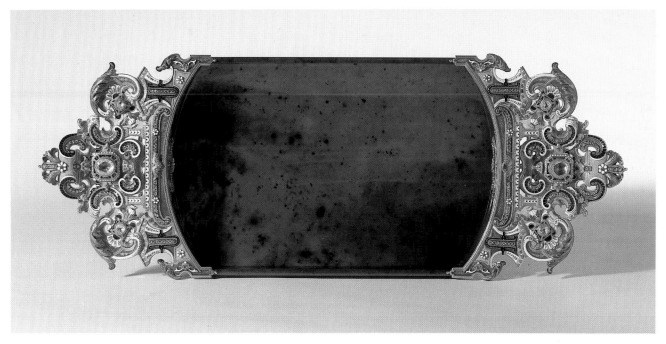

Shallow dish of carved Siberian jade in Renaissance style, rectangular with gently curved ends. The red gold chased handles are reserved with fields of granulated yellow gold and are composed of an elaborate system of scrolls enamelled translucent scarlet and pale green on *guilloché* backgrounds and opaque black and white. To give yet another dimension to this already sumptuous object, rivers of rose diamonds and large single stones in raised collets serve to light up and punctuate this splendid example of St Petersburg work. It is cradled in an engraved gold strapwork frame. It was presented to Queen Wilhelmina of the Netherlands on the occasion of the Royal Dutch Wedding in 1901 by the Dutch colony living in St Petersburg.
Length 13⅝ inches Signed МΠ
Reproduced in colour in *The Connoisseur* of June 1962.

Rectangular dish in aventurine quartz, supported on a matt yellow gold beaded mount with, at the corners, a *flambeau*, the shaft chased with a spiral flute with a flame as finial, each one confronted, at either side, by a seated winged sphinx.
Length $3\frac{3}{4}$ inches Signed МП
Gold mark crossed anchors

Chestnut leaf realistically carved in Siberian nephrite with three chestnuts in dull yellow gold clustered at the centre, the shell of one partially open revealing a cabochon almandine garnet, representing the conker within.
Length $5\frac{9}{16}$ inches No marks
HCB plate 26

Left :
Lamp with Loetz glass body of opalescent silver and orange lighting from within. The silver-gilt mounts matching the figuration in the glass, are chased with wave and foliate motifs to suggest the sea; four dolphins form the base. This *art nouveau* object is from the Royal Yacht *Standart*.
Height (excluding shade) 11 inches
Signed BA

Jar in Tiffany glass mounted in oxidized silver and set with pearls. A striking example of *art nouveau* by Fabergé.
Height $4\frac{1}{8}$ inches Signed BA
AKS plate 58

Vase of Tiffany glass decorated with peacock feather motifs. Its base is composed of three chased silver-gilt peacocks. The vase was given by Louis C. Tiffany to Miss Julia Grant, daughter of General Grant, and Prince Michael Cantacuzene on the occasion of their wedding at the White House, where the bride was born. Later when the couple lived in Russia, Fabergé was commissioned to design the mount.
Overall height $7\frac{3}{4}$ inches Mount signed BA

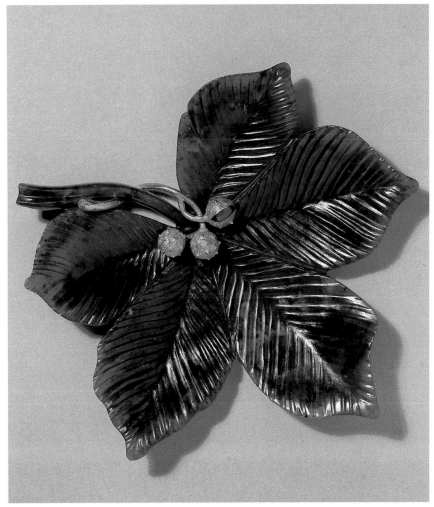

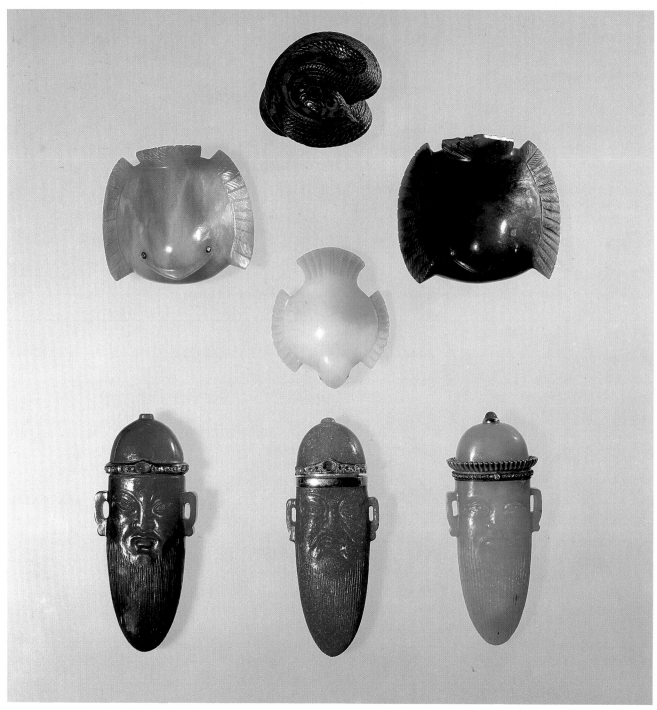

Top:
Coiled snake, carved from one piece of brown and black jasper perfectly describing the natural marking and set with rose diamond eyes. This object is taken directly from a carved wood netsuke now in the Bauer Collection, Geneva.

Top left:
Sparrow. Aventurine-quartz with rose diamond eyes in silver mounts. This conventionalized model is based on Fabergé's admiration for Japanese netsuke.
Length 1½ inches

Top right:
Sparrow. Nephrite with rose diamond eyes.
Length 1½ inches AKS plate 248

Centre:
Pecking sparrow. Pale bowenite with cabochon ruby eyes.
Length 1½ inches

Bottom row, left to right:
Scent flacon. Nephrite, Chinese style, carved as a mask mounted in yellow gold and set with rose diamonds and a cabochon ruby. A scent flacon very like this one, but with a pearl finial

and signed by Wigström, is illustrated in AKS, plates 67 and 68.
Height 2 7/16 inches No marks

Scent flacon, carved in green aventurine-quartz mounted in yellow gold and set with rose diamonds and a cabochon ruby.
Height 2 7/16 inches No marks

Scent flacon. Bowenite mounted in dull yellow gold and set with rose diamonds, with a brilliant diamond push-piece and surmounted by a cabochon ruby.
Height 2 7/16 inches Signed К.ФАБЕРЖЕ

Stone Carvings

The carvings shown on pages 64, 66–71 and 74 are from the collection at Sandringham and are reproduced by gracious permission of Her Majesty The Queen.

Fabergé's menagerie of animals and his bird and fish carvings in agate, jade, crystals and other semi-precious stones emerged from the Noah's Ark of his workshops two by two in the sense that they came in two entirely distinct manners.

It would seem that over half were sculpted in minute detail indicating the precise nature and quality of the fur, hair, skin or feathers, while other subjects were handled in a much broader and more conventionalized way; sometimes the treatment was even jocular and good-natured, an idiom which always carries the danger of overstepping the mark and becoming arch. Very occasionally, it must be confessed, Fabergé is not quite guiltless in this respect. However, even in the rare cases where he is a little self-indulgent, the sheer quality of the craftsmanship saves him from the twin pitfalls of feyness and the commercial sentimentality of Walt Disney. Nevertheless, I believe that Fabergé's witty, stylized essays in stone carving to be among the most Russian of his wares, and the groups from Sandringham illustrated on pages 46 and 74 eloquently demonstrate this point.

The naturalistic models present no problems, but those I have described as conventionalized form a disparate group. Many are deliberate simplifications exulting in, for example, the rotundity of a pig or the compact bulk of an elephant.

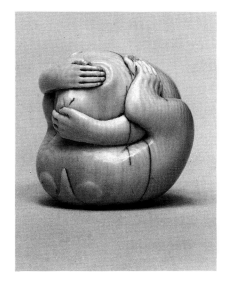

Left to right :
Three Mystic Apes which symbolize the injunction to see, hear and speak no evil, combined in a single carving in amazonite.
Height $1\frac{3}{16}$ inches
AKS colour plate XXXIV

The same subject carried out in obsidian. Both these carvings derive from an ivory netsuke of almost identical design by K(w)ai-gyokusai Masatsugu (1813–1893). See catalogue of Eskenazi of London, June–July 1976, and photograph above.
Height $1\frac{1}{4}$ inches

Frog in nephrite, set with rose diamond eyes, with its front legs thrust into its mouth and one back leg jerked spasmodically to one side.
Height 1 inch

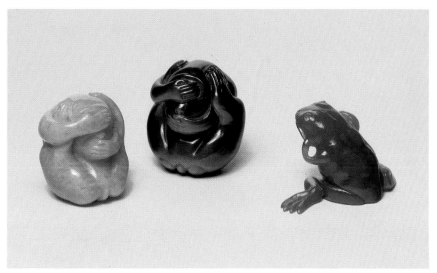

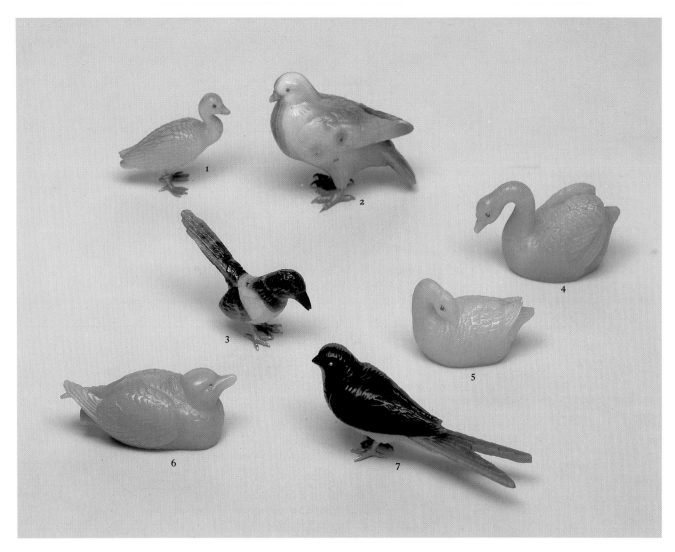

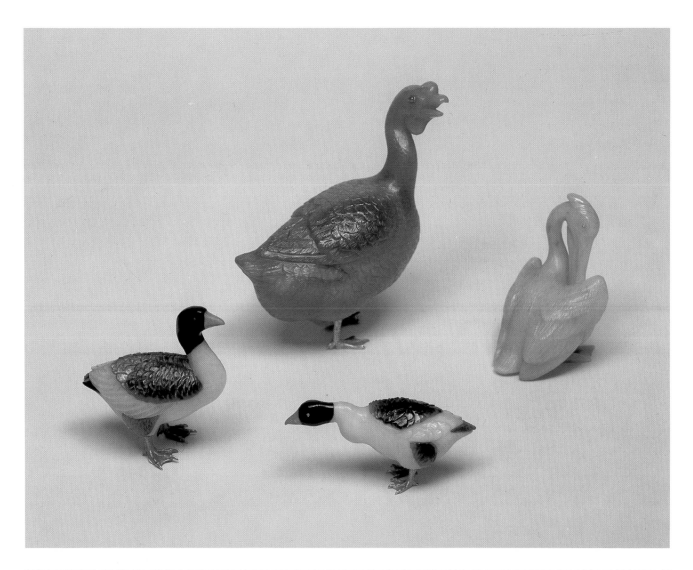

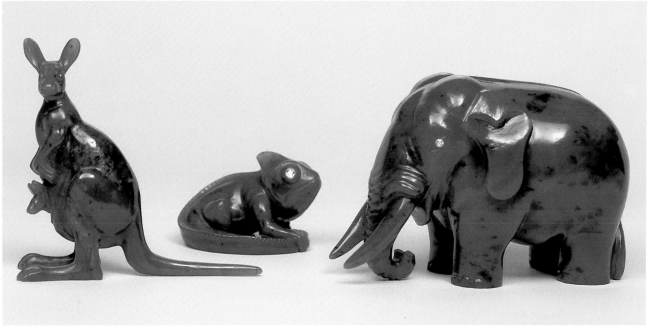

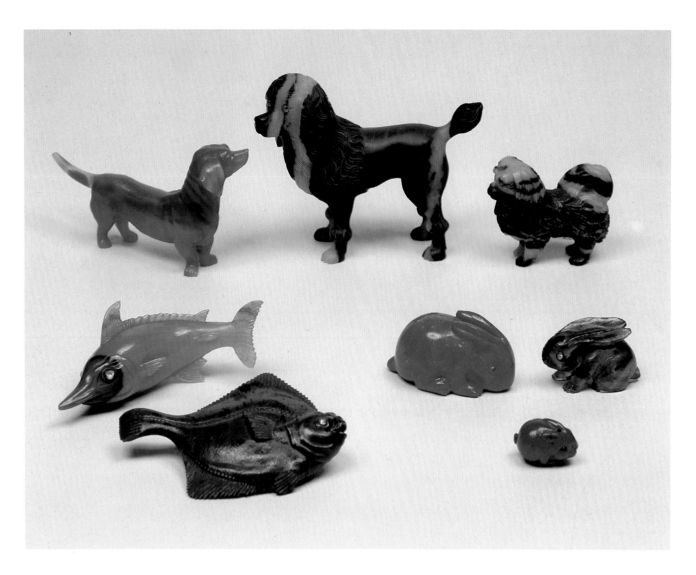

Top row, left to right:
Dachshund. Striated brown agate with rose diamond eyes.
Length 3 inches
AKS colour plate XLII

Poodle carved from dark grey and white banded agate with yellow-stained cabochon chalcedony eyes.
Length 3⅛ inches
AKS colour plate XLII

Pekinese carved from dark grey banded agate with creamy striations, set with rose diamond eyes.
Length 1¾ inches

Other animals, left to right:
Big game fish. Dark blue-grey and pinky-brown chalcedony with rose-diamond eyes.
Length 2¾ inches
AKS plate 227

Speckled brown flat fish, known in Norfolk as a butt, with rose diamond eyes set in gold.
Length 2¾ inches
AKS plate 273

Opposite page, upper picture:
Clockwise from top left:
Duckling flapping its wings. Pale creamy-brown quartzite with rose diamond eyes foiled pale green, chased red gold legs.
Height 2¼ inches Gold mark 72
Signed HW
AKS colour plate XLII

Duckling. Pale butter-coloured chalcedony with olivine eyes and chased red gold legs.
Height 2¾ inches Signed HW

Rabbit. Purpurine with rose diamond eyes.
Length 1⅛ inches

Tiny rabbit. Lapis-lazuli set with rose diamond eyes.
Length ¾ inch

Rabbit. Amethyst with rose diamond eyes.
Length 1¼ inches

Duckling in pale creamy-brown chalcedony, with cabochon ruby eyes and chased red gold legs.
Height 1⅞ inches Gold mark 72
Signed HW

Duckling of mustard coloured cornelian with cabochon ruby eyes and chased red gold legs.
Height 1 5/16 inches Gold mark 72
Signed HW
AKS colour plate XLII

Duck. Vari-coloured grey to mauve agate, carved to simulate a downy texture, with rose diamond eyes and chased yellow gold legs.
Height 1⅛ inches
AKS colour plate XLII

Shire horse. Aventurine-quartz with cabochon sapphire eyes in gold settings, a portrait model of Sandringham's champion 'Field Marshal'.
Length 7 inches
HCB plate 93 AKS colour plate XLII

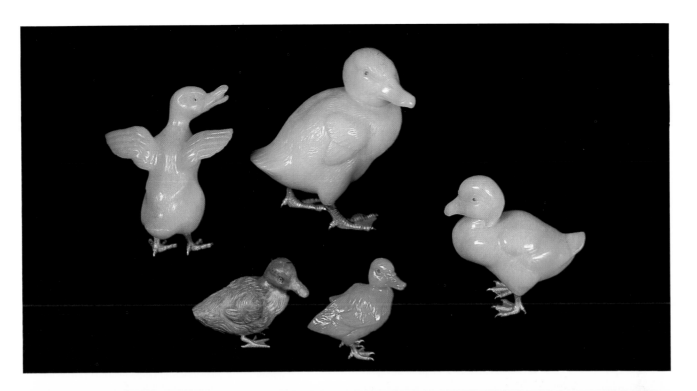

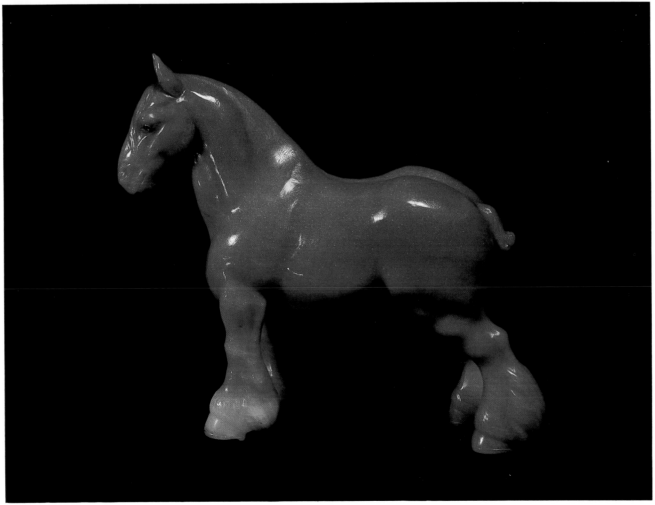

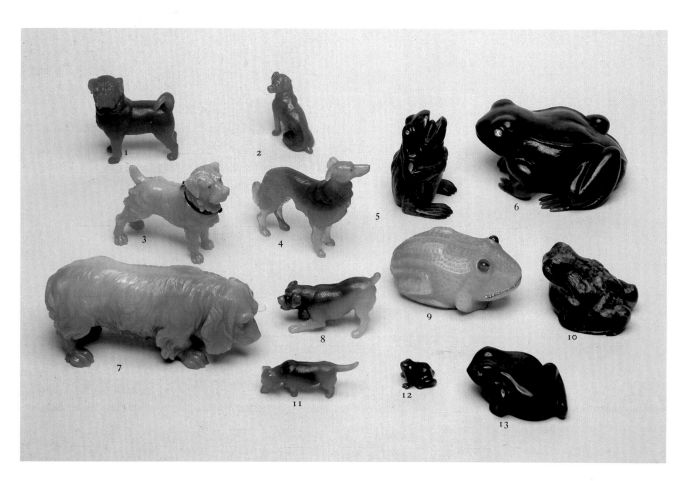

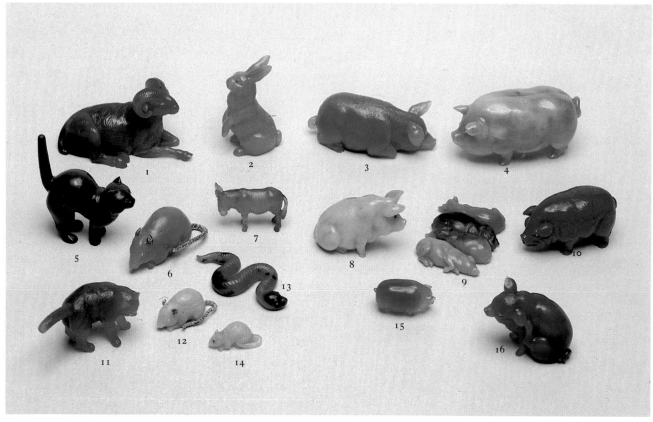

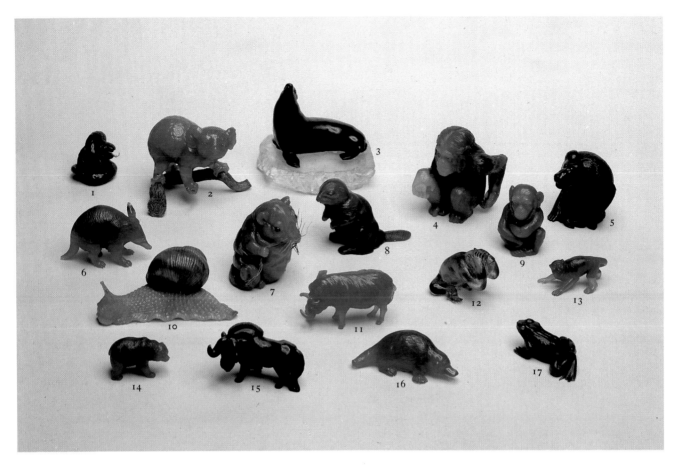

Captions for illustrations opposite appear on page 73.

Above:

1 Snake in brown and black speckled jasper set with pale olivine eyes and gold fangs, carved as a rising coil through which the head emerges, mouth open to hiss. This is taken from a netsuke.
Height $1\frac{1}{2}$ inches

2 Koala, honey-coloured agate with cabochon emerald eyes, poised on a chased silver branch.
Length of koala $2\frac{13}{16}$ inches Signed HW

3 Californian sea-lion in obsidian with rose diamond eyes, on a rock crystal ice floe.
Length of sea lion $3\frac{1}{16}$ inches

4 Chimpanzee, looking deeply troubled. Brown, mauve and blue chalcedony with olivine eyes.
Height 3 inches
HCB plate 73 AKS plate 240

5 Sacred baboon. Obsidian with rose diamond eyes.
Height $2\frac{1}{4}$ inches
HCB plate 87

6 Aardvark in banded agate in shades of brown, blue, ochre and grey, with rose diamond eyes.
Length $2\frac{5}{8}$ inches
HCB plate 87

7 Dormouse, holding gold blades of straw. Blue-grey to brown chalcedony with cabochon sapphire eyes, and platinum whiskers.
Height $2\frac{1}{2}$ inches
HCB plate 86 AKS colour plate XLII

8 Beaver, on its haunches. Nephrite with rose diamond eyes set in gold.
Height $2\frac{3}{16}$ inches

9 Chimpanzee with folded arms, in vari-coloured agate, with olivine eyes. A one-piece carving in which the body is of a tawny colour and the face grey-blue.
Height 2 inches
HCB plate 87

10 Snail in chalcedony of pale grey-green, the shell of translucent jasper in shades of blue-grey, rust, mauve and pastel greens.
Length $3\frac{15}{16}$ inches
AKS plate 273

11 Warthog. Pale brown chalcedony with rose diamond eyes.
Length $2\frac{5}{8}$ inches

12 Stump-tailed macaque symbolizing 'see no evil' with its hands covering its eyes. Smoky crystal quartz.
Length $2\frac{1}{4}$ inches

13 Rhesus monkey, pausing on all fours, in sandy brown and pale sepia translucent agate, with rose diamond eyes.
Length $2\frac{1}{16}$ inches

14 Brown bear. Agate set with rose diamond eyes.
Length $1\frac{9}{16}$ inches

15 American bison. Honey-coloured chalcedony with rose diamond eyes.
Length $2\frac{5}{16}$ inches

16 Duck-billed platypus. Pale brown chalcedony with rose diamond eyes.
Length $2\frac{13}{16}$ inches AKS plate 227

17 Toad. Highly polished Siberian nephrite to simulate the wetness of the creature. Brilliant diamond eyes in gold settings.
Length $2\frac{1}{8}$ inches

Top row, left to right:

Policeman (*gorodovoi*) in Caucasian uniform of obsidian quartzite, gloves and face in a prepared composition with cabochon sapphire eyes, mountings in gold, silver and enamel. The number 251 is applied in gold on the cap. Engraved ФАБЕРЖЕ under right boot.
Height 6 inches
AKS colour plate XLV
Mr Charles R. Wood, U.S.A.

Carpenter (*plotnik*) with aventurine quartz face and arms, purpurine shirt, lapis-lazuli breeches, white quartz apron, brown jasper hair and beard, obsidian boots, cabochon sapphire eyes; he tests a gold and silver axe, the axe-head stamped HW and with silver mark 91. Engraved ФАБЕРЖЕ under right foot.
Height 5 inches
HCB colour plate 97 AKS colour plate XLVII
Mr John Cowdy, Northern Ireland.

Peasant (*mujik*) with face in a prepared composition, hair and beard in Norwegian sunstone, eyes in sapphires, overcoat in alabaster bordered by brown Caucasian sard, undershirt in quartzite, hat and boots in obsidian, belt in purpurine. The staff is in silver-gilt stamped HW 88. Engraved ФАБЕРЖЕ under right boot.
Height $6\frac{3}{4}$ inches
HCB colour plate 98
Wartski, London.

Portrait model of the house boy (*dvornik*) who used to sweep out Fabergé's St Petersburg premises. The face in aventurine quartz with sapphire eyes, shirt in lapis-lazuli, breeches in grey Kalgan jasper, waistcoat in obsidian, white translucent quartz apron and obsidian boots and cap, to which is applied a pierced gold badge giving the address of the firm; 24 Morskaya, beneath, the word *dvornik* in Russian characters. He holds a gold broom. Engraved ФАБЕРЖЕ under right boot.
Height 5 inches
HCB colour plate 97 AKS colour plate XLV

Nobleman (*boyarin*), coat in purpurine, the borders and collar in brown Caucasian sard, mountings chased in gold, hat in brown Caucasian sard and nephrite, shoes in nephrite, face in a prepared composition, hands in white quartzite, beard and hair in Siberian jasper, eyes in sapphires, staff in oxidized silver with gold knop and ferrule. Engraved ФАБЕРЖЕ under right shoe.
Height 6 inches
HCB colour plate 98
Mr Charles R. Wood, U.S.A.

Bottom row, left to right:

Ukrainian peasant (*hohol*) in aventurine-quartz, lapis-lazuli, white quartz, coffee jasper cloak, hair and moustache; cabochon sapphire eyes, obsidian hat and boots and purpurine belt, collar and front of quartzite shirt decorated with painted enamel, and holding a gold pipe. Engraved ФАБЕРЖЕ under left boot.
Height $5\frac{3}{8}$ inches
HCB colour plate 97 AKS colour plate XLV
Mr Charles R. Wood, U.S.A.

Soldier of the Preobrazhensky Regiment of His Imperial Majesty the Tsar in nephrite uniform and obsidian boots, hat in obsidian and nephrite, face and hands in aventurine-quartz, eyes in cabochon sapphires, rifle in gold and mountings in gold, silver and red translucent enamel. Engraved ФАБЕРЖЕ under right boot.
Height 5 inches
Illustrated in *The Connoisseur*, April 1936.
Madame Josiane Woolf, Paris.

Peasant (*mujik*), playing a silver-gilt balalaika, stamped HW and ФАБЕРЖЕ with the silver mark 88. Face and hands aventurine

quartz, cabochon sapphire eyes, hair and moustache in stained cornelian, grey Kalgan jasper blouse, lapis-lazuli breeches, socks in quartzite, boots in Norwegian sunstone, bench in banded brown chalcedony.
Height 4⅝ inches
HCB plate 100 AKS colour plate XLVII
Madame Josiane Woolf, Paris.

Labourer (*zemlekop*) in purpurine, lapis-lazuli, with obsidian hat and boots, sard beard and hair, aventurine quartz face and hands, Norwegian sunstone coat, quartzite socks, cabochon sapphire eyes and holding a silver-gilt shovel. Engraved ФАБЕРЖЕ under right foot.
Height 4½ inches
HCB colour plate 98 AKS colour plate XLVII
Madame Josiane Woolf, France.

Coachman to the nobility (*barski-kutcher*) in nephrite; belt and hat in purpurine, gloves in white quartz, face in aventurine quartz, mountings in gold. Engraved ФАБЕРЖЕ on base.
Height 5 inches
Illustrated in *The Connoisseur*, April 1936.

Page 70, upper picture :

1 Standing griffon of haughty mien. Brown agate with rose diamond eyes.
Length 1⅞ inches

2 Seated King Charles spaniel in greenish-grey translucent chalcedony with rose diamond eyes.
Height 1⁷⁄₁₆ inches

3 Portrait model of Edward VII's Norfolk terrier 'Caesar' in white chalcedony with cabochon ruby eyes and gold bell and a translucent brown-enamelled gold collar inscribed 'I belong to the King'.
Length 2¼ inches
HCB plate 95 AKS plate 255

4 Collie in translucent brown and blue-grey agate, with cabochon ruby eyes.
Length 2¹¹⁄₁₆ inches

5 Croaking frog. Dark red speckled jasper with olivine eyes.
Height 2⅛ inches
AKS plate 273

6 Frog. Dark green Siberian nephrite with large rose diamond eyes in gold settings.
Length 3⅜ inches

7 Portrait model of a Clumber spaniel with pale grey chalcedony with cabochon ruby eyes.
Length 4⅛ inches
HCB plate 95 AKS plate 255

8 Border terrier. Vari-coloured blue-grey chalcedony with rose diamond eyes, about to spring.
Length 2¹⁄₁₆ inches

9 Frog. Bowenite with large cabochon garnet eyes and rose diamond teeth set in yellow gold, designed as a box with a red gold lid enamelled *champlevé* opaque black and set with rose diamonds.
Length 2⅝ inches Signed МП
AKS plate 273

10 Speckled grey labradorite toad, the stone has unusual green translucent inclusions, with cabochon ruby eyes in gold settings. Carved underneath in the manner of a netsuke.
Length 1⅞ inches

11 Sniffing dachshund puppy. Vari-coloured brown and grey agate with rose diamond eyes.
Length 1⅞ inches
AKS plate 255

12 Tiny frog. Dark nephrite with rose diamond eyes.
Length ⅝ inch
AKS plate 227

13 Three-legged toad carved in the style of a netsuke in chocolate brown jasper and set with olivine eyes.
Length 1¾ inches

Page 70, lower picture :

1 Mountain sheep. Dark brown to blue-grey chalcedony with rose diamond eyes, shown seated.
Length 2⅞ inches

2 Crouching rabbit in translucent grey chalcedony with cabochon ruby eyes.
Height 2 inches

3 Pig. Pink striated agate with yellow and grey inclusions, with olivine eyes.
Length 2¾ inches
AKS plate 256

4 Sow. Pinky-brown chalcedony with rose diamond eyes.
Length 2⅞ inches
AKS plate 256

5 Cat with arched back in grey Kalgan jasper, known in Russia as *troitsk*, with emerald eyes set in yellow gold.
Height 2³⁄₁₆ inches
AKS plate 250

6 Rat. Grey agate with rose diamond eyes; ears and tail set in silver.
Length 1¹⁵⁄₁₆ inches

7 Small donkey. Translucent brown chalcedony with rose diamond eyes.
Length 1½ inches

8 Seated pig in white and pink aventurine-quartz with cabochon ruby eyes.
Length 2⅛ inches
AKS plate 258

9 Litter of four sleeping piglets in differing tones of chalcedony, connected beneath by a gold trellis mount.
Length 2½ inches Signed МП
AKS colour plate XXXVII illustrates a very similar group.

10 Standing pig. Purpurine with rose diamond eyes.
Length 2⅛ inches
AKS colour plate XLII

11 Kitten in blue and brown vari-coloured agate set with rose diamond eyes, edging sideways.
Length 2 inches

12 Mouse. Translucent pale blue chalcedony with rose diamond eyes; ears and tail set in silver.
Length 1¼ inches

13 Snake, possibly an adder. Vari-coloured agate with rose diamond eyes.
Length 2¼ inches
AKS colour plate XLII

14 Rat. White opal with cabochon ruby eyes.
Length 1 inch
AKS plate 240

15 Fat pig. Orange-brown chalcedony with rose diamond eyes.
Length 1⅛ inches

16 Seated pig, scratching its ear. Vari-coloured agate with rose diamond eyes.
Length 1⅝ inches

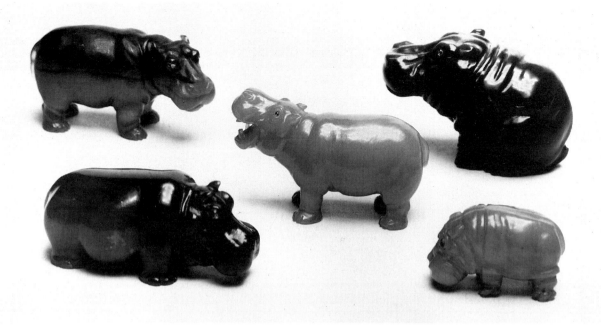

There is also a substantial corpus of figures which derive almost directly from Japanese netsuke but which, because of the materials chosen and the subtle hand of the modeller who fashioned the original maquettes, have become very much Fabergé objects. A striking example is the secular Trinity of the three-in-one monkey which triumphantly illustrates the admonition 'see no evil, hear no evil, speak no evil' in a single wittily carved fragment of amazonite (page 65). This is Fabergé's version of a favourite oriental subject 'The Three Mystic Apes'.

Another form sometimes adopted was the visual pun, not unlike Picasso's use, years later, of a child's toy metal motor car crammed out of shape to form the vivid likeness of a baboon's head. In Fabergé's work we find this particular form of punning in objects such as Easter Eggs which turn out, on closer examination, to be elephants (page 31) or imaginary birds.

Fabergé was, all his life, an enthusiastic admirer of Japanese netsuke—we have a photograph of his living-room in which one of the key items of furniture is the vitrine containing his own collection of carefully chosen examples. The Bauer Collection in Geneva includes among its many delights, a small dark carved wood netsuke designed as a coiled sleeping snake. Fabergé's version of this tiny artefact, carried out in a speckled brown and black jasper, is illustrated on page 64. Apart from the materials employed, the two pieces are, to all intents and purposes, identical. The sincerest form of flattery indeed! There are a number of similar examples in stone of his love for this art form in the Queen's Sandringham Collection, notably a group of small sparrows, some boxes fashioned as masks, and carved frogs and toads which have such a feeling of tactile immediacy that they almost cry out to be

Top left:
Hippopotamus in striated grey-brown chalcedony with rose diamond eyes.
Length $2\frac{5}{16}$ inches

Centre:
Pale grey chalcedony carving of a hippopotamus with its mouth open, set with cabochon ruby eyes.
Length $2\frac{3}{16}$ inches

Top right:
Obsidian carving of a stylized seated hippopotamus with rose diamond eyes.
Length $2\frac{3}{16}$ inches

Bottom left:
Nephrite carving of a fat hippopotamus with rose diamond eyes.
Length $2\frac{5}{16}$ inches

Bottom right:
Bowenite hippopotamus with a melancholy expression, set with pale cabochon sapphire eyes.
Length $1\frac{7}{16}$ inches

handled. These exercises can, I think, be fairly regarded as good-natured tributes to the art of netsuke. A *magot* seated on a pedestal composed of a variety of stones, with nodding head and hands is a more elaborate illustration of the esteem Fabergé had for this oriental genre.

One can easily visualize the designer of one of these models carefully contemplating a fragment of stone in its rough state and deciding just where the natural differences of colour should figure in the final carving.

Whatever the style of the final result, this selection and thoughtful use of the *matière* was always the germ, or what Sickert used to call the 'letch', which fired the imagination of the sculptor. The striations or imperfections in a stone would be eagerly pounced upon to add to the *verismo* of a particular study. Thus the gradations of tone and colour of a piece of varicoloured agate very effectively fulfilled certain appointed functions—the patch on the breast of a robin glows red-brown in exactly the proper place, while the characteristic 'shirt front' of a penguin is happily expressed as the dark grey material turns to a pearly blue-grey, and a dark grey chalcedony ostrich with a warm brown stomach and head sports a bunch of grey-white tail feathers, demonstrating just how skilfully a single stone can be exploited (page 143). The translucent sheen which darts and flickers across the polished surface of black to silver-grey obsidian, is peculiarly appropriate for the simulation of a slippery walrus or sea lion (page 71).

Very often, the artist, realizing that he or she (one of the most successful of Fabergé's team of modellers was Elena Shishkina) was dealing with a small object of a semi-precious nature would feel justified in accenting the work by setting tiny stones, usually rose diamonds, cabochon rubies or sapphires, to light up the eyes.

Where the subject called for sharply contrasting colours not to be found in a single piece of stone, the craftsmen would occasionally introduce a different material which would be carved and cemented into its allotted place in the composition—obsidian ears added to a quartz guinea pig and a labradorite tail feather to a magpie (page 66). Whether the search for naturalism is reason enough to infringe the purity of a sculpture in this way, is frankly questionable, but it has to be allowed that the results are often spectacular. We must not forget that most of the ancient Greek sculptures that we so admire in museums in their present chaste monochrome were originally painted in vivid colours.

The same ambivalence is present when it comes to the figures of Russian national types which are built up of different semi-precious stones. Some of them occasionally teeter dangerously near the brink over which the drop into the dreaded territory of the garden gnome is too near for aesthetic comfort. Again, it is the consummate technical

virtuosity and transparent affection for the particular subject, whether it is a splendidly robed boyar or a poorly clad tea-seller, which gives them, after all, a unique place in the decorative arts of Russia.

The story of how Mrs George Keppel, the friend of Edward VII, suggested to Henry Bainbridge, Fabergé's manager in London and later his biographer, that studies of the animals on the farm at Sandringham should be made is too well known to need detailed repetition here.

I should, however, like briefly to set down again what followed the King's decision to proceed with the work. Mr Bainbridge (concealed for some obscure reason, like a latter-day Polonius, behind a hedge) was able to record how, on 8th December 1907, he observed His Majesty, encased in a tight-fitting overcoat and beneath what appeared to be a mini cricket cap, leading his guests after luncheon from Sandringham House across the lawn to Queen Alexandra's Dairy.

The purpose of this pilgrimage was to examine the display of wax models which a group of artists from St Petersburg had been preparing during the previous month. Included in this working party was Boris Froedman-Cluzel together with the Swiss, Frank Lutiger. When the *maquettes* arrived back in St Petersburg, the most appropriate stones were selected with the greatest care.

The interest and value of this extraordinary group of carvings lies in the fact that it is substantially complete and its authenticity is beyond question. It thus affords us a useful yardstick against which to judge individual examples we may doubt.

This whole Sandringham programme had come about initially as a result of the happy circumstance of two sisters, both Danish Princesses, in their sovereign roles of Queen of England and Tsarina of all the Russias sharing an unaffected admiration for the work of Carl Fabergé. Their enthusiasm has brought us a rich heritage.

Monkey in nephrite, seated on its haunches and drinking from a shallow pink rhodonite bowl; the eyes set with cabochon rubies. Height $1\frac{7}{8}$ inches

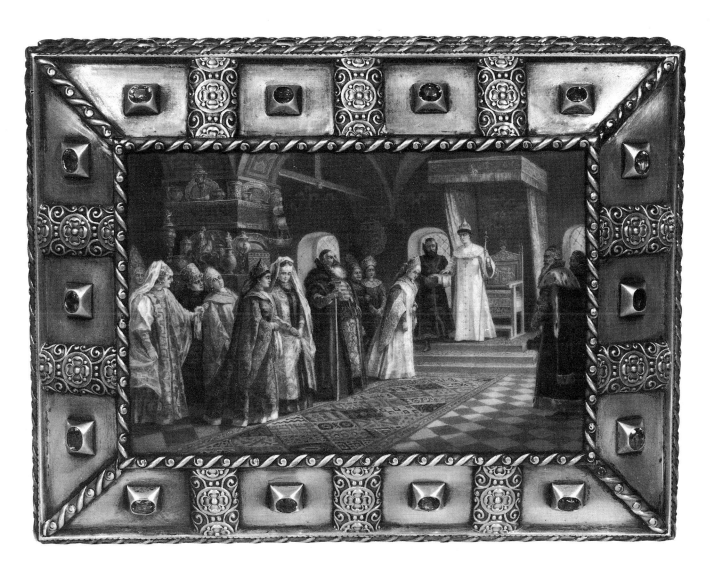

Casket in oxidized chased silver, in the seventeenth century Russian manner (the Old Russian Style) set with blue, yellow and brown sapphires. In the cover, an enamelled copy, painted by Haritonov of Constantine Makovsky's masterpiece in the Tretiakov Gallery in Moscow. It depicts the traditional selection of a bride for the Tsar during the sixteenth century. One of the objects made during the 1913 Romanoff Tercentenary celebrations.

Length 7⅞ inches Signed К. ФАБЕРЖЕ
AKS plate 63

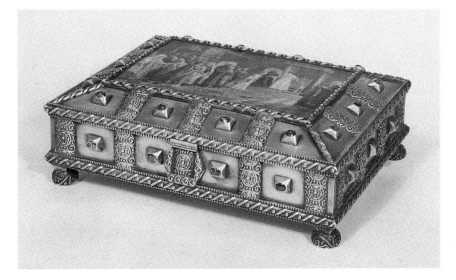

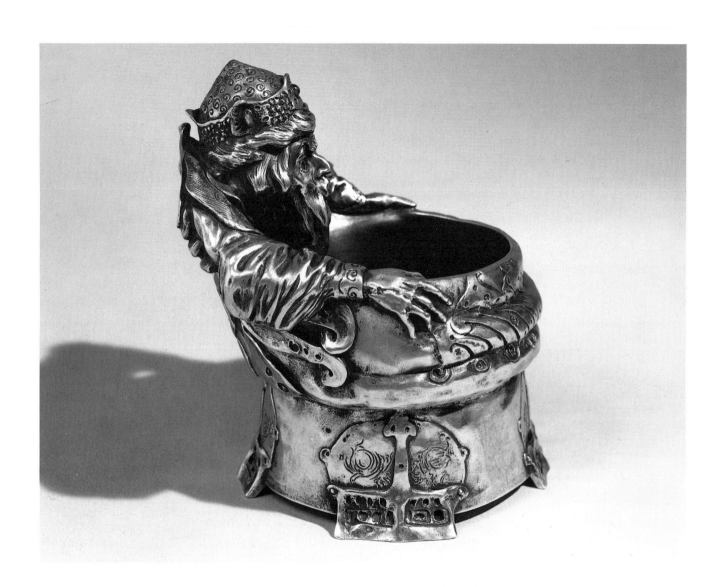

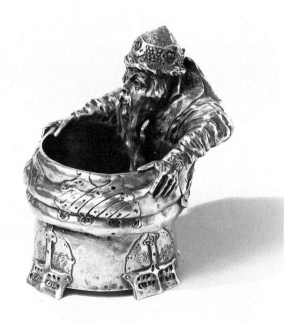

Portrait of Ivan Kalita, the celebrated folk hero and miser, ingeniously designed in silver. He is modelled as a moneybag (*Kalita*) in the Old Russian style, and the model is set with two cabochon emeralds and a ruby and is gilded within. Ivan Moneybag, who reigned from 1328 to 1341 was the first of the Gatherers of the Lands of Russia, Grand Dukes of Muscovy who united the feudal states; the last of them was Ivan the Terrible. Despite his miserliness, it is traditionally held that he nonetheless gave alms to the poor.
Height 6½ inches Signed К. ФАБЕРЖЕ
Mr Irving M. Feldstein, Chicago

Covered silver cup chased in the Rococo manner and set at intervals with roubles. Set in the cover, which is surmounted by the Cypher of Catherine II, are three roubles from the reigns of Peter the Great (1723), Catherine I (1727) and Peter II (1729). In the body of the vase are six roubles from the reigns of Anna (1740), Elizabeth (1742), Peter III (1762) Catherine II (1767), and two specially struck roubles, one from the reign of Nicholas I to commemorate the monument to Alexander I in 1834 and one from the reign of Alexander II in 1859 to commemorate the unveiling of the monument to Nicholas I.
Height 21 inches
Signed ФАБЕРЖЕ and bearing the unidentified initials ICA. An identically stamped desk-set is illustrated as AKS plate 179.

Flower Studies

The studies of flowers in gold, enamel and stones represent to many people the ultimate achievement of Fabergé's artist-craftsmen. They attain an astonishing refinement in both conception and execution and succeed in transmitting their uncomplicated message of freshness without apparent effort. Nevertheless, every individual subject exemplifies the cliché of the art that conceals art, as much cunning has gone into its making.

Another aspect of these floral essays has already been noted, but since it seems relevant here, may bear repetition: it is simply that the more closely the pieces follow nature, the more unmistakably they become Fabergé objects.

A subject is chosen, let us say the eglantine illustrated on page 83; the gently undulating gold petals are enamelled a delicate opaque pinkish-white, the veining suggested by lightly painted dark green hairline strokes of enamel. The calyx from which they emerge has been accurately observed and modelled in gold and covered with translucent emerald enamel which allows the engraved texture underneath to be seen. The leaves, in this instance of Siberian jade, have been carved to suggest the authentic surface and the green gold stalk which bears them has been delicately stroked by the engraver's burin. As a final touch, a small brilliant diamond has been set to wink from the centre of the stamens in the flower-head itself.

The flower has then been placed in a small rock crystal pot which has been cleverly carved by the lapidary to convey the illusion of having been nearly filled with water. This 'water' has been drilled to provide a snug accommodation for the stalk which descends at an angle deep into the pot. The effect thus given is enchanting: a single flower casually put in a small glass vase, a colourful reminder of sunshine to set against a long and chilly Russian winter.

In the Sandringham collection of flowers, there is another example of outstanding imagination—the little rose with its diamond dew drop in the Jan van Huysum manner (page 86). What a romantic confection has been created here—it does not require an extravagant leap of the imagination to visualize the hushed presentation of this admittedly golden rose to an

The flower studies shown on this page and on pages 86–88 are from the collection at Sandringham and are reproduced by gracious permission of Her Majesty The Queen.

Left to right:
Bleeding-heart in rhodonite and white chalcedony, dull green gold stalks, carved nephrite leaves, in a rock crystal vase.
Height 7¾ inches No marks
HCB plate 85 AKS plate 294

Mock-orange in white quartzite with olivine centres, on a red gold stalk with carved nephrite leaves, in a rock crystal jar.
Height 5 9/16 inches No marks
HCB plate 83 AKS plate 303

Chrysanthemum of green gold thinly enamelled pale yellow and pink, with carved nephrite leaves, in a square rock crystal vase.
Height 9⅞ inches Signed HW
HCB plate 85 AKS plate 303

enraptured young woman by some beautiful Slav Octavian.

The flowers are possibly the most sought-after of all Fabergé's works and without doubt among the rarest. They are very occasionally stamped on the stalk with the initials of Henrik Wigström and sometimes even the House name, but the majority of them bear no marks whatsoever.

To behold a group of these delightful compositions is to share Thomas Treherne's 'Wonder':

> Rich Diamond and Pearl and Gold
> In evry Place was seen:
> Rare Splendors, Yellow, Blew, Red, White and Green,
> Mine Eys did evry where behold.

Queen Alexandra, who had a distinct *faiblesse* for these floral subjects, owned at least twenty, including sprigs of rowan, holly, catkins, wild cherries, raspberries and cranberries, as well as very attractive studies of japonica, carnation, chrysanthemum, pansies, lilies of the valley, bleeding-heart, mock-orange, field daisies and even a miniature pine tree. Together they form a very agreeable garden planted early in this century by a lady of taste.

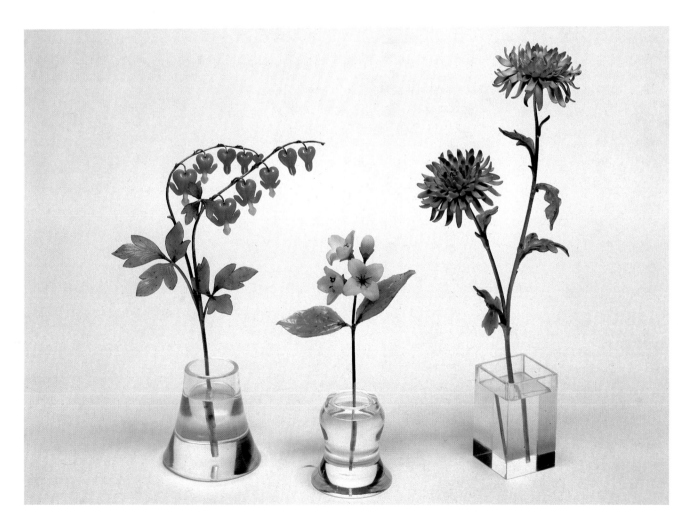

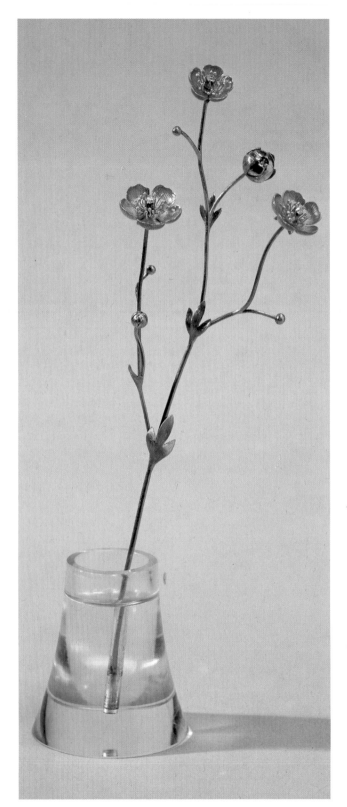
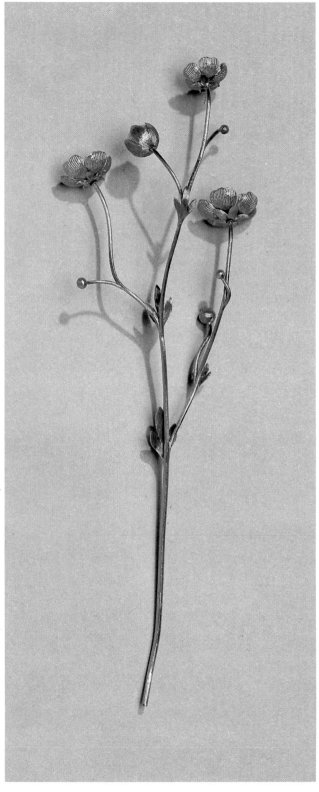

Spray of buttercups modelled in gold and
finely chased with buds and flowerheads set
with brilliant diamonds and enamelled trans-
lucent pale yellow in a rock crystal pot.
Height 6 inches No marks
Madame Josiane Woolf, France

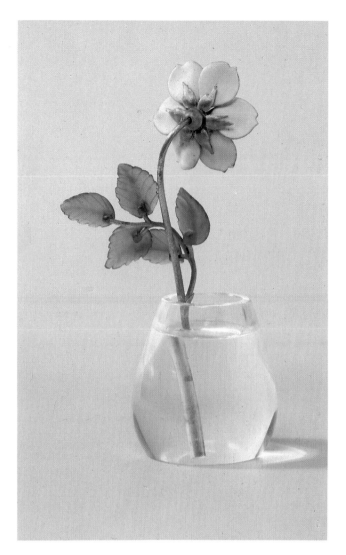

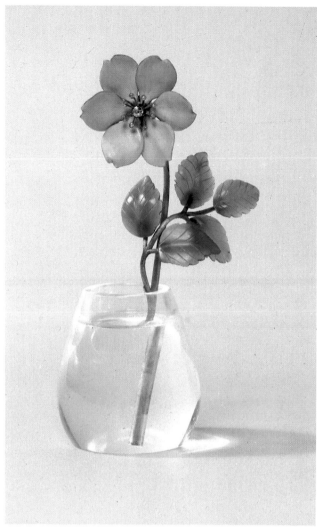

Eglantine. Gold, naturalistically enamelled
in shades of pink and white, and veined in
blue, the five carved and engraved leaves in
Siberian jade are supported on an engraved
gold stem. The flower rests in a rock crystal
pot. Fabergé's London branch in Bond Street
closed down in 1915 and the premises and
remaining stock were subsequently taken
over by the Paris jewellers, Lacloche Frères.
The lid-linings in the wood boxes containing
each object were replaced by satin linings
stamped with the name of the new owners.
The eglantine shown here is fitted in its
original Fabergé holly wood box with a 'new'
lid-lining stamped by Lacloche.
Height $4\frac{1}{8}$ inches No marks
The Duchess of Alba, Madrid.

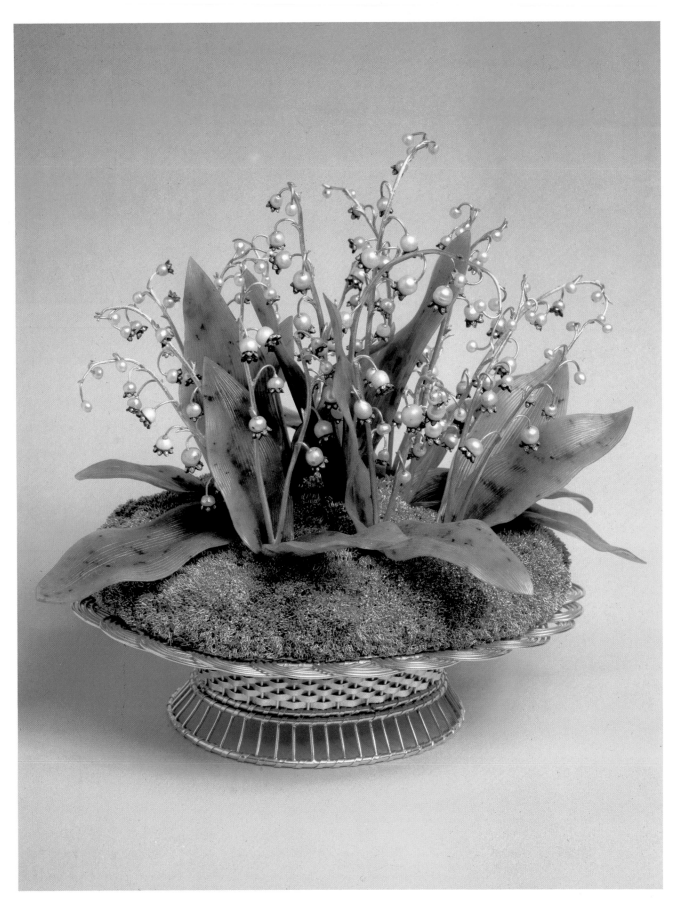

Basket of lilies of the valley in woven yellow gold. Nine sprays of lilies with engraved gold stalks, carved nephrite leaves and pearl and rose diamond flowers grow in a bed of spun green gold and platinum simulating moss and executed in clipped wire polished and unpolished in patches. The following is a translations of the Russian inscription engraved underneath the basket:

'To Her Imperial Majesty Tsarina Alexandra Feodorovna from the Iron-works management and dealers in the Siberian iron section of the Nijegorodski Fair in the year 1896'.
Height $7\frac{1}{2}$ inches
Signed ФАБЕРЖЕ. Indecipherable maker's mark previously and wrongly read as that of Wigström, who became workmaster only after Perchin's death in 1903.
Gold mark crossed anchors
HCB colour plate II AKS colour plate LXIII
Matilda Geddings Gray Foundation Collection, New Orleans.

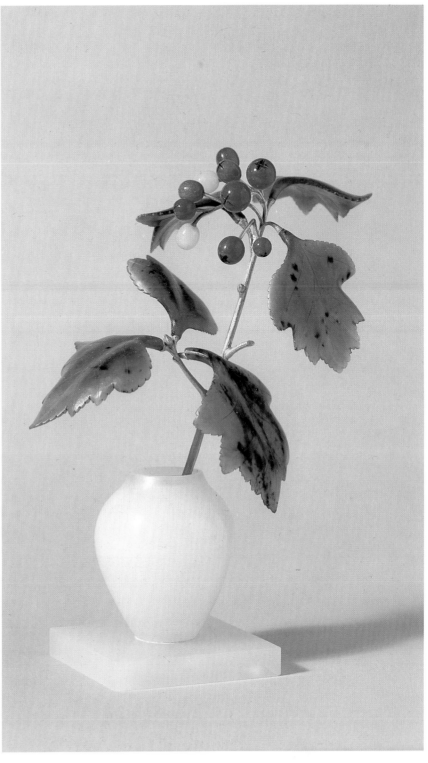

Spray of Hawthorn planted in a white chalcedony baluster shaped vase supported on a square platform of the same material. The engraved gold stalk, which bears carved nephrite leaves and ripe and unripe berries in purpurine, aventurine quartz and chalcedony, grows from a mound of granulated gold simulating earth which gives the appearance of filling the vase.

Height $5\frac{5}{16}$ inches
Gold mark 72
Signed HW

Provenance: Miss Yznaga (sister of the Duchess of Westminster).
Exhibited: Exhibition of Russian Art, 1 Belgrave Square, London, 1935.
Madame Josiane Woolf, France.

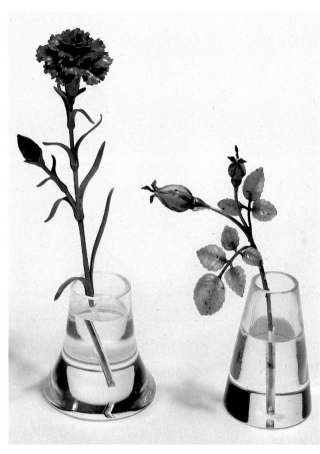

Carnation, in yellow gold enamelled translucent red-bronze, the engraved green gold stalk, leaves and bud tinted with translucent green enamel, in a rock crystal pot.
Height 7¼ inches No marks
AKS plate 299

Rosebuds, enamelled opaque pink and translucent green, stalk in red gold, leaves carved in nephrite, in a rock crystal pot.
Height 5½ inches No marks
HCB plate 83 AKS plate 294

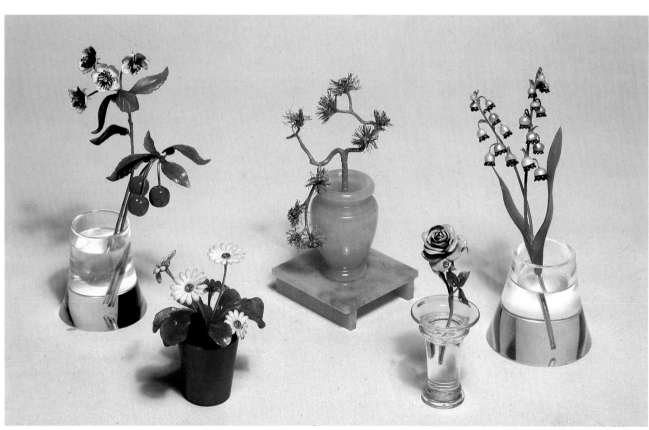

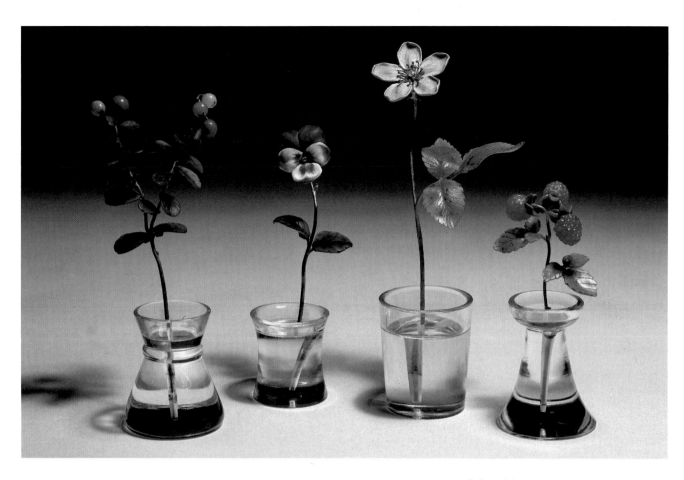

Left to right :
Wild cherries, in carved purpurine, blossom
enamelled opaque white with brilliant dia-
mond centres, the two stalks in dull red gold,
leaves carved in nephrite, in a rock crystal pot.
Height $5\frac{3}{8}$ inches No marks
HCB plate 82 AKS plate 293

Five field daisies, each flowerhead enamelled
opaque white, pale pink and translucent pale
green behind, with bronze-foiled rose dia-
mond centres, on green gold stalks, nephrite
leaves, in a silver flower-pot enamelled
opaque terra-cotta with simulated soil within.
Height $3\frac{1}{16}$ inches Signed HW
AKS plate 301

Pine tree, in engraved dull red gold set with
rose diamonds, in a carved bowenite vase
supported on aventurine quartz platform.
This model was taken from nature at Sand-
ringham.
Height $5\frac{1}{8}$ inches No marks
HCB plate 83 AKS plate 292

Rose and bud. Yellow gold, enamelled opaque
pink, with green translucent enamelled leaves
and rose diamond dew-drop, in a rock crystal
vase.
Height $3\frac{7}{16}$ inches No marks
AKS plate 303

Lily-of-the-valley, in pearls and rose dia-
monds, on green gold stalk with carved
nephrite leaves, in a rock crystal jar.
Height $5\frac{7}{16}$ inches No marks
AKS plate 303

Left to right :
Cranberry, with carved cornelian and chal-
cedony berries, nephrite leaves, red gold
stalk, in a rock crystal vase.
Height $5\frac{5}{8}$ inches No marks
AKS plate 302

Small pansy, enamelled opaque violet with
naturalistic markings and a brilliant diamond
centre, gold stalk and jade leaves, in a rock
crystal pot.
Height $4\frac{1}{4}$ inches No marks
AKS plate 301

**Wild rose of pink and white opaque enamel
with red gold stamens and set with a brilliant
diamond centre, green gold stalk and nephrite
leaves, in a rock crystal vase.**
Height $5\frac{3}{4}$ inches No marks
AKS plate 301

Small raspberry plant, in carved rhodonite
with nephrite leaves and red gold stalk, in a
rock crystal jar.
Height $3\frac{9}{16}$ inches No marks
AKS plate 302

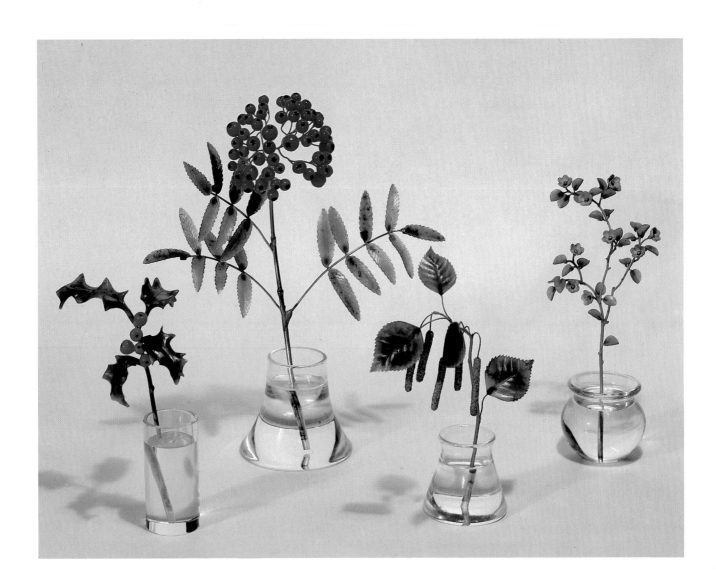

Left to right :

Holly, with berries carved in purpurine, stalk in dull green gold, the leaves of highly polished dark nephrite to express their naturalistic glossy surface, in a cylindrical rock crystal pot.
Height $5\frac{7}{8}$ inches No marks
HCB plate 82 AKS plate 292

Rowan tree, with purpurine berries, dull red gold stem and pale carved nephrite leaves, in a rock crystal vase.
Height 9 inches No marks
HCB plate 84 AKS plate 293

Catkins in spun green gold, stalk in dull red gold and leaves carved in nephrite.
Height $5\frac{7}{8}$ inches No marks
AKS plate 293

Japonica, the blossom in pinky white opaque enamel with rose-diamond centres, engraved dull green gold stalk, carved nephrite leaves, in a rock crystal pot.
Height $6\frac{3}{4}$ inches No marks
AKS plate 300

88

Imperial Easter Eggs

In Russia, Easter, the most important holy festival of the entire calendar, was marked by the traditional exchange of eggs, the symbols of Resurrection, and three kisses.

Many of the Imperial Easter Eggs designed by Fabergé for the Tsar to present to the Tsarina, and during the reign of Nicholas II to his mother, Marie Feodorovna as well, are very beautiful indeed while others, to put it charitably, are quite strange.

Fabergé was never rigid in his ideas and was not afraid of attempting something new and original if sufficiently intrigued. Most of the Eggs contained a surprise of some sort, sometimes of a mechanical nature, designed with the specific intention of providing the Tsarina, when she opened her Egg on Easter morning, with a *frisson* of pleasure, the memory of which would persist for the rest of that day.

For all their glory, the Easter Eggs present a very mixed bag indeed. An eccentric group of goldsmith's follies dedicated —those from 1895 to 1917 at any rate—to a bored Imperial couple remote from their people, the Tsarina, for her part, under the thrall of a corrupt and mangy divine.

The understandable temptation to compare this anthology with the objects made for the Archduke Rudolf in 17th-century Prague must be qualified in one important respect, especially when we come to consider the examples made for presentation by the last Tsar of all the Russias; these certainly derive from Fabergé's imagination rather than that of his unlively client—Nicholas was no Rudolf.

The first Imperial Egg made, we think, in 1884 for Marie Feodorovna, was the result of a very close collaboration between Alexander III and the young Fabergé. Although Nicholas declared on succeeding to the throne that he intended to emulate his late father in everything, this was not, alas, to prove the case as a result of his chronic weakness of character.

We are, however, left with an impressive number of examples in this genre which are quite astonishing as masterpieces of the goldsmith's craft, comparable with many of the treasures of Renaissance Italy or the extraordinary conceits made for the Elector of Saxony by Melchior Dinglinger.

Top left and bottom centre :

Peacock Egg, presented to the Dowager Empress Marie Feodorovna by Nicholas II, dated 1908. This rock crystal Easter Egg in Louis XV taste, engraved with crowned monogram of Marie Feodorovna and the date, each within a border of scrolls, is supported on a silver-gilt scrolling base. Within the Egg a mechanical gold enamelled peacock, one of Fabergé's most ingenious creations, is perched in the branches of an engraved gold tree with flowers in enamel and precious stones. The Egg falls into two halves, each with a heavily chased silver-gilt rococo mount, when opened at the top by means of a clasp. The peacock, when lifted from the branches, wound up and placed on a flat surface, struts proudly about, placing one leg carefully before the other, moving its head and, at intervals, spreading and closing its vari-coloured enamel tail.

Eugène Fabergé has written in a letter dated 19th March 1952:

'Of the many clever craftsmen I would single out Dorofeev, a self-taught mechanic. It was he who made the mechanical peacock for a rock crystal egg. It took him three years to make it'.

Height of Egg 6 inches
Length of peacock $4\frac{3}{4}$ inches
Signed HW
HCB plate 65 AKS plates 356 and 357

Bottom left :

Resurrection Egg, presented to Marie Feodorovna by Alexander III, made between 1885 and 1890. In the form of a monstrance, this Resurrection Egg is one of Fabergé's masterpieces; exquisitely made in the manner

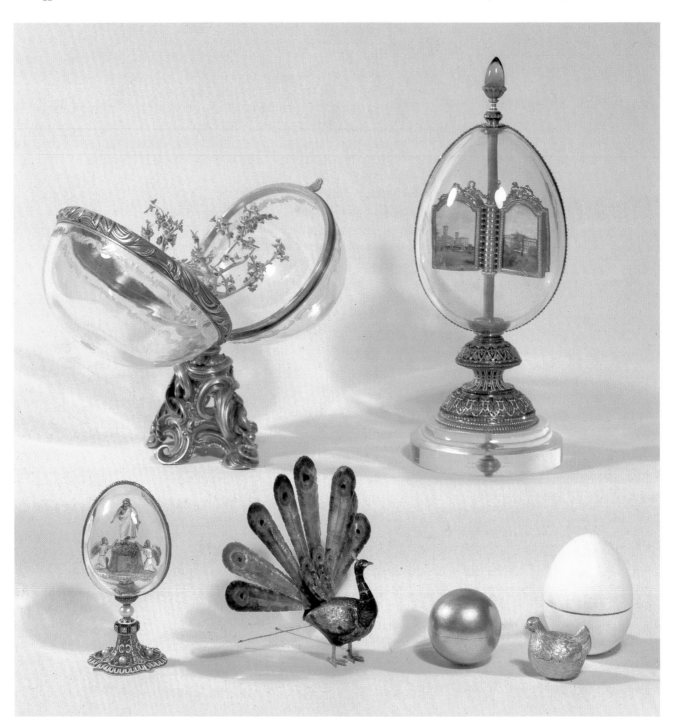

of the Italian Renaissance, it is essentially a jewel.

The three gold figures in the group are naturalistically enamelled *en ronde bosse* – white drapery and lilac-coloured wings. The grass and the ground upon which the group is arranged are enamelled pale green and brown with yellow flecks, and this base is surrounded by a narrow belt of rose diamonds. The door of the Tomb is enamelled to simulate marble with a coral-coloured handle. The whole Resurrection scene is contained within a carved rock crystal Egg, the two hemispheres held together by a line of rose diamonds. The plinth supporting the Egg is enamelled translucent strawberry, green and opaque white with opaque black-painted enamel motifs, and opaque cerulean blue. The gold used is yellow, and the piece is set with eight brilliant diamonds in opaque black enamel collets; an Indian pearl is set on each of the four main panels of the base which is richly set with rose diamonds, and a large pearl serves as the shaft for this Egg.

Height 3⅞ inches Signed МП
Gold mark crossed anchors
AKS plate 317
Forbes Magazine Collection, New York.

Top right:
Egg with revolving miniatures, presented to Alexandra Feodorovna by Nicholas II, probable date, 1896. The two halves of this rock crystal Egg are held together by a narrow rose diamond and translucent emerald green enamelled gold mount, culminating at the top with an elaborately set Siberian emerald weighing 27 carats, cabochon and pointed. The Egg is supported on a circular rock crystal plinth decorated with *champlevé* enamel of various colours and richly set with rose diamonds; the monograms of the Tsarina, as the Princess Alix of Hesse-Darmstadt before her marriage, and as Alexandra Feodorovna, Empress of Russia, each surmounted by their respective crown, appear as separate continuous formal patterns encircling this plinth. Twelve miniature paintings signed by Zehngraf, framed in chased gold acanthus borders, revolve round a fluted gold shaft which passes through the centre of the Egg when the cabochon emerald in the top is depressed and turned. The miniatures show Royal Residences in Germany, England and Russia associated with the life of the Tsarina and include views of various places in and around Darmstadt and Coburg in Germany, Windsor Castle, Osborne House and Balmoral in Great Britain and the Alexander, Anitchkov and Winter Palaces in Russia.

Height 9¾ inches Signed МП
Gold marks 56 and crossed anchors
AKS plates 327–329
Lillian Thomas Pratt Collection of the Virginia Museum of Fine Arts, Richmond.

Bottom right:
The first Imperial Easter Egg, presented to Marie Feodorovna by Alexander III, probable date 1884. This was the first of the Fabergé Imperial Easter Eggs, and the pleasure that it gave to both the Tsar, who pre-

(continued on page 92)

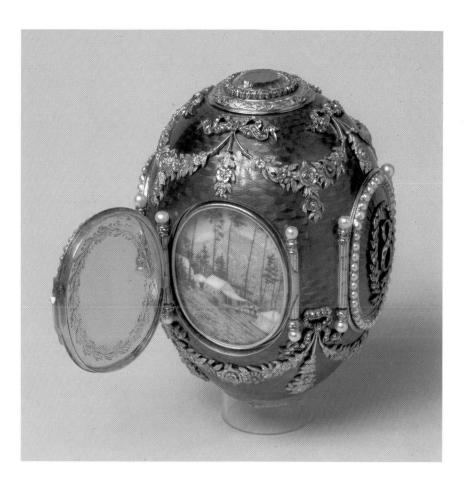

Captions on page 92.

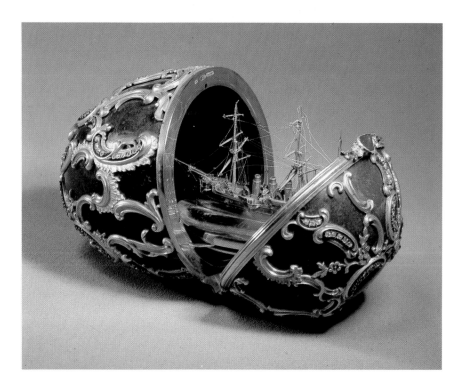

91

(continued from page 91)

sented it, and the Tsarina, who received it, established a custom which was to continue without interruption until the violent end of the Romanov dynasty.

The shell of the Egg is gold, enamelled opaque white, and polished to give the effect of a hen's egg. The two halves are held together by a bayonet fitting; when these are opened, a yellow gold yolk with a dull sandblasted surface is revealed. Inside this yolk, which opens in the same way as the shell, sits a yellow and white tinted gold hen as though in a nest. Each feather is most carefully engraved, and two cabochon ruby eyes are set in the head; the beak and comb are in red gold. By lifting the head, the hen opens on a hinge at the tail. Originally, a diamond replica of the Imperial Crown was contained within the hen, and when this was opened, a tiny ruby pendant was found hanging inside.

Height of Egg 2½ inches
Length of Hen 1⅜ inches
There are no marks at all on this Egg.
Forbes Magazine Collection, New York.

Caucasus egg, presented to Marie Feodorovna by Alexander III, dated 1893. Mounted with *quatre-couleur* gold floral swags held by rose diamond bows, this splendid engraved gold Egg in Louis Quinze style is enamelled a translucent crimson over an engraved field, with four pearl-bordered oval doors each bearing a diamond-set numeral of the year 1893 within a diamond wreath. The doors open to reveal painted views of Abastouman, a mountain retreat high in the Caucasus, signed by Krijitski. It was here that the Grand Duke George Alexandrovitch, the younger brother of Nicholas II, was obliged to spend the greater part of his life owing to his ill health. When the Egg is held to the light, a miniature of the Grand Duke in naval uniform is seen through portrait diamonds at the top and base.
Height 3⅝ inches Signed МП
Gold marks 72 and crossed anchors
The Matilda Geddings Gray Foundation Collection, New Orleans.

Page 91, lower picture:

Azova Egg. Presented to Marie Feodorovna by Alexander III in 1891 and made to commemorate the Tsarevitch's recent voyage round the world in the cruiser *Pamiat Azova*, which sailed in 1890 and returned in the following August. The Egg itself is carved from a solid piece of heliotrope jasper, and is decorated in the Louis XV style with yellow gold scrolls set with brilliant diamonds and chased gold flowers; the broad fluted gold bezel is set with a drop ruby clasp. A tiny replica in gold of the *Pamiat Azova* set on a piece of aquamarine is contained inside the Egg. The model of the cruiser is the work of August Holmström himself, and the minute attention to detail and the delicacy of the craftsmanship are of the highest order; it is carried out in red and yellow golds and platinum.
Length of Egg 3⅞ inches
Length of ship 3¹⁄₁₆ inches Gold mark 72
Signed МП
AKS plates 321, 322, 323
Armoury Museum of the Kremlin in Moscow.

It should perhaps be emphasized again that from a purely technical point of view, every single one of them, whether it pleases us or not, is beyond reproach.

Among the most completely successful of this Imperial procession must be counted the Uspensky Cathedral Egg. A covered cup of gilded copper in the form of a medieval castle in the Victoria & Albert Museum seems to have provided the inspiration for this, the most Russian of the series. Hugh Honour illustrates this astonishing object in his book *Goldsmiths and Silversmiths* (Weidenfeld & Nicolson, 1971) and writes 'Its body is embossed to simulate rusticated masonry; its feet are fashioned like three tiny gate-houses apparently containing flights of steps which lead up to the ring of fortifications round the base; its top consists of buildings huddled round a spired church. At first sight it may seem a realization of some Romantic's dream of the Middle Ages. But it was, in fact, made in Nuremberg in the late fifteenth or early sixteenth century and may thus be called late medieval. Yet it dates from a period when gunpowder was making fortresses less impregnable, and the Holy Roman Emperor, Maximilian, was leading a revival of chivalry. We may not, therefore, be entirely wrong in detecting in this piece a note of yearning for a more colourful and picturesque past.' The work is attributed to Sebastian Lindenast, the leading coppersmith of that proud city of Guilds, which has been so memorably celebrated in music-drama.

Fabergé has roughly preserved the copper colour of the original masonry, although it has become smoother, and the green painted roofs have been translated into the green-enamelled towers clustered round the central Egg with its gold Byzantine dome. The encircling crenellated walls, the gateways and windows have all been adapted for this exercise in Russian medievalism which is so reminiscent in form of the Paschal cheese-cake, the *pascha*, from some Goncharova stage set.

Copper and gilt and painted cup, *c*1500, attributed to Sebastian Lindenast (*c*1460–1526) of Nuremberg.
Height 14½ inches
Victoria & Albert Museum, London

Cuckoo Egg, presented to Alexandra Feodorovna by Nicholas II, dated 1900.
Easter Egg clock in dull yellow, green and red golds, enamelled opalescent white and translucent violet on a zig-zag *guilloché* field, set with pearls and rose diamonds. The dial, which is encircled by pearls set in red polished gold, is enamelled with translucent emerald green trefoils, and the rose diamond numerals are set on pale greenish white opalescent enamel within opaque white enamel rings. A yellow gold leaf pattern surrounds the central pivot on which the red gold hands revolve. The Egg is supported on an elaborate base set with three large rose diamonds by a central shaft and three struts enamelled opalescent white. When a button at the back of the clock is pressed, the circular pierced gold grille which surmounts it opens, and a cuckoo, plumed with natural feathers, set with cabochon ruby eyes, and standing on gold legs, rises crowing on a gold platform, the beak and wings moving authentically, until, the crowing finished, it descends once again into the Egg, and the grille closes down. Surmounting this grille, the date 1900 is inscribed beneath a portrait diamond.
Height 8⅛ inches Signed МП
Mr and Mrs Bernard C. Solomon, Los Angeles.

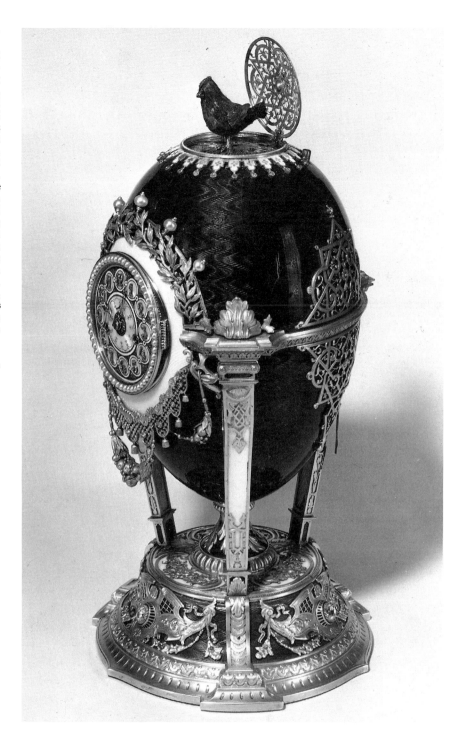

Fabergé may have seen Lindenast's cup in the Museum during a visit to London—it was acquired in 1874—or the line drawing included by John Hungerford Pollen in his *Ancient and Modern Gold and Silver Smith's Work in the South Kensington Museum, London* of 1878.

In all, I have calculated that 57 Imperial Eggs must have been made for Alexander III and Nicholas II. I have attempted to set down for the record a complete *catalogue raisonné* in *The Art of Carl Fabergé* (Faber & Faber, 1953). Since that book

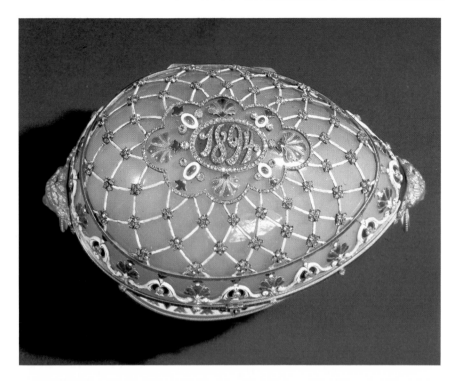

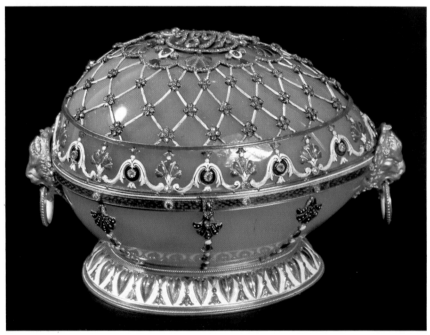

Egg in the Renaissance style, presented to Marie Feodorovna by Alexander III. Dated 1894. Clearly based on Le Roy's masterpiece in the *Grüne Gewölbe* at Dresden, this Easter Egg in the Renaissance style is carved from a large block of milky grey agate to form a jewel casket. A scalloped border in rose diamonds at the top of the cover encloses a strawberry-coloured translucent enamel medallion with the year in diamonds. The Egg, which is mounted horizontally on an enamelled gold base, is richly decorated with a trellis pattern and numerous other gold motifs enamelled strawberry, emerald green, cerulean blue, opaque white and is set with an abundance of rose diamonds and cabochon rubies. The clasp is set with rose diamonds. Chased gold lions' heads holding rings in their mouths are mounted at either end of this, the last Easter Egg given to Marie Feodorovna by her husband. The surprise has been lost.

In comparing Fabergé's work with Le Roy's, note how carefully the modern goldsmith has carried out an almost identical composition in a far lighter vein, by means of a subtle appreciation of the basic egg shape and a careful adjustment of the scales as instanced by the gentle curve added to the trellis pattern, and the more substantial base in relation to the casket as a whole.

Length 5¼ inches Signed MΠ
Gold mark crossed anchors
HCB plate 63
AKS colour plate LXXII and plate 324
Forbes Magazine Collection, New York.

was published, new evidence has become available concerning two of the Imperial Eggs which makes it necessary to amend the record.

I gave the probable date of the Egg with Love Trophies as 1910 or 1911. Its whereabouts were not then known nor even if indeed it was still in existence. All I had were two old photographs (which I reproduced as plates 361 and 362) with a pencilled description and dates on the back—both I now think, inaccurate. Happily, the Egg has recently been located and an

Egg with Danish Palaces and Residences, presented to the Dowager Empress Marie Feodorovna by Nicholas II, probably 1895. A star sapphire within a cluster of rose diamonds and chased gold laurel leaves surmounts this *trois-couleur* gold Egg which is enamelled a translucent pink on a *guilloché* pattern of repeated crosses. The Egg is divided into twelve panels by broad bands consisting each of a line of rose diamonds within continuous laurel leaf borders chased in gold; an emerald is set at each intersection of the lines of rose diamonds.

A folding screen of miniature paintings framed in vari-coloured gold is recessed within the Egg. Painted on mother-of-pearl by Krijitski and dated 1891, eight of the ten panels depict palaces and residences in Den-

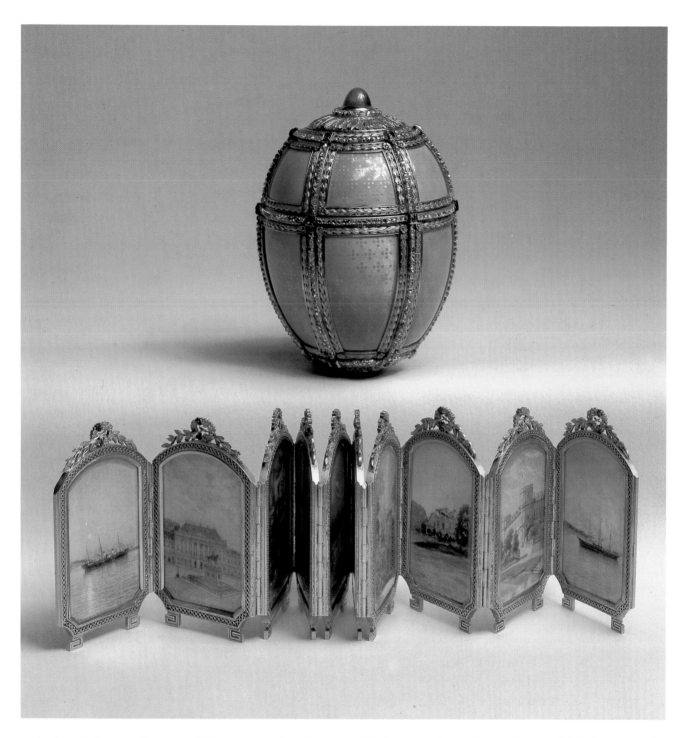

mark where the Dowager Empress, as Princess Dagmar, spent her childhood; the paintings at either end of the screen show the Imperial yachts *Standart* and *Poliarnaya Svesda*. The natural mother-of-pearl is vividly revealed when the miniatures are held up to the light. The date 1895 is written in ink on the outside of the velvet case containing this Egg.

Height 4 inches Signed МП
Gold mark crossed anchors
The Matilda Geddings Gray Foundation Collection, New Orleans.

examination provided a number of new facts which have made a reappraisal necessary. The illustrations on pages 104 and 105 give a very clear indication of just how similar in inspiration this object is to the Colonnade Egg of 1905. Dr Geza von Habsburg and Alexander Solodkoff offer convincing evidence in their forthcoming book (*Fabergé : Court Jeweller to the Tsars*, Office du Livre, Fribourg) that Alexandre Benois was the designer of that Egg which celebrates the birth of the Tsarevitch in 1904. Benois himself told me some twenty six years ago that

he had prepared drawings at Fabergé's request for a clock embellished with cherubs for Alexander III who died in 1894.

If, and it seems very possible, the Colonnade Egg is by Benois, this means either that the painter's memory understandably played him false in old age or that he actually designed an earlier clock and the Egg for 1905 was a second one made by Fabergé from his drawings for a special occasion.

A careful comparison of these two Eggs, both based on the theme of love, reveals such striking similarities in design and decorative motifs, that it seems reasonable to attribute them to the same hand. I should now like to suggest that they were companion pieces presented on the same Easter morning to the Tsarina and the Dowager Empress in celebration of the recent birth of an heir to the throne.

Finally, the hallmark on the Love Trophy Egg turns out to be the *Kokoshnik* for 1899–1908, which provides further evidence to support this view. The original surprise contained within the Egg, which I illustrated with the old photograph, is now missing, although its impression still remains on the velvet. It consisted of a gold and enamelled heart-shaped miniature frame set with diamonds, with a strut in the form of the signature Niki. Did the frame, empty in the old photograph, originally contain a picture of the infant Tsarevitch?

An old Russian proverb informs us that 'The gift of an egg is dear on Easter Day', a sourish reference to the substantial bribes which were regularly expected and received by court officials on that day. The Imperial collection at least is free of such taint and genuinely reflects an uncomplicated wish on the part of two men to give pleasure to their partners.

The Tsarina, Alexandra Feodorovna, in the gardens at Livadia.

The four Grand Duchesses on board the Imperial Yacht *Standart*, 1913.

The Tsar, Nicholas II, and the Tsarevitch in Tsarskoe Selo, 1914.

Coronation Egg, presented to Alexandra Feodorovna by Nicholas II, dated 1897. This superb red gold Egg, enamelled translucent lime yellow on an engraved field, is enclosed by a green gold laurel leaf trellis-work cage mounted at each intersection by a yellow gold Imperial double-headed eagle enamelled opaque black, and set with a rose diamond. A large portrait diamond is set in the top of the Egg within a cluster of ten brilliant diamonds; through the table of this stone, the monogram of the Empress is seen, the crowned 'A' described in rose diamonds, and the Russian Ф in cabochon rubies set in an opaque white enamel plaque. Another, smaller, portrait diamond is set within a cluster of rose diamonds at the end of the Egg, beneath which the date is inscribed on a similar plaque.

The surprise concealed inside this elaborate shell is an exact replica of the Imperial coach used in 1896 at the Coronation of Nicholas and Alexandra in Moscow. In yellow gold and strawberry coloured translucent enamel, the coach, one of the most splendid achievements of the goldsmith's art, is surmounted by the Imperial Crown in rose diamonds and six double-headed eagles on the roof; it is fitted with engraved rock crystal windows and platinum tyres, and is decorated with a diamond-set trellis in gold and an Imperial eagle in diamonds on either door. It is perfectly articulated in all its parts, even to the two steps which may be let down when the doors are opened, and the whole chassis is correctly slung. The interior is enamelled with pale blue curtains behind the upholstered seats and footstool, and a daintily painted ceiling with a turquoise-blue sconce and hook set in the centre. The meticulous chasing of this astonishing piece was carried out with the naked eye without even the aid of a loupe. George Stein, who had been a Master Carriage Builder and who made the coach while he was employed in Perchin's workshop, explained that at that time, when he was a young man of twenty-three, his sight was so good that he could easily detect a flaw in a diamond by simply holding it up to the light. He evidently spent about fifteen months on this model, paying many exploratory visits to the famous Coach Museum in St Petersburg before starting the work. His pay was considered lavish at the rate of 5 roubles (or 10 shillings) a day – days which were sometimes sixteen hours long; Stein only earned three roubles a day at Kortmann's, his previous place of employment, but the conditions were better there than at Faberge's before the removal to new premises in 1900. The yellow and black shell of the egg is a reference to the sumptuous Cloth of Gold robe worn by the Tsarina at her Coronation.

The name of Wigström, Perchin's assistant, is roughly scratched on the inner surface of the shell.

Height of Egg 5 inches
Length of coach $3\frac{11}{16}$ inches
Signed МП Gold mark crossed anchors
HCB colour plate 58 AKS colour plate LXXIII
Wartski, London.

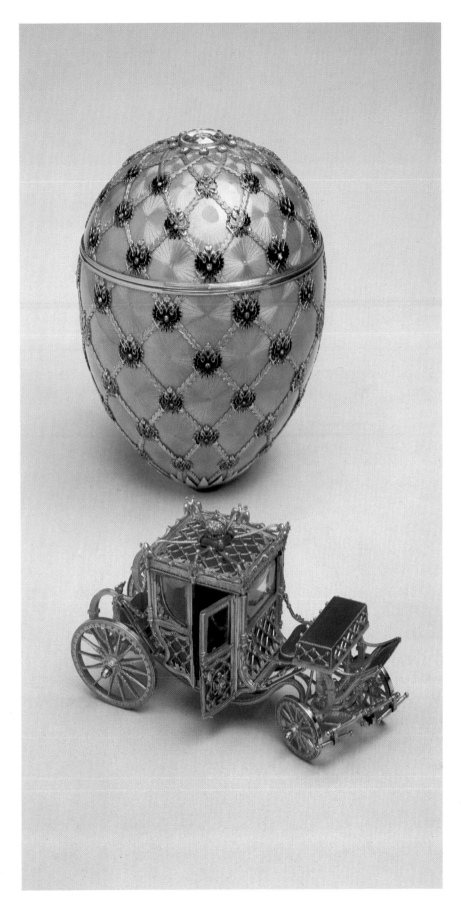

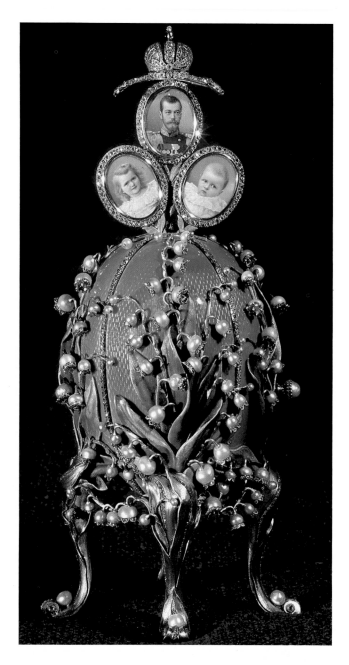

Madonna Lily Egg. Presented to Alexandra Feodorovna by Nicholas II in 1899, this is one of the most pleasing of all the Eggs and startling in its *panache*. It takes the form of a clock with a revolving dial. The four-colour gold Egg is enamelled translucent daffodil yellow, and is richly set with diamonds. It stands on an onyx platform decorated with coloured gold scroll mounts, rosettes and the year in diamonds, and is designed as a vase with red gold scrolls serving as extra supports at either side. The belt of the dial which divides the Egg is enamelled opaque white with diamond set numerals and the hours are pointed by the head of an arrow in a drawn bow. The gold rim of the vase is chased as a cluster of roses; a bunch of Madonna lilies carved from quartzite and each set with rose diamonds emerges from the vase. A small enamelled egg was hung from the green enamel foliage of this bunch of flowers as a further personal surprise gift for the Tsarina.
Height 10½ inches Signed МП
AKS plate 332
Armoury Museum of the Kremlin in Moscow.

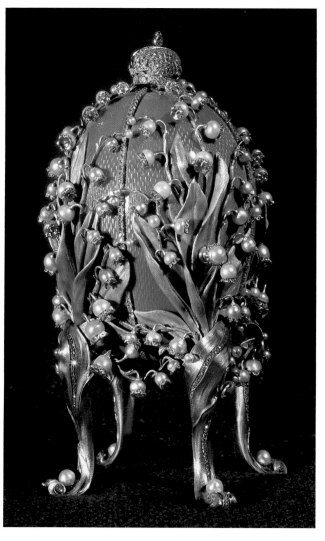

Lilies-of-the-Valley Egg, presented to the Dowager Empress Marie Feodorovna by Nicholas II, dated 5th April 1898. Gold Egg enamelled translucent rose on a *guilloché* field and supported on four dull green gold cabriolet legs composed of overlapping leaves veined with rose diamonds. The Egg is surmounted by a rose diamond and cabochon ruby Imperial Crown set with two bows and quartered by four lines of rose diamonds and decorated with lilies-of-the-valley in pearls and rose diamonds, the stalks lightly engraved green gold and the leaves enamelled translucent green on gold. The 'surprise' consists of three oval miniatures of Nicholas II in military uniform, and the Grand Duchesses Olga and Tatiana, his first two children, signed by Zehngraf within rose diamond borders which rise out of the top of the Egg by means of a geared mechanism and spread into a fan when a gold-mounted pearl button at the side is turned; a turn in the opposite direction automatically folds and returns the miniatures back to the interior of the Egg. The date is engraved on the reverse of the miniatures.
Height (closed) 5¹⁵⁄₁₆ inches (extended) 7⅞ inches Signed МП
Gold mark crossed anchors
Wartski, London.

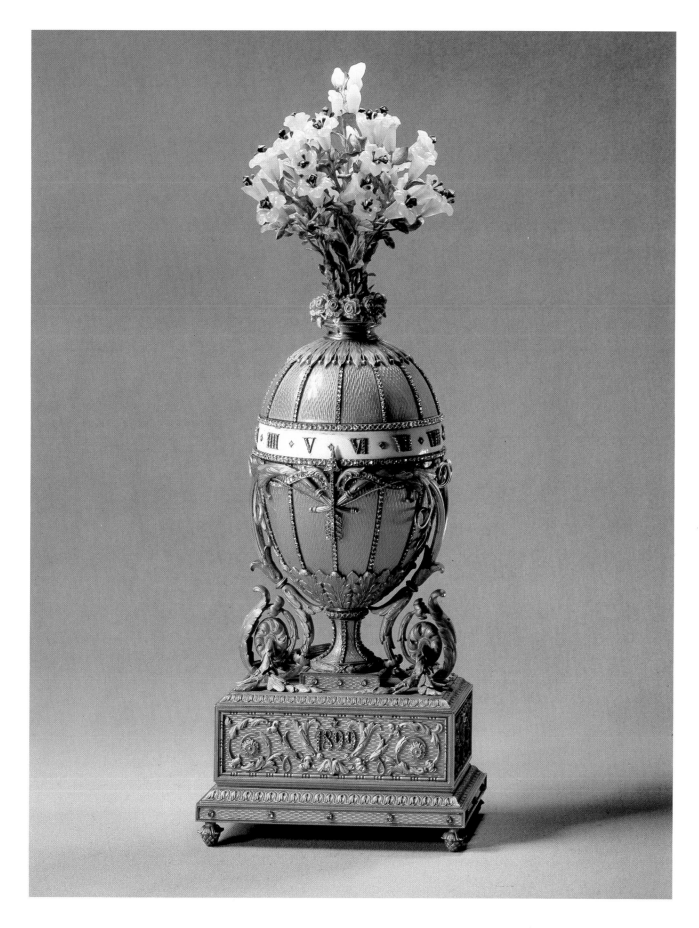

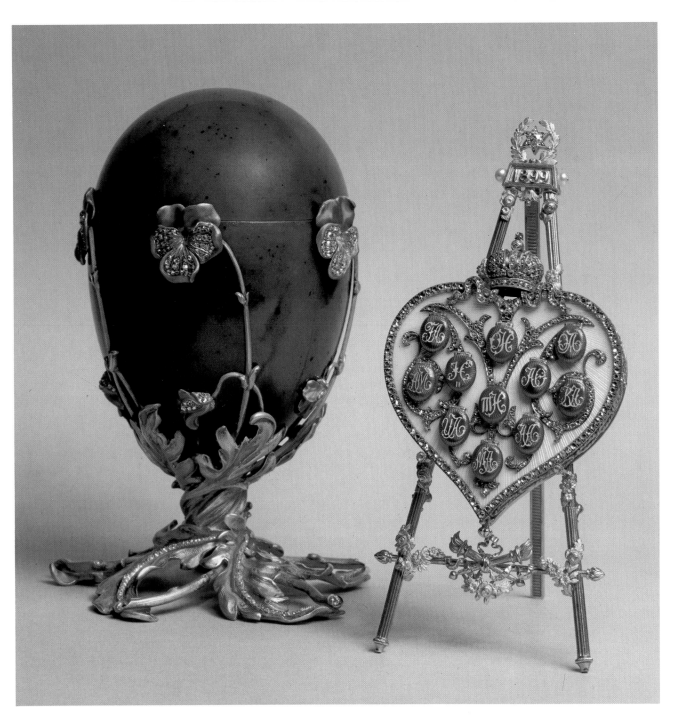

Pansy Egg, presented to the Dowager Empress Marie Feodorovna by Nicholas II, dated 1899. Supported on a spiral twist of silver-gilt leaves and twigs set with rose diamonds, this carved nephrite Egg, designed in the 'Art Nouveau' style, is decorated with opaque violet enamelled pansies, symbols of remembrance and affection. Inside is a gold easel surmounted by a diamond-set Star of Bethlehem within a wreath over the date; the easel is fluted and embellished with chased gold floral and torch motifs and is set with gems and pearls. On it rests a heart-shaped plaque enamelled opalescent white on a sun-ray *guilloché* background and bordered by rose diamonds set in silver and surmounted by the Romanov Crown also in diamonds. Eleven tiny translucent strawberry enamelled gold covers, each bearing its own monogram, are connected by a large diamond 'M' to form a decoration for the front of this plaque. When a button is pressed, the enamelled covers open simultaneously to reveal eleven miniatures of the immediate Imperial Family. Reading vertically, those in the first row are: Grand Duke George, younger brother of the Tsar, Grand Duke Alexander, husband of the Grand Duchess Xenia, the Tsar's sister. In the second row are Tsar Nicholas II and Grand Duchess Irina, subsequently Princess Youssoupoff, daughter of Grand Duke Alexander and Grand Duchess Xenia; in the third row, Grand Duchess Olga, the first child of the Tsar and Tsarina, Grand Duchess Tatiana, their second child, and Grand Duke Michael, youngest brother of the Tsar. The fourth row shows the Tsarina and Grand Duke Andrew, brother of Grand Duchess Irina, and the fifth, Grand Duchesses Olga and Xenia, sisters of the Tsar.

Height of Egg 5¾ inches Signed МП

Top :

Gatchina Palace Egg, probably presented to the Dowager Empress Marie Feodorovna by Nicholas II, circa 1902. Enamelled opalescent white on a gold *guilloché* carcass, this superb Egg is divided into twelve panels by lines of pearls. Portrait diamonds are set at either extremity, but unfortunately both the monogram and the year which, presumably, they once covered, have disappeared. Classical motifs painted in enamel in each of the segments refer to the various fields of endeavour actively and consistently encouraged by
Marie Feodorovna. When the Egg is opened, a wonderfully detailed model of the Gatchina Palace, near St Petersburg, is revealed; it is executed in four colours of gold, and under close scrutiny, shows trees, bridges, cannon, turrets and so on. This piece must be accounted one of Fabergé's most delightful compositions. Under the model of the palace, Marie Feodorovna's favourite residence, a velvet-lined space originally concealed some precious jewel now separated and lost.
Height 5 inches Signed МП
Walters Art Gallery, Baltimore.

Left :

Rose trellis Egg, presented to either his wife or mother by Nicholas II, dated 1907. Gold Easter Egg in pale green translucent enamel latticed with rose diamonds and decorated with opaque light and dark pink enamel rose blooms and translucent emerald green leaves. A portrait diamond is set at either end of this very charming Egg, the one at the base covering the date; unfortunately the monogram has disappeared from beneath the other. An oval jewelled locket was originally concealed in the *(continued on page 102)*

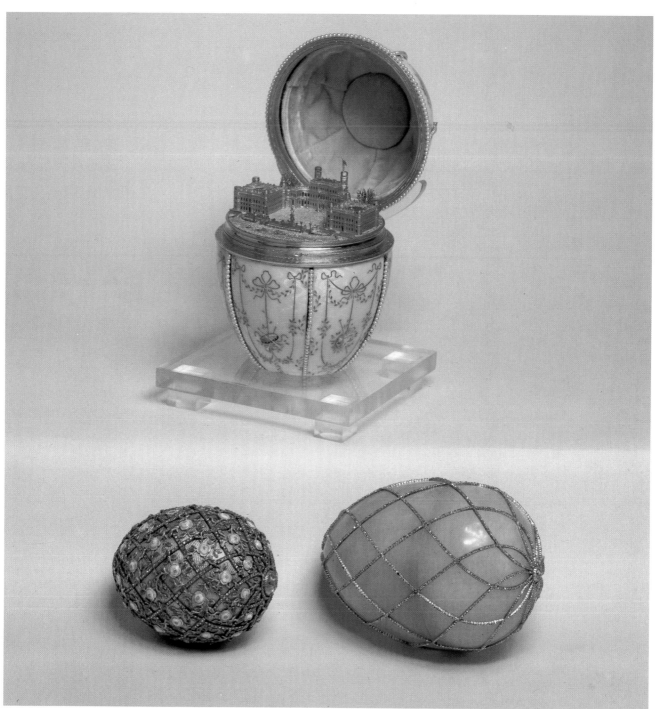

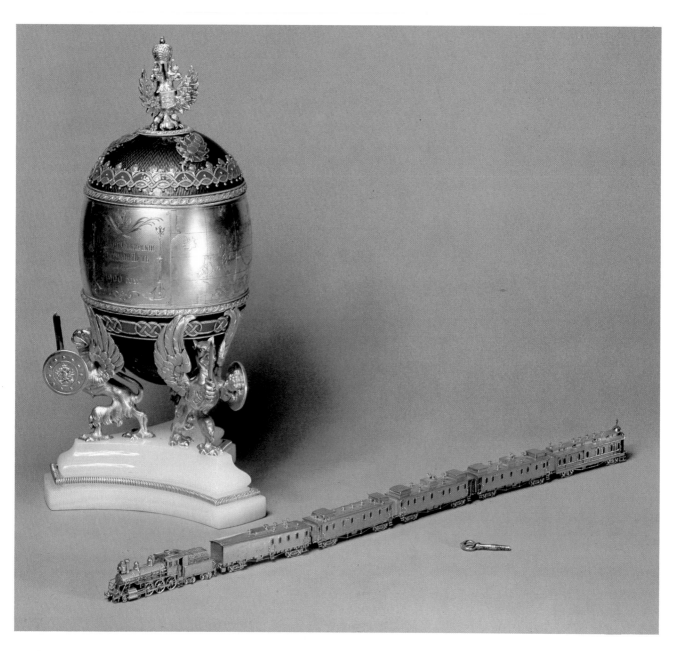

Trans-Siberian Railway Egg. Presented to Alexandra Feodorovna by Nicholas II probably in 1901. A map of the route of the Trans-Siberian railway as it was in 1900, from St Petersburg to Vladivostock, engraved on silver, each station marked by a precious stone, forms a broad belt around this translucent green enamelled gold Egg decorated with blue and orange enamel mounts. The Egg is surmounted by a three-headed Eagle in gold bearing the Imperial Crown and is supported by three Romanov Griffins each brandishing sword and shield, and mounted on a white onyx base. The Egg is opened on a hinge where the enamelled top meets the silver map, and within is concealed, in three sections, a faithful miniature replica of the Trans-Siberian Express, the engine and tender in platinum and gold, and five coaches in gold, minutely chased to give every detail;

the three parts may be connected to form a train which runs along when the clockwork locomotive is wound up above the driving wheels. The last coach is designed as a travelling church, others are marked 'Smoking' and 'For Ladies only'. The Trans-Siberian Railway, begun in 1891, was completed, in the main, by 1900, and this ingenious Egg, probably given in the following year, commemorates the ceremonial opening. An engraved gold plaque bears the following inscription beneath the Imperial Crown: 'The Grand Siberian Railway in the Year 1900'.
Height of Egg $10\frac{3}{4}$ inches
Length of train $15\frac{11}{16}$ inches
Height of train $\frac{9}{16}$ inches
Signed MΠ
AKS plate 336
Armoury Museum of the Kremlin in Moscow.

(continued from page 101)
Egg, but now, unfortunately, only its impression on the satin lining remains.
Height $3\frac{1}{16}$ inches Signed HW
Walters Art Gallery, Baltimore.

Right:
Diamond Trellis Egg, presented to Marie Feodorovna by Alexander III, probable date 1892. Carved in bowenite and encased in a fine and gently undulating trellis of rose diamonds, the pale yellow-green colour of the serpentine with its opalescent finish adds to the overall delicacy of this elegant object by Fabergé's chief jeweller. The Easter Egg is hinged and set at the top with a large rose diamond.
Height $4\frac{1}{4}$ inches Signed AH
Gold mark crossed anchors

Uspensky Cathedral **Egg**. Presented to Alexandra Feodorovna by Nicholas II in 1904. This, the most ambitious of the Imperial Eggs, represents the Uspensky Cathedral where **the Tsars of Russia were crowned.** Based on a cup by Sebastian Lindenast (page 92), the walls, towers and staircases are clustered round the central opalescent white enamel Egg, the top of which takes the form of a graceful yellow gold cupola. The turrets of the Kremlin are described in red gold and the roofs are enamelled translucent light green. There are chiming clocks on two of the towers, the dials each measuring approximately half an inch in diameter. Through the windows of the Egg can be seen a minutely accurate representation of the interior of the cathedral with its rich carpets, decorations and High Altar. The melody of the traditional hymn 'Ijey Cheruvime' is played when a button at the back of the Egg is pressed. The clockwork mechanism is wound by a gold key $2\frac{1}{2}$ inches long. Tiny enamelled ikons decorate the walls of the cathedral. The Egg, which rests on a white onyx base, is consciously designed as a pyramid and is built up of other smaller pyramids.

Engraved at the foot of the model ФАБЕРЖЕ 1904.

Height $14\frac{1}{2}$ inches

AKS plate 346

Armoury Museum of the Kremlin in Moscow.

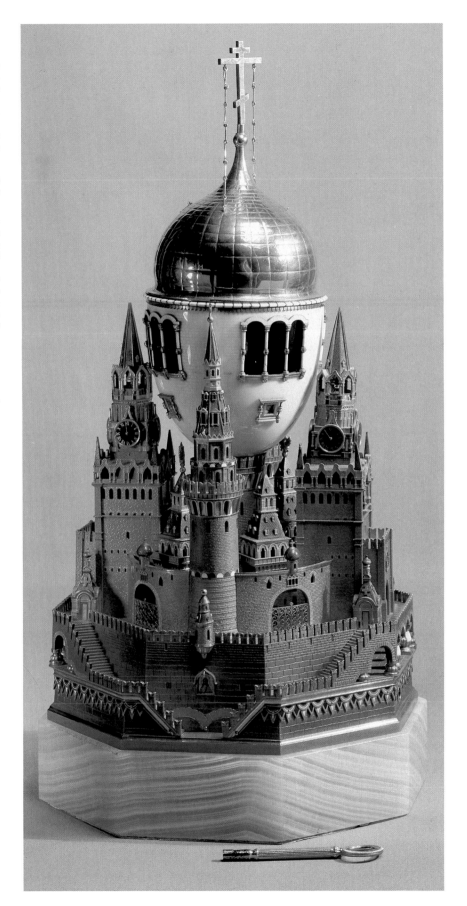

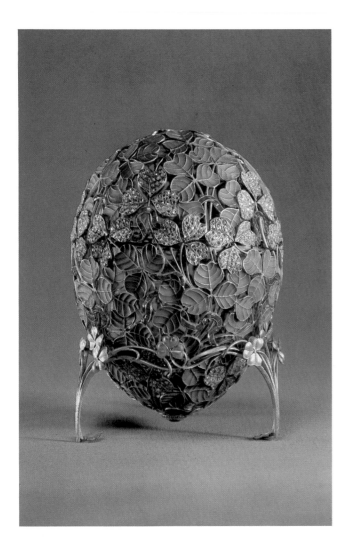

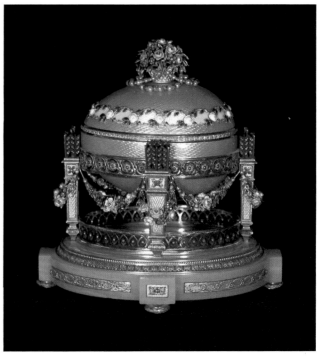

Clover Egg. Probably presented to Alexandra Feodorovna by Nicholas II in 1902. (Date given by Kremlin Armoury Museum.) The shell of this exquisite Egg is composed of closely packed clover leaves carried out in *plique à jour* green enamel, dull green gold and diamonds massed so closely together that the settings are quite invisible. A cabochon ruby and diamond cluster is set at the point of this egg which is further decorated by a pattern of *calibré* ruby ribbons. The supporting tripod is carried out in the same style as the Egg itself. The surprise originally contained within has been lost.

Height $3\frac{3}{8}$ inches Gold mark 72
Signed МП
AKS plate 338
Armoury Museum of the Kremlin in Moscow.

Egg with Love Trophies. Probably presented to Marie Feodorovna by Nicholas II in 1905. Gold Egg in Louis XVI style enamelled translucent pale blue over a *guilloché* ground, decorated with an elaborate band composed of painted enamel roses and translucent emerald green enamelled leaves and panels of opalescent oyster enamel, and further bands of scrolls and acanthus chased in coloured golds. It is surmounted by a pierced basket in coloured golds of enamelled roses among foliage set with rose diamonds and hung with pearl swags. Four oyster-enamelled quivers of rose diamond-set arrows linked by heavy swags of enamelled roses and leaves set with rose diamonds and pearls encircle the Egg. The whole is supported upon a carved oval white onyx base inlaid with pale blue and oyster enamelled panels overlaid by chased trails of laurel in green gold with red gold rosettes, and stands on four bun feet in chased coloured golds.

Height 7 inches Signed HW

Colonnade Egg, presented to Alexandra Feodorovna by Nicholas II, probable date, 1905. Conceived as an arcadian Temple of Love, this rotary clock Egg commemorates the birth of the long-awaited heir to the throne in 1904. A silver-gilt cupid, an allegorical representation of the Tsarevitch surmounts the gold Egg, which is enamelled opalescent pale pink on an engraved ground and is encircled by the broad band of a translucent white enamelled dial set with rose diamond numerals; a diamond-set pointer projects from a colonnade in pale green bowenite, which supports the Egg. The base of this colonnade, which is made up of six gold-mounted Ionic columns, is set with coloured gold chased mounts and a broad band of pale pink enamel. Four silver-gilt cherubs, representing the Tsar's four daughters, are seated at intervals around this elaborate base and are linked by floral swags chased in *quatre-couleur* gold. Two cast and chased platinum doves are perched on a white enamel plinth raised within the circle of columns.

Sir Sacheverell Sitwell has suggested that the design for this Egg derives from Eisen's illustrations to *Les Baisers* of Dorat. (See *Carl Fabergé*, Wartski Coronation Exhibition 1953.) Another suggestion has been put forward and is discussed on page 92.

Height $11\frac{1}{4}$ inches Signed HW
HCB plate 61 AKS colour plate LXXVII
From Queen Mary's collection. Her Majesty The Queen.

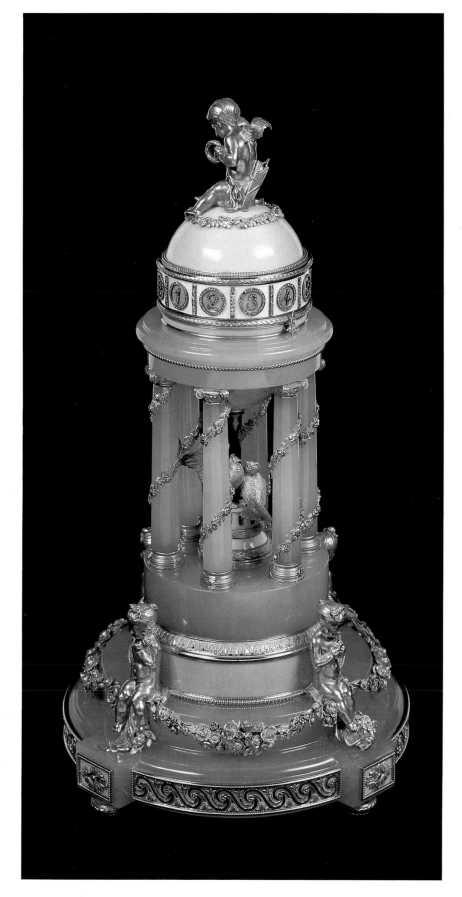

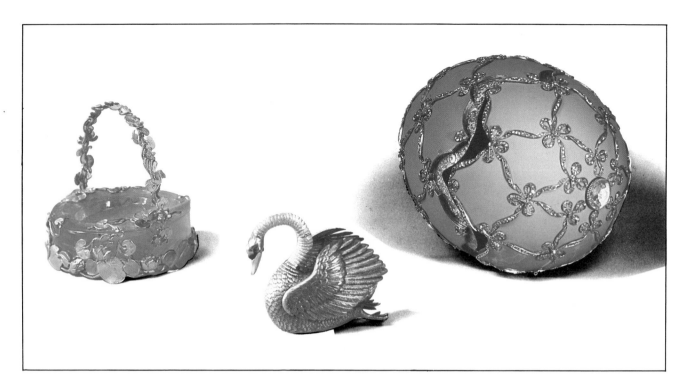

Swan Egg. Presented to Alexandra Feodorovna by Nicholas II in 1906. This gold Egg is matt enamelled mauve within a twisted ribbon trellis of rose diamonds with a four-looped bow at each intersection. The top, carefully designed to conceal the division when closed, is surmounted by a large portrait diamond covering the year; another is set in the base. Lifted from the Egg by a handle formed of water lilies in four colours of gold, a miniature lake is revealed composed of a large aquamarine, also richly decorated with water lilies, upon which rests a superbly chased platinum swan.

When wound up under one wing, chased gold webbed feet guide the bird along its course; it wags its tail characteristically. The head and arched neck are proudly raised then lowered and the wings are opened and spread to display each feather separately.
Height of Egg 4 inches Gold mark 56
AKS plates 348–350
The late Maurice Sandoz.

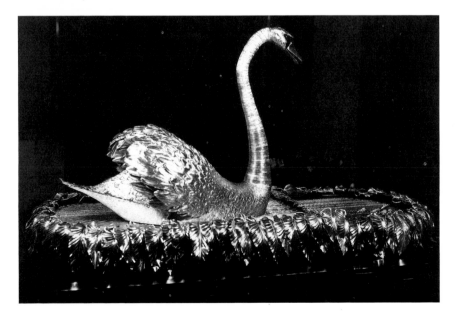

The life-size Silver Swan in the Bowes Museum was originally 'part of the stock of James Cox, bankrupt' and was included in the famous dispersal by lottery of the Cox Museum in 1775. The Swan was acquired by Harry Emanuel, the court jeweller, who retailed in Bond Street. The leaves covering its base are a later addition in electroplated metal, and it seems reasonable to assume that they were fashioned by Emanuel, who showed the Swan at the 1867 Paris International Exhibition, where it was seen by Mark Twain and described in Chapter XIII of his *The Innocents Abroad*: 'I watched the Silver Swan which had a living grace about his movements and a living intelligence in his eyes – watched him swimming about as comfortably and unconcernedly as if he had been born in a morass instead of a jeweller's shop – watched him seize a silver fish from under the water and hold up his head and go through all the customary and elaborate motions of swallowing it.' Just as the Peacock Egg was inspired by the automaton clock by Cox in the Hermitage Museum, Leningrad (AKS plates 311 and 312), it would appear that the Silver Swan was similarly influential in the case of the Swan Egg.
The Bowes Museum, Barnard Castle, County Durham.

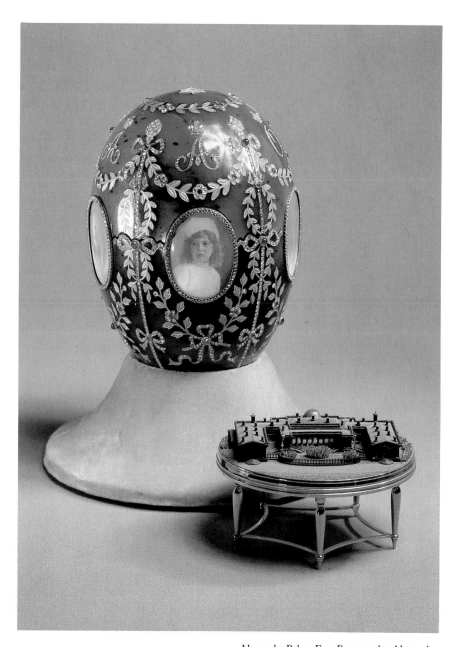

Alexander Palace Egg. Presented to Alexandra Feodorovna by Nicholas II in 1908. Surmounted by a beautifully cut triangular diamond, this attractive Siberian nephrite Egg is decorated with yellow and green gold mounts and set with cabochon rubies and diamonds. Five miniature portraits of the Tsar's children form a belt encircling the Egg; each one is set within a frame of rose diamonds and is surmounted by the appropriate initial in diamonds. Concealed within is a coloured gold model of the Alexander Palace, the favourite home of the Imperial Family in Tsarskoe Selo, the roofs enamelled pale translucent green and the grounds decorated with bushes in spun green gold wire, the whole set out upon a miniature gold table with five legs.
Height $4\frac{5}{16}$ inches Gold mark 72
Signed HW
AKS plates 353–355
Armoury Museum of the Kremlin in Moscow.

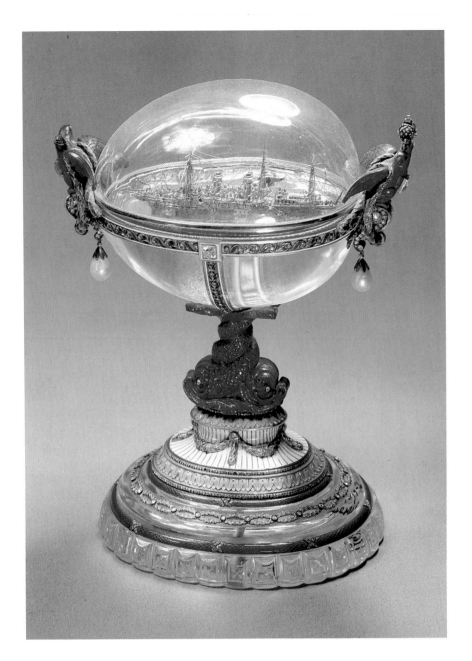

Standart Egg. Presented to Alexandra Feod-
orovna by Nicholas II in 1909. This rock
crystal Egg is mounted in gold richly enamelled
and set with gems; it is supported on a rock
crystal pedestal similarly decorated, two inter-
twined lapis lazuli dolphins forming the shaft.
The eagles perched on either side of the
horizontally-set Egg are also carved in lapis,
and these surmount two pearl drops. When
this Egg in Renaissance style is opened, a faith-
ful replica in gold of the nineteenth-century
yacht *Standart* is revealed set on a large piece
of aquamarine to give the impression of the sea.
Derived from Jürg Ruel's sixteenth-century
masterpiece in the Dresden collection, this
Egg is one of the most brilliant of the series. It
is sadly marred, however, by the ridiculous
little ship within, which besides being quite
out of scale with its surroundings, strikes a
completely anachronistic note, and very

nearly wrecks an excellent design. Eugène
Fabergé put the date of this Egg at about 1908,
and it may well have been made to com-
memorate the part played by the Tsarina
when, on 11th September, 1907, the yacht
struck a rock and appeared to be sinking fast
and, as Baroness Buxhoeveden tells us in her
Life and Tragedy of Alexandra Feodorovna:
'The Empress arranged that the children and
the ladies' maids should be first lowered into
the boats. Then she rushed into the cabins,
tore the sheets off the beds and tossed all
valuables into them, making huge bundles of
the most necessary and precious things. It was
all done in about a quarter of an hour. The
Empress was the last woman to leave the
yacht.'
Height 6⅛ inches Signed HW
AKS plates 359, 360
Armoury Museum of the Kremlin in Moscow.

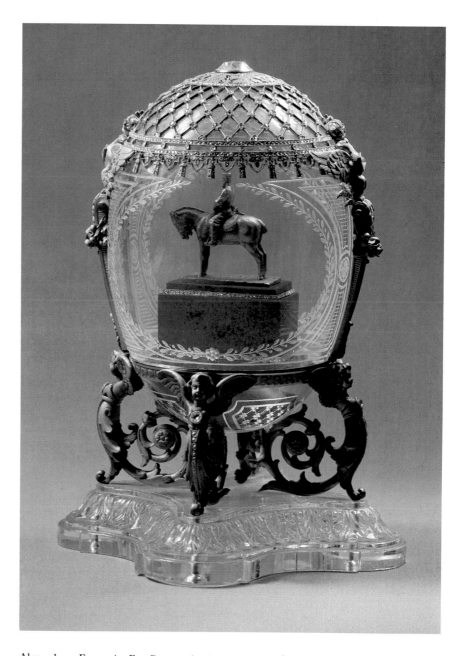

Alexander III Equestrian Egg. Presented to the
Dowager Empress Marie Feodorovna by
Nicholas II in 1910. Made presumably to per-
petuate the memory of the Tsar Alexander III,
this, the first Egg to be set entirely in platinum,
is one of the most beautifully designed of all.
The Egg itself is carved from a solid piece of
rock crystal and is surmounted by a diamond-
set platinum lacework fillet, a large rose dia-
mond at its centre and bordered by a tasselled
fringe. The Egg is supported upon the wings
of four chased platinum *amoretti* set on a
carved rock crystal shaped base. Two vertical
motifs, each slung with carved decorative
swags, join the hemispheres of the Egg.
Through the engraved crystal can be seen a
miniature equestrian statue of Alexander III
in dull green gold on a lapis lazuli plinth; it is a
tiny replica of Prince Troubetskoy's well-
known work.

Height 6⅛ inches Signed К. ФАБЕРЖЕ
AKS plate 364.
Armoury Museum of the Kremlin in Moscow.

109

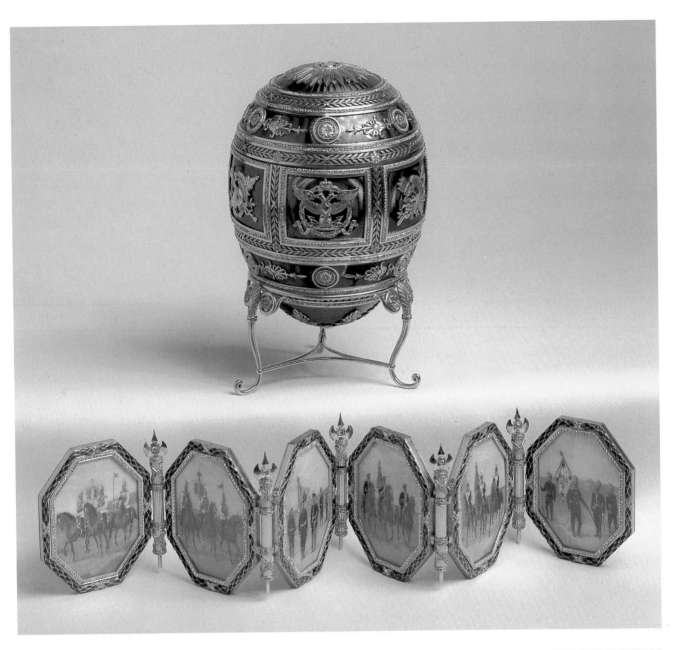

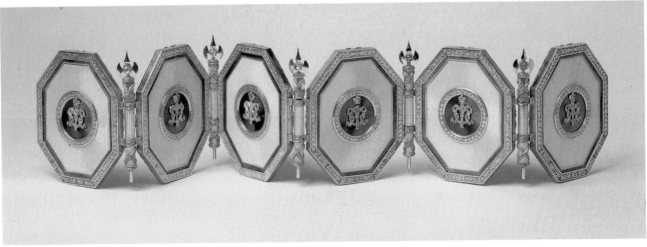

Winter Egg. Presented to the Dowager Empress Marie Feodorovna by Nicholas II in 1913. This enchanting composition consists of an Egg carved from a block of rock crystal with frost flowers engraved on the inside and carried out in diamonds outside. Each half of the Egg, which opens on a hinge, is rimmed with brilliant diamonds; it is surmounted by a moonstone covering the date, and is set throughout in platinum. Within the Egg, a rose diamond and platinum basket of snowdrops hangs by the handle from a hook; the flowers are executed in white quartz with gold-set olivine centres, the leaves in pale nephrite, stalks in gold and the earth in spun gold. The Egg, which is removable; rests on a rock crystal block of ice set with brilliant and rose diamonds; it is held firmly in position by a projecting pin which fits into the bottom of the Egg. Sacheverell Sitwell has described this piece as a 'Winter Egg' and the surprise it contains is particularly felicitous with its promise of Spring. This is one of the best examples of Fabergé's use of gems to express his composition as opposed to their introduction merely as an enrichment. The Egg itself bears no marks, but the bottom of the basket of flowers is engraved 'Fabergé 1913'.
Height of Egg 4 inches
Height of basket $3\frac{1}{4}$ inches
AKS plate 374
Mr Bryan Ledbrook

Napoleonic Egg, presented to the Dowager Empress Marie Feodorovna by Nicholas II, dated 1912. In the Empire style, this green and yellow gold Egg commemorates the hundredth anniversary of the War of the Motherland waged against Napoleon. Military emblems and double-headed eagles chased in gold decorate the translucent emerald green with which the *guilloché* surface of the Egg is enamelled, and these are framed by broad bands of chased gold leaves and rosettes applied to translucent strawberry enamel. In addition to the profusion of rose diamonds with which this magnificent Egg is set, portrait diamonds at either end cover the crowned monogram of the Dowager Empress and the date 1912.

Within the Egg is a folding screen of six signed miniatures by Vassily Zuiev, each showing members of the regiments of which Her Imperial Majesty was Honorary Colonel; the back of each panel bears an inscription identifying these, and is set with her monogram and crown in rose diamonds on a green enamel plaque set in the centre of a translucent white enamel sunburst pattern.
Height $4\frac{5}{8}$ inches Signed HW
AKS plates 370–372
The Matilda Geddings Gray Foundation Collection, New Orleans.

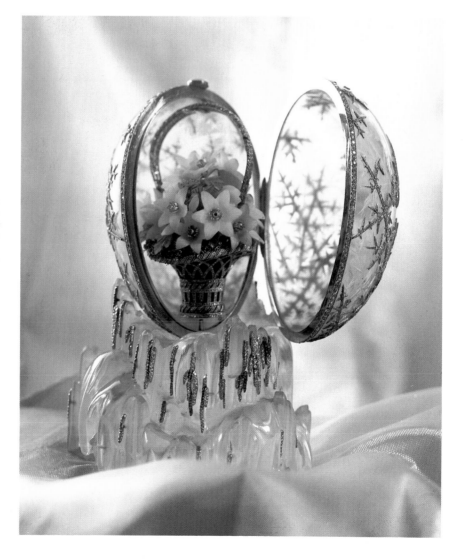

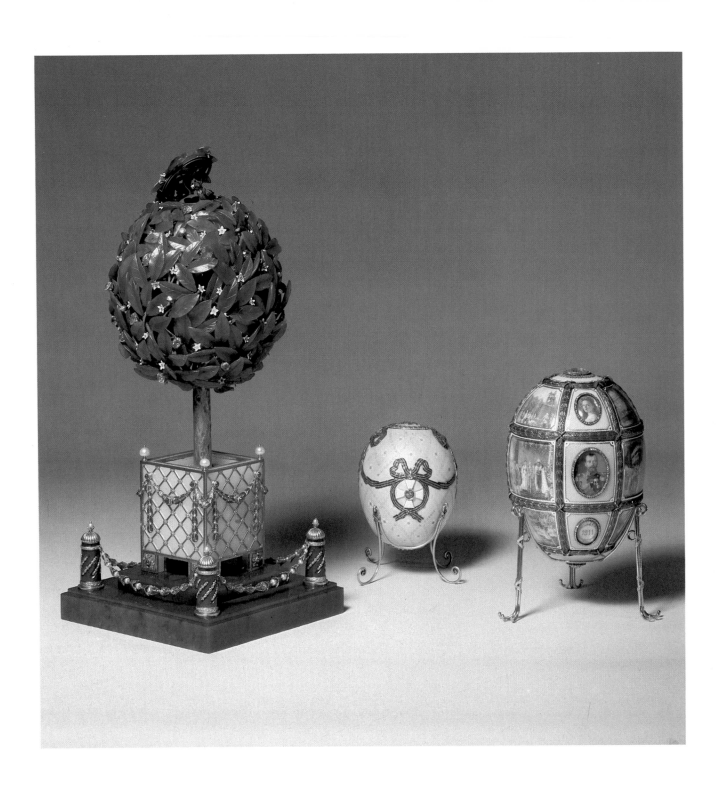

Left to right :

Orange-tree Egg presented to the Dowager Empress Marie Feodorovna by Nicholas II. Date 1911. In the form of an orange tree growing in a tub, this Easter Egg is a remarkable example of the jeweller's art. Based on a solid block of nephrite and surrounded by four gold-mounted nephrite pillars connected by swinging chains of translucent emerald-enamelled gold leaves half covering pearls. A white quartz tub, set with cabochon rubies and pearls, trellised in gold and decorated with chased gold swags, is filled with hammered gold soil. As if growing from this soil, a naturalistically modelled gold tree-trunk supports the egg-shaped foliage composed of single carved nephrite leaves each engraved to show the veining. White opaque enamel flowers with brilliant diamond centres and various green stones (citrines, amethysts, pale rubies and champagne diamonds) representing fruit, are set at random amongst the leaves. Within this nephrite foliage, four main limbs branch from the trunk, and a complex network of smaller branches grows from these, each finally passing through tiny drilled collets concealed behind each leaf. When a small button is pressed, the top leaves spring up and a feathered gold bird rises from the interior of the tree, sings and then automatically disappears. The key to the mechanism is hidden among the leaves and may be located only by the gem set in the top disguised as another fruit.

Height 10½ inches

Engraved FABERGE 1911 on front bottom edge of tub AKS colour plate LXXVIII

Cross of St George Egg, presented to the Dowager Empress Marie Feodorovna by Nicholas II, dated 1916. This Egg was made to commemorate the recent presentation of the Order of St George to the Tsarevitch and the Cross of that Order to his father. In opalescent white enamel, the surface of this silver Egg is trellised with a simple laurel pattern forming panels within which military crosses of St George are painted. The Egg is encircled by the black and orange-striped ribbon of the Order of St George, which was awarded in recognition of outstanding courage; from two of the bows of this ribbon, which is carried out in enamel, hang silver medallions which may be raised upwards by pressing small buttons set beneath them, to reveal painted miniatures set in the main shell of the Egg. One medallion, showing the Tsar's head, covers the portrait of the Tsarevitch and the other, showing the Cross of St George, the portrait of the Tsar. The crowned initials of the Dowager Empress appear raised within a round chased border at the top of the Egg, while the year is similarly applied to the base.

Height 3 5/16 inches ФАБЕРЖЕ engraved on the edge of the medallion with the Tsar's head.

AKS plate 385

Fifteenth Anniversary Egg, presented to Alexandra Feodorovna by Nicholas II, dated 1911. The following is based on a translation of the description given with a photograph of this Egg, printed in *Stolitza y Usadba* (Town and Country), 'The Journal of Elegant Living', a magazine published in what was then Petrograd. This particular issue, dated 1st April, 1916, gave special prominence to a series of photographs of nine of the Tsarina's Easter Eggs:

Red gold Egg commemorating the fifteenth anniversary of Nicholas II's Coronation; it is enamelled opalescent oyster with heavy chased husk borders enamelled translucent emerald green with diamond ties at the intersections. The surface is covered with a series of miniature paintings on ivory by Zuiev depicting notable events of the reign; these are set under carved rock crystal panels and represent:

1. The ceremonial procession to the Uspensky Cathedral.
2. The actual moment of the Holy Coronation.
3. The Alexander III bridge in Paris at the opening of which His Imperial Majesty was present.
4. The House in the Hague, where the first Peace Conference took place, Huis ten Bosch.
5. The ceremonial reception for the members of the first State Duma in the Winter Palace.
6. The Emperor Alexander III Museum.
7. The unveiling of the Peter the Great monument in Riga.
8. The unveiling in Poltava of the monument commemorating the 200th year of the founding of Poltava.
9. The removal of the remains of the sainted Serafim Sarovski.

The paintings are framed by narrow opaque white enamelled borders, and oval portrait miniatures of the Imperial Family are set in opalescent oyster enamelled mounts over *guilloché* fields and rimmed by rose diamonds. Fabergé's signature appears twice in pale blue enamel in three parts (ФА, БЕР, ЖЕ) on a ribbon on the plaques showing the dates 1894 (the date of the wedding) and 1911, below pink bouquets. The chased acanthus mounts encircling the rose diamond cluster at the culot of the Egg, and the portrait and rose diamond cluster at the top, under which is the Imperial Cypher A Ф beneath the crown, are in dull green gold. No gold marks

Height 5⅛ inches AKS plates 365 and 366

These three Easter Eggs are in the Forbes Magazine Collection, New York.

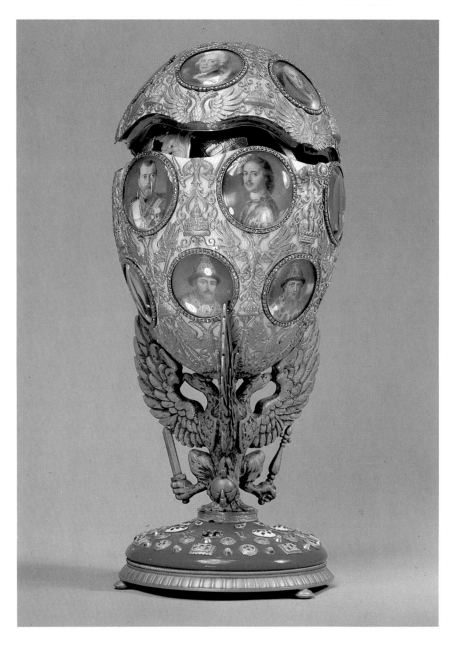

Romanov Tercentenary Egg. Presented to Alexandra Feodorovna by Nicholas II in 1913. This Egg, one of Fabergé's most astonishing pieces, commemorates three hundred years of Romanov rule. Enamelled opalescent white on gold, it is decorated with a pattern of chased gold double-headed eagles and ancient and contemporary Romanov crowns, framing at intervals eighteen miniature likenesses of the most notable Romanov rulers, within rose diamond borders; these are painted on ivory by Zuiev.

The Egg, which is removable, rests on a pedestal in the form of a three-sided Imperial Eagle in pale gold, the three talons holding respectively the Sceptre, Orb and the Romanov Sword. Supporting this, the circular gem-set purpurine base, mounted in gold, represents the Russian Imperial Shield.

Within the Egg is a blue steel globe divided into two halves, one hemisphere showing the map of the Russian Empire in 1613, the other in 1913; the blue steel represents the sea, and the land masses are described in coloured golds.

Portrait diamonds are set at either end of this Egg, the one in the top covering the Tsarina's monogram, that in the base the year.

Height $7\frac{5}{16}$ inches Gold mark 72
Signed HW
AKS plate 373
Armoury Museum of the Kremlin in Moscow.

Opposite page, centre and left :
Mosaic Egg, presented to Alexandra Feodorovna by Nicholas II. Dated 1914.

An Easter Egg, the skeleton of which consists of a system of yellow gold belts to which is applied a platinum network partially *pavé* set with diamonds and coloured gems including sapphires, rubies, emeralds, topaz quartz and green (demantoid) garnets in flower patterns. The Egg is divided into five oval panels by these gold belts which are set with half-pearls within lines of opaque white enamel and five brilliant diamonds are set at each intersection; it is further decorated by grilles of rose diamond scrolls and the rounder end is set with a moonstone beneath which may be seen the gold initials of the Tsarina in Russian characters inlaid in an opaque pale pink enamelled plaque serving as a foil.

The surprise concealed inside, and held in place by two gold clips, consists of a gold, pearl and translucent green and opaque white enamelled pedestal set with diamonds and green garnets and surmounted by a diamond Imperial Crown, supporting an oval plaque. On one side of the plaque is painted, in pale sepia *grisaille* enamel, the profiles of the five Imperial children against a background of engraved vertical parallel lines enamelled opalescent *rose Pompadour*. The reverse is enamelled with a pale sepia basket of flowers against a pale green background, around which the year 1914 and the names of the children are painted in sepia on the opaque ivory enamelled border. Designed as a jewel, this beautiful Egg was made in Holmström's workshop and is engraved with the name К. ФАБЕРЖЕ, but underneath the pedestal, in addition to the sun-in-splendour design, the words G. FABERGE, 1914 have been engraved, presumably by a later misguided hand.

Height of Egg $3\frac{5}{8}$ inches
Height of pedestal 3 inches
HCB plate 51 and colour plate 52
AKS colour plates LXXIX and LXXX
From Queen Mary's collection. Her Majesty the Queen.

Right :
Easter Egg enamelled pale translucent pink and opaque white on a yellow gold *guilloché* surface with twelve reserved panels. Each panel with a painted enamel motif in pale violet and divided by broad bands of opaque enamelled Indian red roses and translucent green enamel leaves on a dull granulated gold field, and set with rose diamonds. The initials of Barbara Kelch appear under a portrait diamond set in the top; the year of its presentation, 1899, under another portrait in the base. The surprise, that was once inside has been lost.

Barbara Kelch was a wealthy eccentric woman whose doting husband, Alexander Ferdinandovitch Kelch, presented her with Easter Eggs quite on a par with those given by the Tsar.

Height $3\frac{1}{2}$ inches No gold marks
Signed MII
AKS colour plate LXXXIII
From Queen Mary's collection. Her Majesty the Queen.

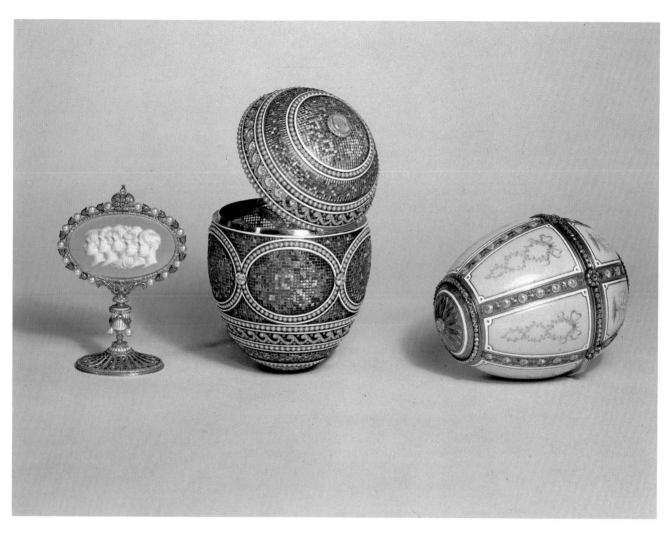

Steel Military Egg. Presented to Alexandra Feodorovna by Nicholas II
in 1916. In steel, this war-time Egg bears the crowned initials of the
Tsarina and the year in gold, and is poised on the points of four miniature
artillery shells ringed with yellow gold bands set vertically on a nephrite
base. Within the Egg, which is surmounted by the Imperial Crown in
yellow gold and is circumscribed by two red gold bands, a white gold or
steel easel supports a gold frame enamelled with an opaque white line
and cross, containing a miniature painting by Zuiev showing the Tsar
and his son conferring with the staff generals at the Front. Eugène
Fabergé said this Egg was originally executed in blackened steel, but the
surface now has the appearance of brightly polished steel or silver.
A banal example of Kitsch.
Height 4 inches Gold mark 72 Signed HW
AKS plates 383, 384 Armoury Museum of the Kremlin in Moscow.

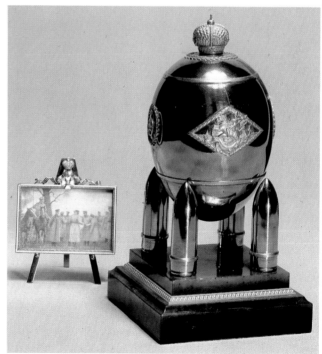

In Retrospect

The first objects by Fabergé I ever saw were those brought back from Russia half a century ago by my father, Emanuel Snowman, who enjoyed arranging them with great care on the mantelpiece and bookshelves of the morning room of our house in Hampstead for his family to admire. These informal and unforgettable exhibitions were the culmination of much comfortless travelling, a great deal of protracted negotiation with the Antiquariat Departments of the Soviet Union and a lot of initiative.

On these occasions, our home was momentarily transformed, as if by magic, into a dazzling *schatzkammer*. Only ten years before, many of those very flowers in crystal pots, those carved stone animals and birds and enamelled Easter Eggs and boxes, had been casually disposed about the opulently furnished salons of Tsarskoe Selo, Gatchina, Livadia and the other Imperial Palaces—the irony was inescapable.

It was, I am persuaded, as a result of this early acquaintance with the products of Fabergé and his competitors that I became so fascinated by the whole subject of the applied arts in Russia.

The actual buying was always a delicate process which called for inexhaustible patience and understanding. One lesson learned at some cost by my father, during his first visit in 1925, was never forgotten and demonstrates very clearly the rather unconventional business methods of the new regime. In Moscow, he had bought a large gilded and painted Imperial Factory standing vase for £80 from the government department which dealt with the disposal of confiscated national treasure. Two days later in Leningrad, the equivalent department there offered him a second vase for what amounted to £200. It was clear that this second example, identical in design to the first, completed what must originally have been a pair. 'Why so much?' he protested, explaining that he had acquired its twin only two days before in Moscow for £80. Upon receipt of this intelligence, the three Government Inspectors on duty conferred anxiously between themselves and withdrew into another room for the rest of the morning before eventually emerging in triumph. 'You are

Carl Fabergé, with his son Eugène, photographed at Pully near Lausanne in July 1920, two months before he died.

quite right Mr Snowman, we have checked and you owe us £120 on the first vase.' The debt, needless to say, required prompt payment for further business to take place.

At that time, the Bolsheviks were selling up their heritage with a will. Quite apart from some of the most sublime paintings (which were sometimes disposed of under a strict seal of secrecy), they sold historic jewels, silver and gold plate, works of art, porcelain, icons, rare stamps, manuscripts, books, carpets, tapestries, valuable furs—everything of value down to the very napery from the Imperial tables and the hand towels with embroidered crowns from the Royal bathrooms.

Indeed, the objects by Fabergé represented but a small fraction of the collections which were dispersed during the 'twenties and 'thirties. When they arrived in London, it was above all Queen Mary who, so to speak, again took up the thread of Royal patronage and continued to buy, fixing her eagle eye on several dramatic items to add to an already impressive Palace collection. The smaller accoutrements designed in St Petersburg were no less beloved by the Queen, as may be learned from the perceptive portrait of her in a poem by William Plomer.

> . . . Straight as a doll,
> Clear as a coloured photograph,

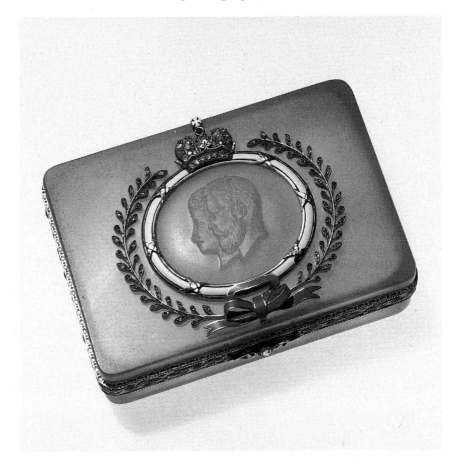

Imperial Presentation Box in pale grey-brown translucent agate mounted in gold, the bezel with a broad granulated yellow gold border decorated with raised *cloisons* of translucent emerald-enamelled leaves over engraved veining and opalescent scarlet and opaque white-enamelled pellets. The thumbpiece is composed of a rose diamond set between two chased red gold scrolls. The hinged cover is applied with an oval cameo in the same stone carved with the profile portrait heads of Nicholas II and Alexandra Feodorovna within an opaque white-enamelled frame mounted in red gold with chased crossed-over ribbon motifs surmounted by the Imperial Crown set with brilliant diamonds and a cabochon ruby. An opaque cerulean blue *champlevé*-enamelled bow under the cameo forms the centre of a laurel wreath of rose diamond leaves and cabochon ruby berries.
Length 3½ inches Gold mark 72
Signed HW

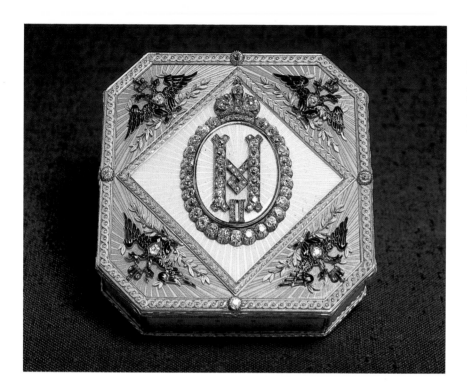

Presentation box in engraved yellow gold with red and green gold chased mounts, enamelled translucent yellow and opalescent white and set with the crowned cypher of Nicholas II in brilliant diamonds with a diamond border surrounded by four Imperial double-headed eagles enamelled opaque black.
$3\frac{3}{16}$ inches square Signed MП
AKS colour plate IV
Victoria & Albert Museum.

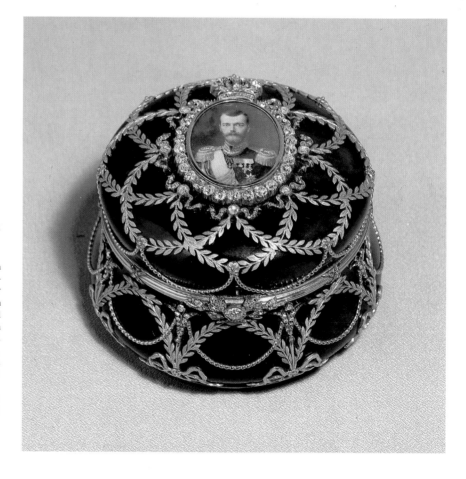

Imperial box in Siberian jade. Mounted with a reeded red gold bezel tied with rose diamonds. The unusually large and slightly *bombé* body profusely decorated with green gold foliate swags and red gold bows and beaded ties; the latter interspersed with rose diamond-set terminals, the lid mounted with a painted miniature of Nicholas II, signed by Vassily Zuiev, surmounted with a crown set with brilliant-cut diamonds and framed with brilliant diamonds.
From the collection of the Dowager Tsarina Marie Feodorovna. Fitted in the original Imperial red leather case.
Diameter $3\frac{1}{4}$ inches Signed HW
The Duchess of Alba, Madrid.

Top:

Presentation box in gold, enamelled on cover and sides in translucent blue-grey over engraving, and mounted with a chased green and red gold border. The hinged cover is applied with a miniature portrait of Nicholas II within a rose diamond frame surmounted by the Imperial Crown in brilliant and rose diamonds and the sunray panel of blue-grey enamel is bordered by a broad pattern enamelled opalescent oyster, set with ten brilliant diamonds at intervals and edged on either side by rose diamonds. The Tsar gave this box to General Trepoff.

Length 3¾ inches Gold mark 72
Signed HW
HCB colour plate 7

Bottom:

Gold presentation box with all its rectangular sides enamelled opalescent oyster with a hint of flame over *guilloché* grounds and bordered by a fine line of opaque white enamel, the main borders in granulated gold 'jewelled' with opalescent enamelled pellets and translucent emerald leaves in sprays centred by ruby enamelled lozenges. The hinged cover with an oval plaque bordered by Vitruvian scrolling enamelled opaque white over a translucent red ground, is set with an enamel-painting *en grisaille* heightened with sepia of the Peter the Great monument signed and dated by Zuiev, 1913. The box is mounted with a brilliant and rose diamond thumb-piece.

Length 3⅝ inches Signed HW
HCB colour plate 7

For three seconds stood one Queen
From toque to toe illustrious
In the pale petal colour called glycine.
Her left hand light upon a shape of jade—
Contrived by Fabergé in Nineteen-Ten
To top just such a wand-thin parasol—

Most people who care for the arts will agree that the least interesting attribute of any art object is its cost. There are many others (and I do not refer exclusively to the Press) who do not subscribe to this view. There is, to be sure, historical interest in any really sensational rise in the valuation (if not the value) of works which have come down to us and are available for examination.

К. ФАБЕРЖЕ
ПРИДВОРНЫЙ ЮВЕЛИРЪ.

С.-Петербургъ.
Москва. ✳ Одесса.
Лондонъ.

——✳——

C. FABERGÉ
JOAILLIER DE LA COUR.

St. Pétersbourg.
Moscou. ✳ Odessa.
Londres.

——✳——

173. New Bond Street,

London, W. 13th January *19*14.

To:- Mr. Thomas,

Secretary of The Hampstead General

& North West London Hospital.

HAMPSTEAD. N.W.

Dear Sir,

 I beg to inform you that, in accordance with the in-

structions of H.I.H. The Grand Duke Michael Michaelovitch, I have

to-day sent you by registered letter post a silver cigarette

case with gold monogram.

 I beg to remain,

 Dear Sir,

 Faithfully yours.

 p.p. C. Fabergé.

Harry C. Bainbridge

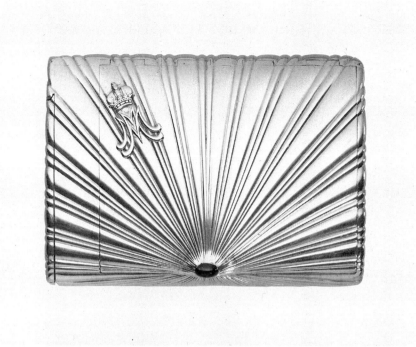

Silver cigarette case with a reeded sunburst pattern, a match compartment, cabochon sapphire thumb-piece and applied with the gold monogram of the Grand Duke Michael Michaelovitch. This is the case referred to in the letter which is reproduced on the opposite page.
Length 3¾ inches Signed A * H
Stamped for the English market.

It is, for example, intriguing to see in old Wartski stockbooks of the 1920s page after page of stone animal carvings by Fabergé costing then between one and five pounds apiece.

We learn that on 26th November 1927 Queen Mary bought the miniature grand piano (page 134) for £75, and on 12th October 1929 Her Majesty acquired the Colonnade Egg (page 105) for £500.

Wartski had paid £1100 in Leningrad for the celebrated collection of eleven Russian figures composed of semi-precious stones which Sir William Seeds acquired from them in 1941. Ten of them are illustrated on page 72. Sir William parted with one of them some years before he died.

Just one figure, the *Dvornik* (Houseboy) sold under the hammer at Sotheby in Zürich on 23rd November 1978 for the equivalent of £34,941. Wartski had sold this same figure to Arthur Bradshaw in 1937 for about £300.

I still have a copy of Christie's catalogue of 87 Fabergé objects which they sold at auction on 15th March 1934: lots 55 and 86 fetched respectively £85 and £110—they were The First Imperial Easter Egg and The Resurrection Egg, both illustrated on page 90.

The only really useful lesson to be learned from all this would seem to be that art works of the highest quality have usually proved a better bet over the years than many of the less captivating investments available to the hopeful punter in, for example, the stock market.

That is why any merchant worth his salt who deals in art objects, when asked—as he so often is—whether a proposed purchase represents a good investment, has only one honest

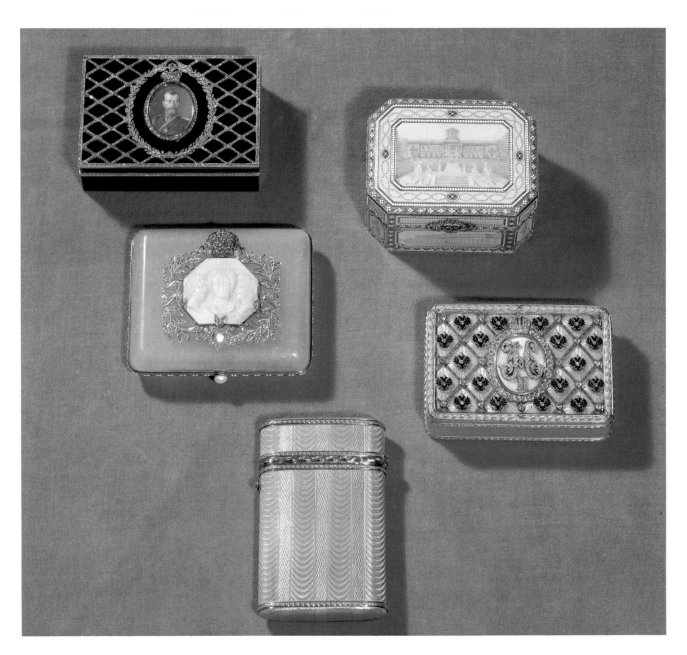

Five boxes photographed when they formed part of the Lansdell K. Christie collection.

Top left:
Presentation box. Nephrite with red and green gold chased mount, the cover enriched with a rose diamond woven trellis set in silver, and a foliate wreath containing a miniature painting of Nicholas II by Zuiev within a border of rose diamonds and surmounted by a diamond crown.
Length $3\frac{3}{4}$ inches Signed HW
HCB plate 125 AKS plate 130
Forbes Magazine collection, New York.

Top right:
Rectangular musical box in gold with chamfered corners featuring enamel-painted panels of six palaces owned by the Youssoupoff family in pale opalescent sepia. The lid shows the Archangelskoe Palace, and the front panel, the residence on the Moika Canal in St Petersburg where Rasputin was put to death by Felix Youssoupoff, one of the two sons whose initials appear on this box. The pictures on the lid and bottom are painted in enamel over a sun-ray pattern; the others are painted over a background of parallel lines. The borders are enamelled with opalescent beads and translucent emerald leaves on *sablé* paths. The initials of Felix and Zénaïde and their two sons, Nicholas and Felix, are painted beneath Imperial crowns at the four corner panels. The diamond thumb-piece is composed of the numerals XXV. This box was presented to the Prince and Princess Youssoupoff on their twenty-fifth wedding anniversary.
Length $3\frac{1}{2}$ inches Gold mark 72
Signed HW
HCB plate 3 AKS colour plate VIII

Centre right:
Coronation presentation box in red gold, enamelled translucent chartreuse yellow on sunray and wave-patterned grounds, with chased green gold husk borders, the cover mounted with a brilliant diamond-set trellis with **opaque black-enamelled Romanov double-headed eagles** and, at the centre, the Imperial cypher of Nicholas II within an oval crowned border, all in brilliant diamonds, applied to a panel engraved with a sunray and enamelled opalescent oyster. This sumptuous box was given by the Tsarina to her husband on Easter Day 1897, the day she received the Coronation Egg.
Length $3\frac{5}{8}$ inches Signed AH
Gold mark crossed anchors
AKS colour plate I
Forbes Magazine collection, New York.

Opposite page, centre left :
Box of carved bowenite. Double-opening, red gold bezel decorated with *cloisons* enamelled as opalescent pellets and translucent red diamond shapes and set with a pearl thumb-piece. The cover is applied with an octagonal opal carving of the Tsarina and her two daughters Olga and Tatiana. The portraits are bordered by rose diamond-set leaves surmounted by a Romanov eagle.
Length 3¾ inches Signed МП
HCB plate 109

Opposite page, bottom :
Box of translucent love-bird green enamel on a *guilloché* pattern of scallops on silver and decorated with chased mounts in red and green golds and a wavy flange in the Louis XV taste with a moonstone push-piece.
Length 3¾ inches
HCB colour plate 80 AKS colour plate XXII

Six cigarette cases photographed when they formed part of the Lansdell K. Christie collection.

Top left :
Red gold, with match compartment enamelled translucent steel grey over a *moiré* ground with granulated borders decorated with translucent emerald enamelled leaves alternating with opalescent pellets and a rose diamond thumb-piece.
Length 4 inches Signed HW
HCB plate 111

Top right :
Mounted in reeded red gold and enamelled translucent Parma violet over an engine-turned pattern of the flights of arrows on silver, the tinder attachment has the unusual feature of a stopper of bun form (as opposed to the more usual acorn) which is enamelled *en suite*

with the case itself. The cypher of King Christian IX of Denmark appears within the case.
Length 4⅛ inches Signed МП

Centre left :
Carved nephrite of flattened oval form with three diamond 'frost' mounts serving as hinges and clasp. This particular motif was a favourite of Dr Emanuel Nobel for whom this case was designed. He was a nephew of the Swedish inventor Alfred Nobel.
Length 3½ inches
Signed FABERGE (engraved)

Centre :
Red gold, enamelled translucent royal blue over engraved scallop-patterned fields with granulated gold borders enamelled opaque white and translucent red and green with
(continued on page 124)

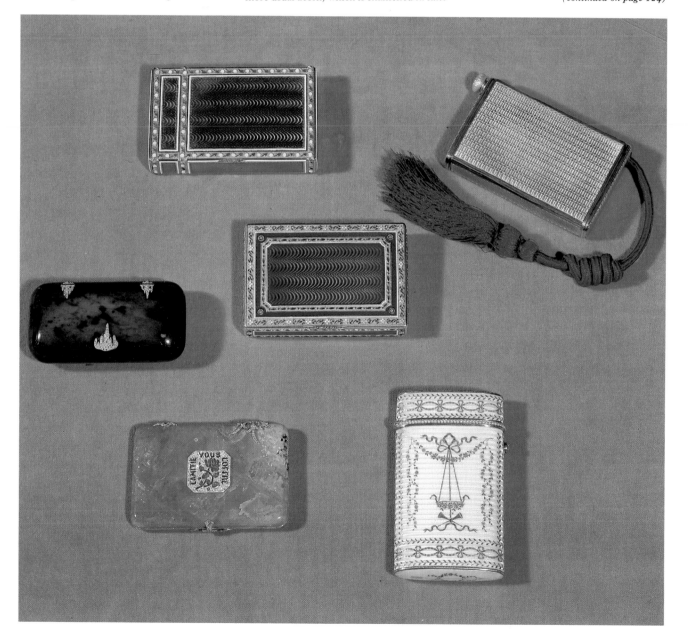

reply. He should say he has not the slightest idea—he is an art dealer, not a stockbroker, an auctioneer, a banker or a fortune-teller. He believes in and likes the article he bought—that, indeed, is why he bought it. Whoever it may be can then be invited to share his own belief in and admiration for it.

Although it is possible, even essential, to value objects on a basis of comparison with earlier transactions involving similar objects, I have personally found it difficult ever to detect any real connection between a work of art and a sum of money. On another plane, Milton is said to have received £13.9.6d. for *Paradise Lost*. Perhaps we are all inclined to take the economics too seriously.

The tradition of collecting for its own sake was carried on by George VI and Queen Elizabeth with notable success, and Queen Elizabeth II and the Royal Family today are no less enthusiastic and discriminating.

Up to the time of his death in July 1954, I had the enormous benefit of the friendship of Henry Bainbridge, Fabergé's man in London, and his advice and recollections were invaluable to a young man trying to reconstruct a picture of this extraordinary Russian enterprise

Eugène Fabergé was also readily available to answer questions and provide authentic information about the way the great House functioned. He told me that there was a special room set aside in the Palace where a wide range of the firm's objects were kept so they would be available as presents when the occasion arose. Eugène went there every month to take stock, to prepare bills for anything that had been taken and to replenish the collection.

Bainbridge has himself picturesquely defined his own role in all this: 'I found myself amidst a whirl of Kings and Queens, millionaires and maharajahs. Fabergé objects were then passing through my fingers as fast as shoals of glistening herrings pass through the sea and all I had to do was to look immaculate and say nothing.' (*Peter Carl Fabergé* by Henry Charles Bainbridge, Batsford, 1949.)

The Fabergé scene at that time was enlivened by the presence of a number of 'originals', notably one particular gentleman, Henry Talbot de Vere Clifton, the Squire of Lytham St Anne's in Lancashire, who threw an Imperial Easter Egg (the one I have called the Rosebud Egg) in fury at his American wife, a performance which did little to improve relations between the two of them or indeed the condition of the Egg itself. Mr Bainbridge once told me that he had actually been kicked downstairs when visiting this particular connoisseur at what would appear, in retrospect, to have been an inopportune moment.

The late Marquis of Anglesey, another enthusiastic Fabergé collector, designed for himself a ping-pong shirt elaborately studded with emeralds set in platinum. My father assured me

(continued from page 123)
opalescent pellets. The thumb-piece is set with rose diamonds.
Length 3¾ inches Gold mark 72
Signed HW

Bottom left :
Double-opening form in carved rhodonite, the gold-mounted hinges and clasp are set with rose diamonds. An octagonal diamond plaque applied to the cover displays a rose and the legend *L'amitié vous l'offre.* Compare with a similar example in the British Royal Collection, shown in colour by Bainbridge on colour plate 117, and which is signed HW.
Length 3½ inches Marks, if any, not known

Bottom right :
Enamelled opalescent oyster over a wavy engraved ground with coloured *paillons* in a décor reminiscent of Salembier, with red gold mounts, a border of half-pearls and a brilliant diamond push-piece.
Length 4 inches Signed МП
AKS colour plate XXII

Medal struck to celebrate the Year of the Pig, presented on the occasion of the 50th birthday of Queen Sawabhapongse, the wife of King Chulalongkorn, Rama VI of Siam. The ribbon, carried out in gold, is enamelled translucent blue over *guilloché* ground with the year 2456 (1913) reserved on a band from which hangs the medallion painted in enamel with two pigs. The majority of the medals presented bore only a single pig, but those who were born in the same year as the Queen received a medal with two pigs. The wording on the reverse of the medallion translates 'Don't forget to regard the pig.'
Signed ФАБЕРЖЕ Height 3⁷⁄₁₆ inches
Mr Douglas A. Latchford, Bangkok.

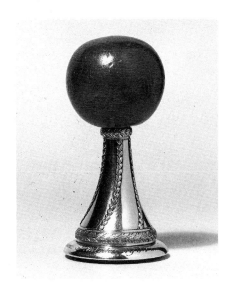

Hand-seal in burnished red gold, the stem of trumpet form, decorated with borders and trails of chased green gold laurel, supporting a single lead shrapnel shell pellet. A sealing stone of white chalcedony is set in the base which bears the engraved inscription in Russian: 'Recalling the Salute of 6th January 1905.'

Since the time of Peter the Great, every January 6th (Epiphany), a Household Guards Regimental parade, including a gun salute, took place on the frozen Neva facing the Winter Palace. The Emperor, his Family and Suite, watched the parade from behind the windows of the Winter Palace. At this ceremony in 1905 – the year of the first Russian Revolution – the first Battery of the Guards Horse Artillery was on parade. As the salute was fired, the shell of No 1 gun proved to be live instead of blank. Shrapnel pellets hit and damaged the Winter Palace façade. One pellet shattered the window of the Emperor's study behind which the Tsar Nicholas II was standing watching the parade and fell at his feet. Grand Duke Nicholas Nicholaievitch (the younger) standing next to His Majesty picked up the pellet. He got Fabergé to mount it as an Imperial seal and presented it to His Majesty as a souvenir of the occasion.

As a result of this incident, which finally seems to have been proved a ghastly mistake and not premeditated, the officers commanding the Brigade and Battery, and all battery officers, were severely reprimanded and transferred out of the Guards or dismissed from the service. Captain Davidoff, commanding No 1 gun, was imprisoned in the notorious Peter and Paul Fortress until his release was ordered by the Emperor.

Height 2½ inches
Signed with ill-defined initials HW
Prince and Princess Michel Cantacuzène, Paris.

that his Lordship was persuaded that wearing this garment immeasurably improved his game.

Mrs Violet Van der Elst was not only a passionate and active fighter for the abolition of capital punishment, but also a collector of Fabergé's work. She would, however, only receive visitors in the middle of the night in her bedroom and was guarded at all times by a posse of ferocious Great Danes of impressive stature—two circumstances which would not normally be regarded as essential for the transaction of business.

Another nocturnal collector, a Mr Blair of Llandudno, would only decide to acquire a new item if the lunar conditions were absolutely right. This gentleman, clad in a long tweed overcoat and armed with an ancient musket, would disappear for some considerable time into his high-walled garden with the object under review and commune with the spirits before returning through the French windows of his library with a decision which was never to be questioned.

Henry Hill, of Berry-Hill in New York, who were also involved in buying Fabergé objects before the war, has told me of an encounter which exemplifies the pathos that was inevitably attendant upon some of these transactions. Around 1937, he had picked up the scent, in the way successful antique dealers do, of the possible availability of the sumptuous Coronation Box (page 122). An impecunious and rather lame Russian emigré journalist by the name of Bamm had brought this splendid object out of Russia with him to Vienna. A meeting was arranged, and in due course an old taxi cab drew up outside the Safe Deposit of the Kredit Anstallt; it waited while Bamm limped off and finally reappeared with a small brown paper parcel. He wanted £300 for the box and Hill decided without hesitation to buy it. How would he like to be paid? In pounds, dollars, Swiss francs or what? Austrian schillings, came the answer. 'You surely don't want such a weak currency?' 'Unfortunately,' he said, 'I have to eat.' A little later, my father bought the box from Hill and sold it to Arthur Bradshaw who had a magnificent collection at his home in Steeple Aston near Oxford. Bradshaw was an enormous ruddy-faced extrovert of great taste and charm, who owned and ran the Taylor Walker breweries. Eventually Lansdell K. Christie, another engaging personality, who lived on Long Island, acquired the box from Alexander Schaffer, an early Fabergé pioneer who owned *A la Vieille Russie* in New York, a firm now vigorously carried on by his family. Lansdell hugely enjoyed dispensing lavish hospitality at, among other retreats, India House in the Wall Street area, an institution which he rightly designated 'a gen'leman's joint'. His unusually representative collection, which I have illustrated and described in some detail in *Great Private Collections* (Weidenfeld and Nicolson, 1963) was displayed

Four items from the collection of Lansdell K. Christie photographed at his Muttontown, Long Island, home.

Left to right :

Spray of raspberries in carved rhodonite and chrysoprase with nephrite leaves and stalks in lightly engraved red gold placed in a carved rock crystal vase.
Height 6 inches

Watering-can with a gold handle and a rose enamelled translucent strawberry on an engraved ground. Nephrite one-piece carving, set with rose diamond borders. Originally part of the collection of Elizabeth Balletta of the Imperial Michel Theatre.
Length $4\frac{1}{8}$ inches
AKS colour plate XXIX
This object is now part of the Forbes Magazine Collection.

Cornflowers in pale yellow gold, the flower heads enamelled opaque blue, set with small brilliant diamonds. With engraved stalks and buds, in a carved rock crystal pot.
Height 8 inches

Dandelion in engraved green gold with two carved nephrite leaves, the 'puff ball' composed of strands of asbestos fibre, spun platinum and rose diamonds. It is poised in a carved rock crystal pot.
Height $5\frac{5}{8}$ inches
AKS colour plate LXIV

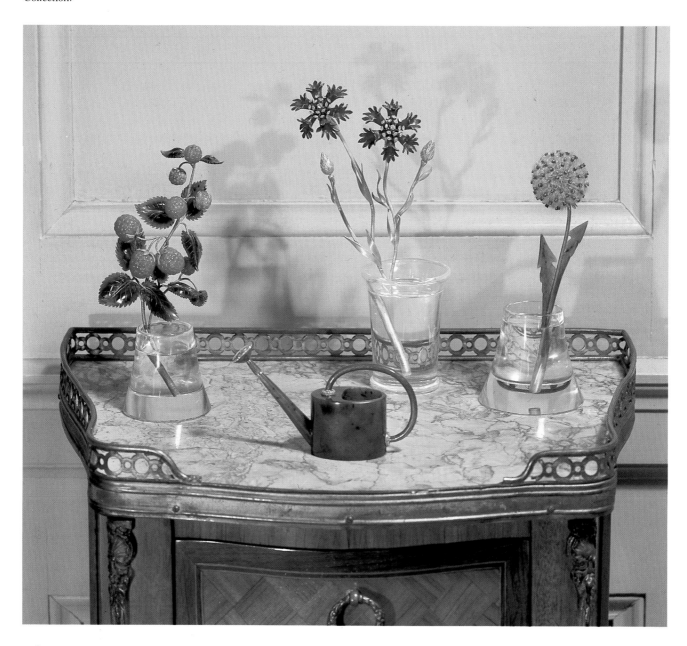

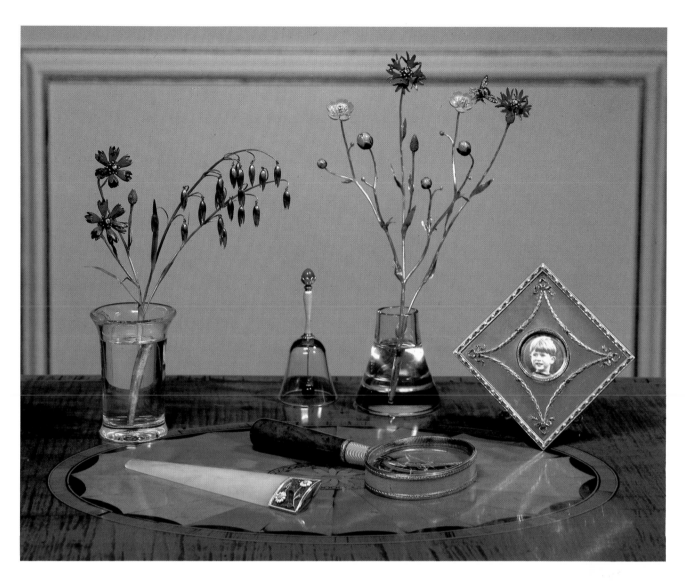

This group of objects was photographed in Clarence House by gracious permission of Her Majesty Queen Elizabeth, the Queen Mother.

Spray of gold cornflowers enamelled translucent blue and set with brilliant and rose diamonds, with a freely swinging stem of oats in dull gold, both in a rock crystal vase.
Height $7\frac{15}{16}$ inches
HCB plate 35 AKS plate 285

Rock crystal hand-bell with a waisted handle enamelled opalescent oyster over an engraved ground, with reeded red gold mounts and a finial of chased green gold leaves holding a large Mecca stone. The clapper is composed of a nephrite ball.
Height $3\frac{3}{8}$ inches

Spray of buttercups in gold enamelled translucent yellow and green over engraved grounds, and cornflowers enamelled translucent blue with diamond centres, with green gold stalks and leaves in a rock crystal jar. A diamond, ruby and black-enamelled bee in red gold is poised on one of the buttercups.
Height 9 inches AKS plate 304

Bowenite strut frame with a red gold border enamelled with alternating translucent red lozenges and opalescent pellets, applied with chased green gold laurel swags with red gold bows and ties and containing a photograph of His Royal Highness, Prince Charles, as a child.
$3\frac{1}{8}$ inches square Signed MΠ

Bowenite letter opener with a red gold engraved mount enamelled translucent strawberry applied with two daisies enamelled opaque white and translucent amber and emerald.
Length $5\frac{15}{16}$ inches Signed MΠ
AKS plate 193

Red gold reading glass with a tubular nephrite handle, enamelled translucent pale rose over

engraved swags with chased green gold laurel borders.
Length $5\frac{7}{8}$ inches Signed HW

Pair of red gold cuff-links, in the form of dumb-bells, each of the four enamelled translucent royal blue over engraving within rose diamond borders and set at either end with rock crystals cut cabochon.
Length of each link $\frac{7}{8}$ inch Signed AT
His Royal Highness the Prince of Wales.

as a loan at the Metropolitan Museum. It later dispersed when, far too young, he died. It formed the basis of the extraordinary group of objects, especially Easter Eggs, assembled by Malcolm Forbes, the dynamic and public-spirited head of *Forbes Magazine.*

Matilda Geddings Gray of Lake Charles, was an outstanding connoisseur whose real home was the entire globe—this indomitable lady, known throughout Louisiana as Aunt Matilda, was decorated by General de Gaulle in recognition of her courageous activities during the war. She surrounded herself with beautiful things, notably the astonishing basket of lilies of the valley on page 84, and an army of good friends who miss her.

Henry Bainbridge's book *Peter Carl Fabergé* a biographical and partly autobiographical record containing much valuable source material was published in 1949, and Wartski, then of Regent Street in London before their move to Grafton Street, put on an exhibition of Fabergé's work which was opened by Sir Sacheverell Sitwell and aroused great interest.

My father and I were putting the final touches to this display, quite late in the evening before the opening day, when an immaculately tailored wraith suddenly appeared as if by magic on the shallow staircase leading down into the main gallery—it was Prince Felix Youssoupoff. He had come, he announced, to wish us luck in our enterprise. After an exhaustive examination of every show case, the visitation ended with the murmured words which gave us such pleasure: 'My old friend Carl Gustavovitch would have rejoiced to see his wares so diligently set out.'

As the late Sir Harold Nicholson put it during the course of a long article in *The Spectator* of 25th November 1949: 'The queue in which I waited . . . was a cultured queue. At the head of this static procession I observed a woman of extreme elegance with real pearls about her neck; at the tail of the procession was an eminent physician, exquisitely arrayed and rich in experience and honours. We were waiting, at the door of a jeweller's shop, to enter, two by two, the exhibition of the works of Carl Fabergé.'

He went on to describe his visits to the famous House in St Petersburg: 'I recalled that well-lighted shop beyond the wide arch which led from the square of the Winter Palace at St Petersburg. The snow in the roadway was the colour of sand; the snow which edged the deep red pediments and lintels of the Winter Palace was dazzling white. The feet of the horses in the roadway made a rapid muffled sound; the feet of the pedestrians upon the pavement flopped and slopped in snow-boots or galoshes. One thus pushed the door and entered the warm and brilliant shop of Carl Fabergé.'

The Coronation of Queen Elizabeth II in 1953 occasioned another Wartski exhibition—this time of 116 objects chosen

A Press luncheon at Wartski in Regent Street in 1949 during the first representative exhibition of Fabergé's work. Standing at the back, from left to right: Sir Sacheverell Sitwell, H. C. Bainbridge, Lady Sitwell, Emanuel Snowman, M.V.O., O.B.E. and Maurice Collis.

from Sandringham, plus other Royal loans, all of which were seen for the first time by the public, apart from ten examples which had previously been lent by H.R.H. Princess Victoria to the Russian Exhibition held at 1 Belgrave Square in 1935.

The Cairo sale of Fabergé objects which had been the property of King Farouk, held in March 1954 in his *crème-de-menthe* carpeted Palace, proved to be a significant milestone in the development of this particular market and the unconventional and often hilarious manner of its procedure might bear recalling. I wrote for *The Sunday Times*:

'In front of the Koubbeh Palace, where Farouk's treasures are being sold, a stretch of lawn gay with marquees and tables sheltered by large coloured sunshades presents a festive appearance, not far removed from the Members' Enclosure at Wimbledon, or a gouache by Dufy. But the military band whirling briskly through its limited repertoire of waltzes and tangos, all served with an unmistakably Islamic flavour, and the endless comings and goings of soft-footed Sudanese

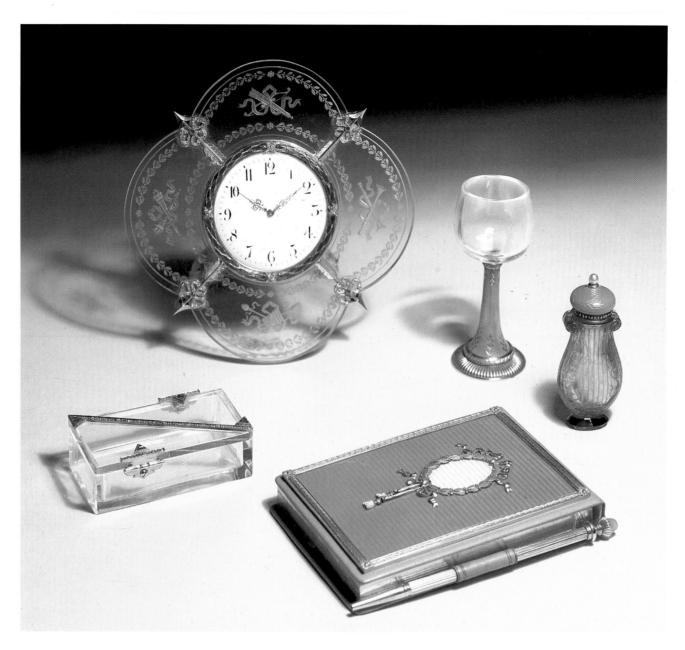

Top, left to right :

Table clock in rock crystal engraved with trophies, the opaque white-enamelled dial framed by a red gold border chased with leaves enamelled translucent emerald with rose diamond ties. The four lobes of the clock are divided by gold arrows with rose diamond bow-knots set with cabochon ruby centres. The hands are of engraved and pierced red gold and the curved strut is of reeded silver. The clock which was given by Alexandra Feodorovna to Queen Victoria, had its permanent place on the desk of George V.

Height and width $4\frac{15}{16}$ inches Signed МП

AKS plate 146

Wine glass with red gold sunray fluted base and green gold chased laurel border, the trumpet-shaped stem enamelled opalescent pink over a *guilloché* ground with single sprigs of green gold reserved leaves. The bowl is of carved rock crystal.

Height 3 inches Signed МП

Engraved scent bottle, in the form of a lyre, made of smoky crystal-quartz, with red gold mounts and set with rose diamonds, the top enamelled translucent pink and surmounted by a pearl finial.

Height $2\frac{9}{16}$ inches Signed МП

Gold mark crossed anchors

Bottom left :

Rock crystal rectangular box, the two hinged lids opening diagonally at the top, with yellow gold mounts set with four triangular-cut cabochon rubies.

Length $2\frac{1}{2}$ inches Signed МП

Gold mark crossed anchors

Bottom right :

Rectangular writing-block cover, in red gold and leather with a chased green gold border and an elaborate oval chased foliate miniature frame with ribbons and tassels and set with two small rose diamonds, applied to the main area which is enamelled translucent pink over a *guilloché moiré* ground. The pencil, in reeded red gold, is set with a blue Mecca stone knop.

Length 4 inches Signed HW

AKS plate 188

Parasol handle, designed as a nephrite carving of a frog with rose dia-
mond eyes set in gold, climbing a tubular column enamelled trans-
lucent emerald green over *moiré* engraving, mounted at its base with a
chased red and green foliate border within bands of opaque white
enamel.
Height 4½ inches Signed HW

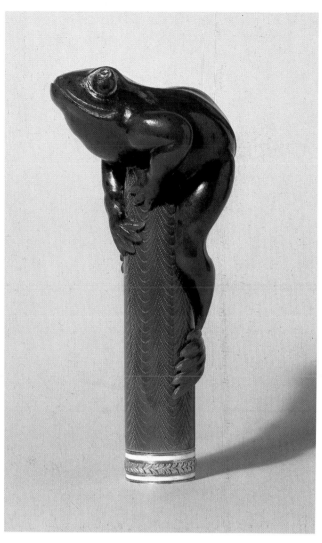

Spray of lilies-of-the-valley. The stalk in lightly engraved yellow gold
with flowers in pearls and rose diamonds set in silver and a carved
nephrite leaf. It is poised in a rock crystal pot in the shape of a baluster,
carved to look as if filled with water.
Height 5 inches
Formerly in the collection of Queen Helen of Rumania.
Wartski, London

waiters in *tarbush* and *galabiyeh*, bearing sweet glutinous fluids for the delectation of buyers, remind us that we are, in fact, in the Middle East.

'Hungry kites, which hover and wheel above the sprawling yellow sports pavilion which is the Palace, find an echoing note in the small, determined coveys of antique-dealers who hover over the bright goodies on display . . . Rumour has it that all one's favourite millionaires will be arriving any minute now. . . .

'The collection as a whole is unselective. When, therefore, one comes across an occasional item which obviously held a particular personal appeal for its late owner, such as a small boy's dream of a monster penknife bristling with all manner of blades, it becomes invested with a certain pathos. Farouk fell a natural victim to the insidious charm of Carl Fabergé's work, and it is well represented here.

'The viewing had been a long, irksome and fly-blown business. It was with a sigh of relief that one jotted down the last valuation on the last agate bonbonnière . . . Wednesday was the day of the Fabergé section of the sale. Prices were good and in some exceptional cases very high. A generous selection of these pieces will be returning once again to England, their first home after leaving Russia in the twenties.'

'The man most in demand at the viewing of the sale was a rather seedy individual with a large pair of pliers. The objects were set out on the Royal book-shelves and the Palace Guards, scornfully laughing at locksmiths, ignored more orthodox methods of securing doors against prying fingers and simply drove long steel nails through the woodwork frames of the book-case doors and then applied sealing wax on top. When, therefore, any intending buyer wished to examine the lots, a general cry went up for Abdul Hamid, evidently the only man in Koubbeh Palace equipped with the invaluable pliers. It must not be deduced from this that there was any lack of

Kenneth Snowman examining an item before bidding at the Farouk Sale in Cairo, 1954.

132

personnel on duty—as a matter of fact, there were so many unshaven guards and security policemen pressing around that it was difficult to hold an object still in one's hand in order to examine it.

'They were not in any way hostile—they were, on the contrary, undisguisedly fascinated by the spectacle of so many richly be-jewelled confections, the like of which they had never seen before. As the sticky Heliopolis hours wore on, one had the impression that the ten representatives of the law present in one of the small viewing rooms were the contemporary embodiments of the ten plagues. They handled everything like delighted giggling children; so much so that the famous automatic Erotica were in time, largely bereft of movement, paralysed by sheer over-work and exhaustion.

'The sale itself was organized by the military. Quite understandably, they had about as much idea of how to run an auction sale of art objects as the Gordon Highlanders would have of taking over the management of the Stock Exchange.' Sotheby's were asked, in a purely advisory capacity, to compose the catalogue but it was not a bit like Bond Street.

Meanwhile Fabergé's popularity steadily grew. An imaginary Easter Egg described as The Terrestrial Globe, was immortalized in 1963 by Ian Fleming (a great enthusiast) in a James Bond story commissioned by Sotheby and entitled

A view of the queue outside the Victoria & Albert Museum waiting to visit the Fabergé Jubilee Exhibition, taken on 20th October 1977. The queue extended round the building as far as the Royal College of Art in Exhibition Road.

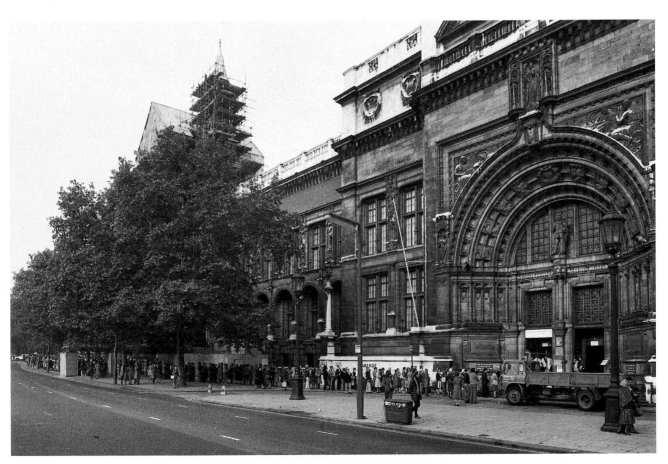

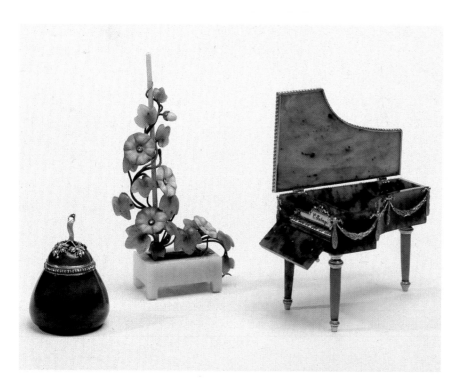

Jar and cover carved as a pear. Nephrite with red gold mounts, the finial in green gold is designed as a spray of leaves set with rose diamonds culminating in an engraved stalk.
Height $1\frac{7}{8}$ inches Signed МП
AKS plate 188

Convolvulus, in gold, growing in a bowenite trough, with two pale blue and two pink enamelled flowers with rose diamond centres, carved jade leaves; climbing up an opalescent oyster-enamelled pole set in simulated soil of gold.
Height $4\frac{1}{2}$ inches No marks
HCB plate 78

Miniature grand piano in Siberian jade, mounted in green and red gold, decorated with chased swags. When the top is opened the keyboard, composed of opaque black and white enamelled keys, is revealed; it is surmounted by a panel bearing the name C. Fabergé inscribed in sepia enamel over a background of opalescent oyster.
Length $2\frac{13}{16}$ inches Signed МП
AKS plate 281

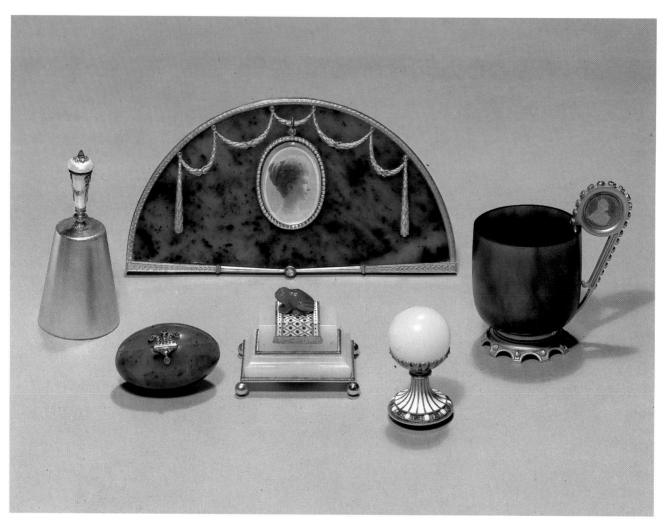

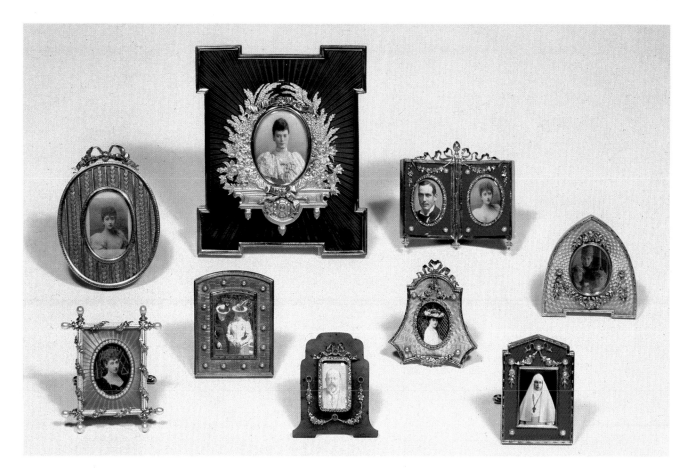

Opposite page, lower picture, top :
Demi-lune miniature-frame, designed as an open fan. Siberian jade, in yellow, red and green chased gold mounts, the 'sticks' join at a rose diamond-set pinion and the oval frame, bordered by half-pearls, hangs from a series of foliate swags. The photograph is of the Hon Julia Stonor, later Marquise d'Hautpoul. Towards the end of the 90s, the Prince of Wales, who tired easily in exclusively male company, was, according to Lady Geraldine Somerset, 'more or less in love' with Julie Stonor, the daughter of Mrs Francis Stonor, lady-in-waiting to the Princess of Wales.
Length $6\frac{5}{16}$ inches Signed МП
AKS plate 167

Other objects, left to right :
Table-bell, silver, with an engraved yellow gold handle, enamelled opalescent oyster, decorated with chased red and green gold swags and bows, and surmounted by a cabochon ruby.
Height $3\frac{1}{4}$ inches Signed К.ФАБЕРЖЕ
AKS plate 161

Box formed as an egg. Siberian jade with *fleur-de-lis* clasp and hinge as a crown in yellow gold set with six cabochon rubies and rose diamonds in silver.
Length $1\frac{3}{4}$ inches No marks

Bell-push. White onyx decorated with chased red gold mounts supported on four ball feet. The push a small nephrite carving of a frog

with rose diamond eyes, crouching on a yellow gold rug enamelled opaque white with black dots and opalescent red beads.
Length $2\frac{1}{16}$ inches Signed МП
AKS plate 188

Small hand seal in red and green golds, enamelled opaque white with translucent emerald leaves and strawberry pellets, surmounted by a white onyx ball and set with an engraved cornelian for sealing.
Height $1\frac{15}{16}$ inches Signed МП
AKS plate 146

Tall cup. Siberian nephrite mounted in dull green gold set with rose diamonds, the handle inset with a rouble of 1756 enamelled translucent strawberry colour.
Height $2\frac{7}{8}$ inches
Signed ФАБЕРЖЕ but maker's mark indecipherable.

The objects shown on this page and opposite (bottom) are reproduced by gracious permission of Her Majesty The Queen.

Above, top row, left to right :
Oval miniature-frame. Red gold with chased green gold vertical stripes of laurel overlaying an engraved field enamelled translucent pale cerulean blue, surmounted by a red gold ribbon tied in a bow-knot. It contains a photograph of Princess Maud of Wales, later Princess Charles of Denmark and Queen of Norway.
Height $2\frac{7}{16}$ inches Signed МП
AKS plate 85

Rectangular miniature-frame, with sides cut away to form squares at the corners. Red gold, enamelled translucent deep violet over a *guilloché* sunray ground. The oval aperture contains a painted portrait of the Tsarina Marie Feodorovna as a young woman and rests upon a decorative shelf supporting a lavish ribboned sheaf of flowers in four colours of gold which surrounds the miniature.
Height $3\frac{3}{4}$ inches Signed МП
Gold mark crossed anchors
HCB plate 88 AKS plate 85

Two hinged rectangular miniature-frames. Red gold with chased gold feet, surmounted by a scrolling gold ribbon forming a bow-knot with, as its central pivot, a pineapple finial. Each frame, enamelled translucent royal blue over sunray engraving, is decorated with three-colour gold chased swags and set with three half-pearls and has oval borders set with rose diamonds. The photographs are of Prince Charles of Denmark (later King

Haakon VII of Norway) and his future wife Princess Maud of Wales.
Height 1¹⁵⁄₁₆ inches Signed BA
AKS plate 85

Other objects, left to right :
Rectangular miniature-frame in red gold, composed of intersecting rods enamelled opaque white between fine gold lines each set with a pearl at either end and entwined with elaborately chased garlands in three colours of gold. The framed mount is enamelled opalescent pale pink over sunray engraving, the oval aperture is bordered by half-pearls and contains a photograph of Princess Louise (later Princess Royal), Duchess of Fife.
Height 1¹⁵⁄₁₆ inches Signed BA
AKS plate 85

Rectangular miniature-frame with a curved top. Red gold, enamelled translucent pale lilac over an engraved field and set with half-pearls. The photograph is not very clear but the subjects appear to be Alexandra, Princess of Wales (left) and Queen Olga of the Hellenes (right).
Height 1¹¹⁄₁₆ inches Signed BA

Shaped miniature-frame of carved nephrite, hung with three-colour gold garlands and swags. The rectangular aperture, bordered by rose diamonds, is surmounted by a scrolling bow-knot and the frame is set with four cabochon rubies and contains a photograph of Albert Edward, Prince of Wales, later King Edward VII.
Height 1⁹⁄₁₆ inches Signed BA
AKS plate 85

Miniature-frame with concave sides and a domed top. Red gold, enamelled translucent aquamarine over sunray engraving, surmounted by scrolling gold ribbon and hung with three-colour chased gold swags secured by four pearls. The oval aperture is edged with rose diamonds and contains a photograph of Princess Maud of Wales, Princess Charles of Denmark, later Queen of Norway.
Height 1¹¹⁄₁₆ inches Signed BA
AKS plate 85

Rectangular miniature-frame, with a triangular top. Red gold, enamelled translucent deep red over engraving and hung with

chased floral swags in golds of three colours and set with pearls. The photograph shows Elizabeth Feodorovna, Grand Duchess Sergei Alexandrovitch of Russia, possibly during the First World War, as a nursing sister.
Height 1¹¹⁄₁₆ inches Signed BA

Miniature-frame, shaped as a medieval arch. Engraved red gold, enamelled translucent green over an engraved background, it is embellished with a three-colour gold swag with garlands set with two rose diamonds. The photograph shows Alexandra, Princess of Wales, with her granddaughters, Lady Alexandra Duff (left) and Lady Maud Duff (right), the daughters of Princess Louise and the Duke of Fife. This tiny strut frame and the other six examples by Viktor Aarne are all backed with mother-of-pearl instead of the more usual ivory.
Height 1¹¹⁄₁₆ inches Signed BA
AKS plate 85

'The Property of a Lady' (now published in *Octopussy* by Triad/Panther Books, 1978). What more prestigious accolade could be contemplated?

1977, the year of the Queen's Jubilee seemed a particularly appropriate moment for a really representative exhibition at the Victoria & Albert Museum. It was offered as a tribute to the Queen and was entitled 'Carl Fabergé, Goldsmith to the Imperial Court of Russia'. Her Majesty generously allowed the Sandringham Collection to be included in this, the first demonstration on this scale of the goldsmith's work to be assembled in a National Museum. The opening was graced by the presence of Her Majesty the Queen Mother. Lady Zia Wernher, daughter of the Grand Duke Michael, and herself a distinguished Fabergé connoisseur and collector, visited the exhibition very shortly before her death.

An old friend, Hugo Wortham, the original Peterborough of the *Daily Telegraph*, had written as far back as 8th October 1949 'There is not a single example of his work in the Victoria & Albert Museum. A Fabergé exhibition at the earliest possible moment is the least that the Museum can offer to excuse this neglect.' As a matter of fact, the Museum now boasts one of Fabergé's most sumptuous Imperial gold Presentation Boxes in bright yellow and oyster enamels, lavishly set with diamonds (page 118), the legacy of Sir William Seeds, formerly British Ambassador in Moscow, and a great and endearing eccentric.

Our end of the twentieth century seems to provide less and less accommodation for really colourful characters and the memory of those whom we were privileged to know must, like the national heritage we hear so much about, be preserved and enjoyed.

Her Majesty Queen Elizabeth the Queen Mother at the Jubilee Exhibition at the Victoria & Albert Museum in 1977.

Rock crystal letter-opener with a red gold mount with a bow-knot of ribbon and pendant drop with one brilliant and four rose diamonds set in silver applied to a broad band of laurel chased in green gold. A Christmas gift from Alexandra Feodorovna to her childhood governess Margaret Jackson. In the lid of the fitted holly wood case a piece of paper was placed bearing the following inscription in the Tsarina's hand: 'For dear Miss Jackson, with loving Xmas wishes from Alix. 1900.'

It was to this same Miss Jackson, then living in London, that the Tsarina sent a ghosted letter through the English tutor, Gibbes, in December 1917 from Tobolsk and which was in reality addressed to the British Royal Family. It was no less than a desperate cry for help and contained detailed plans of the layout of the house in which the Romanovs were held prisoner.

Length $7\frac{3}{16}$ inches Signed КФ

Objects of quality are becoming increasingly difficult to find and those by Fabergé are no exception. Treasures do turn up from time to time, however, and in this particular context, one is not necessarily influenced by the intrinsic value of what has been discovered. I am thinking of the rock crystal letter-opener which is shown on this page and which the Tsarina gave to Miss Margaret Jackson, the English governess who once looked after her as a child in Darmstadt, with a charming note which happily is preserved. This modestly designed piece of desk furniture represents a shining bridge which leads us directly to the heart of the matter, the transparent crystal clearly echoing the uncomplicated wish of the giver to express her appreciation. It is an eloquent example of Carl Fabergé igniting a bright spark of pleasure between people, a function to which he appears to have dedicated his life.

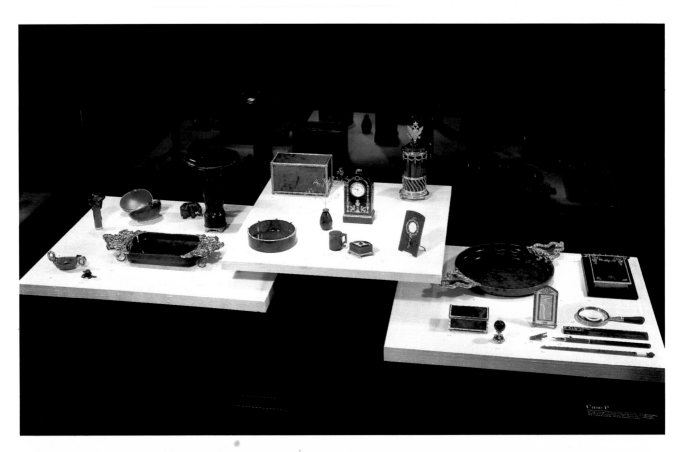

Case P

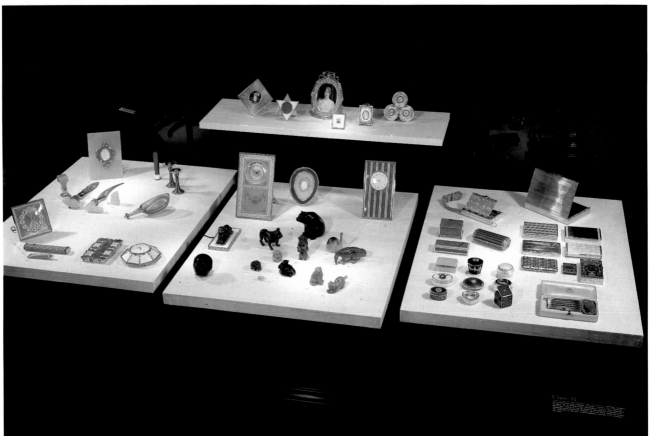

Case R

Circular brooch mounted in silver and gold, resembling a sombrero, the brim of which has a *mille grain* filigree setting of rose diamonds with, at its centre, a large cabochon moonstone.
Diameter 1 inch Signed AT

Lorgnette in reeded and engraved red gold with chased green gold laurel mounts, enamelled translucent peach overpainted with a sepia enamel trellis of leafy branches on engine-turned fields, bordered by an opaque white line and decorated with rose diamond – set cross bands.
Overall length when folded 5⅝ inches
Signed MΠ
Wartski, London

Stamp box. Silver with engraved gold mounts enamelled translucent violet over a wavy engine-turning, 'the hinged lid with an

Edward VII postage stamp framed within a reeded border. The floor of the interior of the box is sloped to the front to facilitate the removal of the stamps.
Length 1 7/16 inches Signed HW
Mr D. Richard Bowen.

Handle for a riding crop enamelled translucent bright yellow over a *guilloché* ground with red gold borders at either end embellished with chased green gold laurel. Works by this early workmaster, Wilhelm Reimer, are rarely found.
Length 1⅝ inches Signed WR
Gold mark crossed anchors
Wartski, London

Rectangular panel brooch. Red gold enamelled translucent rose over a *guilloché* ground with an applied chased green gold leaf and berry mount set with a rose diamond. It has a border of translucent grass green lozenges

and scarlet beads. The back is deeply engraved with a sunburst pattern.
Length 1 3/16 inches Signed A * H
Gold mark crossed anchors

Parasol handle of tapering form designed as a quiver of arrows in bowenite and gold, set with rose diamonds and bound with a crisscross pattern of ribbon in chased red gold and a border of chased green gold laurel.
Length 3⅜ inches Signed MΠ
Wartski, London

Combined pencil-holder and magnifying glass in red gold with chased green gold laurel borders, enamelled translucent strawberry over a *moiré* engine-turned background. The pencil may be slid out by means of an oval rose diamond and moonstone cluster mount.
Length 3 inches Signed MΠ
Gold mark crossed anchors
Wartski, London.

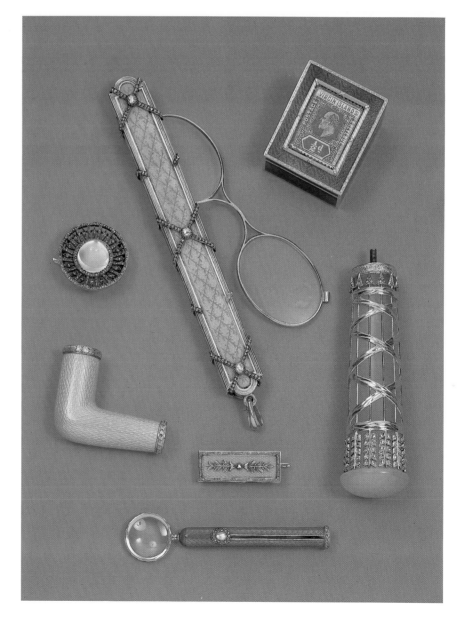

Two of the showcases in the Jubilee Exhibition held at the Victoria & Albert Museum in 1977.

Marks and Standards

State Marks

Up to the year 1899, St Petersburg and Moscow had their own separate cyphers, which are easily distinguishable. St Petersburg, where the bulk of Fabergé's vitrine objects were made, had as the gold mark of the city two crossed anchors intersected vertically by a sceptre.

Moscow, where a much more commercial business was carried on, had as the city mark a Saint George and Dragon.

In 1899, St Petersburg, Moscow and, for that matter, the other manufacturing centres in Russia, abandoned their separate gold and silver marks and adopted a woman's head seen in profile wearing the traditional head-dress known as a *Kokoshnik*.

With the publication in Moscow of the 1974 edition of the invaluable *L'orfèvrerie et la bijouterie russes aux XV–XX siècles* by T. Goldberg, F. Michoukov, N. Platonova and M. Postnikova-Losseva, we now know that it was merely the intention of making the *Kokoshnik* the legal stamp for all towns in Russia that was announced in 1896—its actual implementation did not become compulsory until January 1899, by which time the necessary 2,400 stamps had been made. Until 1974, it had been generally, and wrongly, accepted that the use of the mark had become law three years earlier.

The new intelligence is born out by the marks stamped on the Imperial Eggs which are known to have been made during these vital years. The Lilies of the Valley Egg (page 98), which is dated 5th April 1898, bears the old Petersburg crossed anchors and sceptre mark and both the Eggs dated 1899—the Madonna Lily Egg (page 99) and the Pansy Egg (page 100)—are clearly stamped with the *Kokoshnik*.

It had previously been assumed that the Eggs for 1896, 1897 and 1898 bore the old marks because they had been started some years earlier and had been stamped at an early stage of manufacture.

From 1899 to 1908, the woman's profile with the *Kokoshnik* faces to the left; from 1908 until 1917, to the right.

Gold and Silver Standards

The Russian gold standards in general use at this time were reckoned in *zolotniks* in the same way as ours are expressed in carats. The gold alloy of 96 parts, contains in Fabergé's objects either 56 or 72 *zolotniks* of pure gold, just as our alloy of 24 parts, or carats, contains a certain proportion of pure gold, 9, 18, or 22 parts being the most common. It is useful to remember that the 96 parts of the Russian alloy correspond to the 24 parts of the English alloy—a ratio of 4 to 1. Hence, if the Russian gold standards (56 and 72 *zolotniks*, for instance) are divided by 4, the results represent the English standard equivalents (14 and 18 carats respectively).

The Russian standards for silver are also indicated by the number of *zolotniks* of pure silver out of 96 *zolotniks* of alloy. The most frequently found proportions are 84 and 88, although it is not altogether uncommon to find objects stamped 91. The English sterling standard requires that at least 925 parts out of a total of 1000 parts of silver alloy be pure silver. Thus, the Russian standards 84 and 88 are below the English standard for sterling silver, but the standard 91 is above.

Makers' Marks

Most, but by no means all, Fabergé objects bear some sort of mark of the House. The first obvious exceptions to this rule are the carvings in stone; a mark, even if practicable, would almost always disturb the surface beauty of such pieces, and when a signature of some sort is found, for example on the undersurface of a stone animal, this is tantamount to a proclamation that the carving is not by Fabergé at all.

The form of the signature stamped or engraved on an object usually reveals its origin of manufacture; pieces made in St Petersburg simply bear the name Fabergé in Cyrillic characters, ФАБЕРЖЕ. without any initial, usually followed or preceded, by the workmaster's initials. Sometimes a piece will be found to bear only the House name or only the workmaster's initials. Objects made in St Petersburg are sometimes marked К.Ф. Most workmasters' initials appear in Roman letters but some are stamped in Cyrillic characters, for example 'I. P.' for Julius Rappoport.

The pieces made in Moscow are marked with the signature К.ФАБЕРЖЕ beneath an Imperial double-headed eagle, or, as in St Petersburg, they too are simply stamped with the initials К.Ф., as are those made in Odessa and Kiev, where Fabergé had branches and small workshops. A Greek initial which appears alongside the *Kokoshnik* stamped on objects made from 1908 to 1917 indicates the place of manufacture: an α for St Petersburg, Δ for Moscow, κ for Odessa and ν for Kiev.

The metal on Fabergé objects was scratched with a stock-number when there was space.

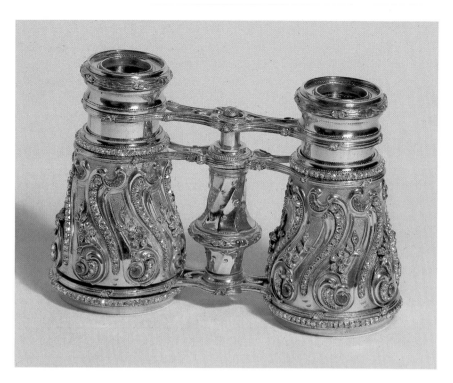

Pair of opera glasses. Red gold, chased with rococo scrolling and reserved with granulated areas, set with rubies, rose diamonds and two brilliants.
Length 4 inches Signed МП
Mrs Bing Crosby, California.

The full Moscow mark signifies that the firm held the Royal Warrant of Appointment and was entitled to stamp the Imperial cypher above the House name. Occasionally such pieces also bear initials of certain work-masters such as Rappoport, Nevalainen and Wäkewä, whose activities clearly extended to Moscow, but as a rule they are stamped with the House mark only.

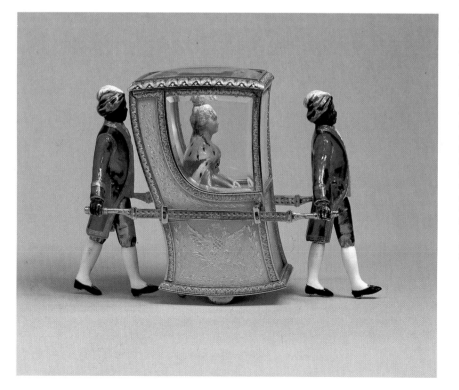

Mechanical sedan chair in engraved red gold with green gold acanthus borders, enamelled translucent yellow over a ground engraved with Romanov double-headed eagles within trails of leaves. The windows and roof are set with bevelled rock crystal panels. A miniature gold figure of Catherine the Great in her Imperial ermine cloak, enamelled in natural translucent colours and wearing a rose diamond crown and order is seated inside. The chair is borne along by two scarlet-coated Court Arabs in gold and enamels who walk naturalistically when the clockwork mechanism is wound with a small gold key. This object was one of the first to have left Russia after the Revolution, bought from the Soviet Government by Emanuel Snowman.
Signed HW
Overall length 3¼ inches Gold mark 72
AKS colour plate LIII and plate 286
Sir Charles Clore, London.

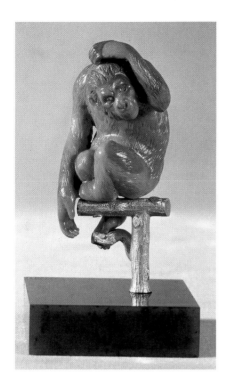

Ape in a characteristic pose, carved in red jasper, set with rose diamond eyes, seated upon a silver-gilt perch chased to simulate wood, supported on a block of nephrite.
Height 4 inches
A la Vieille Russie, New York.

Pieces made in St Petersburg, however, were treated differently. Fabergé felt that credit should be given to the particular workmaster responsible for an object, which was not an anonymous product of the House, but the original work of the man whose initials it bore, and that man, whether he was Perchin, Wigström or any of the others, was clearly not a Warrant holder.

It was in this characteristically generous way that the workmaster was recognized by Fabergé. The workmaster was in charge of a carefully selected group of talented craftsmen and was entitled to sign his own creation.

During the course of a talk entitled 'Giving Presents' in the Third Programme of the BBC on 2nd December 1950 (and published by them), H. C. Bainbridge said:

'The guiding principle of the House of Fabergé was that each object should be produced in one workshop and by one individual craftsman. Of course, it had to leave the craftsman at times to be enamelled and so on, but it always came back to the same man for finishing. And therefore he could always say "That is *my* child." '

'And that was the secret of Fabergé's phenomenal success.'

One of the questions which most exercised my mind during the preparation of my previous study of Fabergé was the number of workers the firm employed. Although Mr Bainbridge in his valuable book had put the figure as high as seven hundred, I was to learn that this was an exaggeration which has been tirelessly perpetuated by every writer on the subject since 1949.

I have a letter from Fabergé's eldest son Eugène, dated 20th November 1952, in which he answers my specific question on this point as follows: 'We consider that the number of all our collaborators, as those in the shops and book-keeping, workmen of all kind, designers, modellers and other specialists,

Seated ostrich. Vari-coloured agate with chased gold legs and set with green garnet eyes.
Length 2⅜ inches Signed HW

Chimpanzee seated upon a stool carved from a single piece of vari-coloured jasper, and set with brilliant-cut diamond eyes.
Height 2½ inches

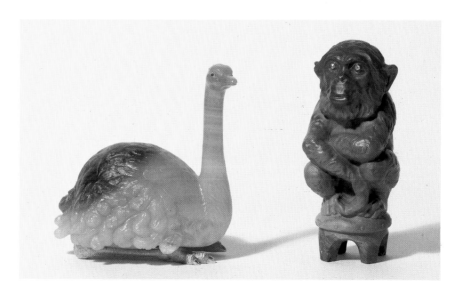

as well in St Petersburg as in Moscow, Odessa and London might have reached 600 persons nearly.' (*Sic*).

Following the receipt of this letter, I had several conversations with Eugène (who later checked my manuscript in detail before I passed it to the publisher) and with Andrea Marchetti, the former manager of the Moscow silver workshop. As a result of much careful thought, they decided that this estimate should be further modified. Thus, I wrote in *The Art of Carl Fabergé* in 1953 that 'Altogether, a total of about five hundred people were employed in the various Fabergé establishments.'

I really think that this must be about right.

FABERGE'S WORKMASTERS AND THEIR MARKS

Erik August Kollin	E.K.
Michael Evlampievich Perchin	M.П.
Henrik Wigström	H.W.
Julius Alexandrovitch Rappoport	I. P.
August Wilhelm Holmström	A.H.
Alfred Thielemann	A.T.
August Fredrik Hollming	A*H
Johan Viktor Aarne	B. A.
Karl Gustav Hjalmar Armfelt	Я. A.
Anders Johan Nevalainen	A.N.
Gabriel Niukkanen	G.N.
Philip Theodore Ringe	T.R.
Vladimir Soloviev	B C.
Anders Michelsson	A.M.
G. Lundell	Г. Л.
Fedor Afanassiev	Ф. A.
Edward Wilhelm Schramm	E.S.
Wilhelm Reimer	W.R.
Andrej Gorianov	A. Г.
Stephan Wäkewä	S.W.
Alexander Wäkewä	A.W.
Knut Oskar Pihl	O.P.
Fedor Rückert	Ф. P.

Occasionally, certain combinations of initials have been found on objects stamped Fabergé, either with or without the double-headed eagle. These initials have never been identified, but seem to be those of bona fide workmasters. They are: AR (without the eagle), found on small objects of function, and ИП (IP), and ICA on larger Moscow pieces such as tea sets. More details of the specialized functions of all Fabergé's workmasters and a list of his competitors are in *The Art of Carl Fabergé*.

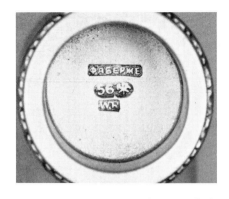

The early St Petersburg mark (up to 1899) with the rarely found initials of the workmaster Wilhelm Reimer, taken from the handle on page 139.

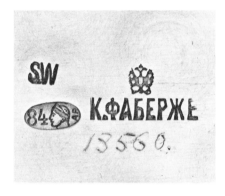

Moscow mark with, in one lozenge, the silver mark 84 with the *Kokoshnik* (facing left) for the years 1899 to 1908 and the Cyrillic initials AP for the Hall Inspector. The initials of the workmaster Stephan Wäkewä, the Moscow House mark and the engraved Fabergé stock number. Taken from part of a tea-set.

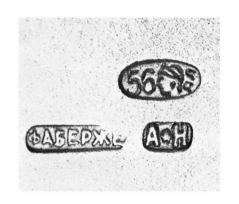

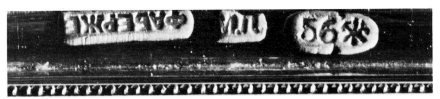

The House name and the initials of the work-master Michael Perchin, both in Cyrillic characters, the gold mark 56 and the St Petersburg mark which was in use up to the year 1899, the crossed anchors and sceptre. As is often found, part of the mark is stamped upside down.

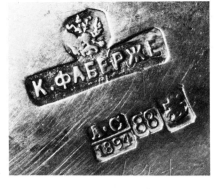

Moscow version of the House name stamped in Cyrillic characters on a silver object, with the initial K and surmounted by the Romanov double-headed eagle. Other marks are the Cyrillic initials AC of the Hall Inspector above the date 1894, the silver mark 88 and the St George and Dragon mark for Moscow up to the year 1899.

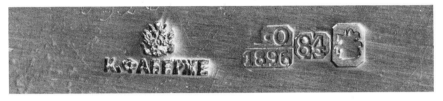

An early Moscow mark taken from the jug on page 57 with the Cyrillic initials ЛО of the Hall Inspector, the lower silver mark 84 and the St George and Dragon mark of Moscow up to 1899. The Hall Inspector's initials and the Moscow mark are both poorly expressed, as is often the case with all marks.

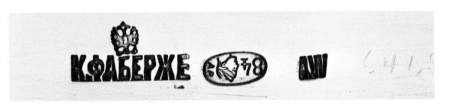

Identical marks stamped on another object in the same tea-set as the middle picture opposite, but with the initials AW of the workmaster Alexander Wäkewä, the son of Stephan.

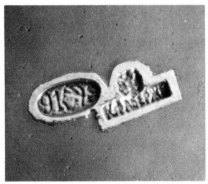

Moscow mark stamped on the enamelled *kovsh* illustrated on page 57 with the high silver mark 91. Note how the enameller has taken care to paint round the marks.

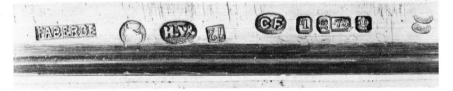

St Petersburg mark from the box illustrated on page 31. The House name in English indicating an object made for the British market, the *Kokoshnik* for the years 1908 to 1917, the initials of the workmaster Henrik Wig-ström, the high gold mark 72, the initials CF for Carl Fabergé and the normal British 18 carat hall marks for the year 1911. This higher grade of gold was often used for objects made for royalty.

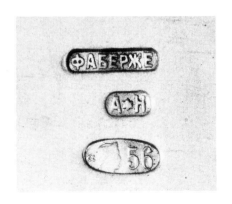

Left :
St Petersburg mark with the initials of the workmaster August Hollming and, in one lozenge, the gold mark 56, the *Kokoshnik* for the years 1899 to 1908 (facing left) and the Cyrillic initials ЯЛ of the Hall Inspector.

Right :
The mark taken from the two-colour gold cigarette case on page 54 with the initials of August Hollming and, in one lozenge, the Greek letter alpha for St Petersburg, the *Kokoshnik* (facing right) for the years 1908 to 1917 and the gold mark 56.

Wrong Attributions, Pastiches and Forgeries

Small objects of value have always attracted the attention and challenged the skills of fakers, and it is hardly surprising that imitations of Fabergé objects find their way on to the art market from time to time.

Very often, spurious items are offered in good faith simply because the owners do not know enough about their subject. In particular, the studies of flowers in pots have been frequently copied because the rewards are so tempting. Some of the most atrocious examples have been presented, especially in the United States, to Museums and publicly exhibited collections whose curators or trustees have not always faced the fact that bountiful patrons (or patronesses) sometimes come bearing false floral gifts—and for that matter zoological ones as well. The problem is further complicated by our knowledge that certain Paris jewellers, quite legitimately, designed flowers of their own. Cartier and Tiffany both worked in this idiom—the latter gained well-deserved praise for ingenious mother-of-pearl models in the Japanese manner. Some, though by no means all, non-Fabergé flower studies in museums are by entirely respectable French jewellers. They are just wrongly labelled.

Even Henry Bainbridge, the most conscientious of men, failed to identify the true creator of the sumptuous egg-shaped basket of flowers and grasses dated 1910 which is in the Sandringham Collection. He illustrates it on plate 33 of his book as the work of Fabergé, although a close inspection of the object reveals the name Boucheron, who also worked briefly in Petersburg, crisply engraved underneath the base of the vase. This original confection may well have been a gift to Queen Alexandra from her sister the Dowager Empress Marie Feodorovna.

An occasional error of this sort is almost bound to occur when dealing with such a mass of material. Indeed, a page of the catalogue of the exhibition entitled 'France in the Eighteenth Century' held in London's Burlington House in 1968 is devoted entirely to the illustration of an attractive but uncompromisingly English agate *nécessaire* (of the right period) in a gold cagework mount.

I have seen clumsily carved copies of Fabergé's famous balalaika player and others of the stone figures of Russian

national types gazing dishonestly through their newly-set cabochon sapphire eyes, out of shop windows in Paris and Geneva. They appear in London too, but at least in their true (if, in my view, tarnished) colours, as contemporary replicas. Fortunately, these unwelcome copies are very easily recognized.

The animal carvings however, demand a greater degree of discrimination from the potential collector. Experience in handling and examining them is the only really reliable teacher. One learns to look for a basic liveliness and charm in these small works of sculpture, qualities which are notably absent in the copies usually made in Idar-Oberstein or the Soviet Union, and which give the impression of having been prized off onyx ashtrays. These I generally find solemn, dull and without life.

As far as works in precious metals are concerned, the inconsistency of the marks often proclaims that the object is false. However, the most dependable method of judging the authenticity of any art object must remain, as always, one's own taste.

Subjects have sometimes been embellished in order to increase their intrinsic value. What I have called The Twilight Egg, which is composed of a mosaic of lapis lazuli and dated 1917, has suffered at the hands of a misguided restorer: inappropriate jewellery has been added to what was certainly intended as an austere symbol for a particularly melancholy Easter. This Imperial Egg, which the Bolsheviks would not allow Eugène Fabergé to deliver, has been illustrated and described in detail in the catalogue of the Jubilee Exhibition, 'Fabergé, 1846–1920' held at the Victoria & Albert Museum, London, in 1977.

Genuine Russian objects by contemporary makers regularly appear on the market, spoiled by the addition of the newly stamped name or initials of Fabergé; the authentic maker's mark is usually allowed to remain, such is the perpetrator's brazen confidence in the buyer's ignorance.

When an object is stamped with a false mark, this can often be detected by careful examination of the metal, which rolls up perceptibly round its margin; the original marks are always quite flush with the metal—they were, in most cases, stamped before the object was assembled and finished.

A craftsman who sets out to make a copy of an earlier object cannot, try as he may, shed the accent of his own period. The flavour of his century will surely creep into his work, although this may not become evident until years later. There is a well-documented story of how Carl Fabergé was challenged by Alexander III to make a gold snuff box as magnificent as a scarlet-enamelled example in the Hermitage dated 1777 and made by the Paris goldsmith Blerzy. When he duly produced his own version in green enamel, the Tsar was so impressed that he ordered both boxes to be displayed side by side in the

Palace, just as he had done in the case of Erik Kollin's replicas of the gold jewels from the Kelch peninsula.

When I had the opportunity of examining them again while arranging the 1977 Jubilee exhibition, it was brought home to me that the Russian box was an unmistakably nineteenth century object. Heavier in design and marginally more elaborate, it belongs undeniably in the same world as the Albert Hall, although Perchin devoted his considerable talents to the manufacture of as convincing a pastiche as he could make in the Louis XVI manner.

We know that neither the Tsar, nor anyone else, could detect any stylistic difference whatsoever when the second box was set down next to its eighteenth century precursor; today, about eighty years later, a trained eye cannot miss it. Similarly, the copies of Renaissance jewellery made in the 1870s and later which masquerade as sixteenth century jewels are just now being unmasked by inquisitive scholars. Charles Truman has recently unearthed an exciting collection of annotated nineteenth-century drawings in the Renaissance style, some of which he has published in *The Connoisseur* of March 1979— 'Reinhold Vasters—"the Last of the Goldsmiths"?' The jewels themselves are, as a matter of simple fact, (and quite apart from any aesthetic reservation we may justifiably make), too substantial and technically proficient to have been the products of the sixteenth or seventeenth centuries, and their similarity to articles being made by such splendid jewellers as the Giuliano family in London in open admiration of their forbears is becoming increasingly clear to our twentieth century eyes.

When deliberate copies are made with great accuracy it seems they often remain undetected for a very long time— this has been so in the notorious case of the Hungarian Weininger, who was employed as restorer to the *Geistliche Schatzkammer* (Spiritual Treasury) of the Holy Roman Empire in Vienna. John Hayward has given fascinating details in the course of an article 'Salomon Weininger, Master Faker' in *The Connoisseur* of November 1974 in which he records the machinations of this merchant-adventurer of the workbench who replaced authentic pieces from the Treasury (which he had sold to wealthy collectors) by his own skilfully made forgeries.

Although he ended his days in the Austrian State prison at Stein on the Danube in 1879, a small gold enamelled casket set with engraved rock crystal panels, a revered possession of the Kunsthistorisches Museum in Vienna, was only recently discovered to have been from his hand.

Inevitably, many doubtful items are sent in to the big auction houses. Usually they are recognized and very properly refused by the particular department concerned. Nevertheless, clever replicas, sophisticated, over-restored, damaged and even

broken objects do get through, and it would seem prudent for a private connoisseur to seek advice from a recognized specialist before bidding.

However, many buyers thoroughly enjoy the heady atmosphere, so reminiscent of a casino, which they find in the saleroom. A flutter is often stimulating, but an expensive mistake is always a disaster. A big public auction can represent a minefield for the unwary, since catalogues list not only splendid, rare and absolutely first-class lots, but also numerous trade rejects which add up to a long, limping procession of lame ducks, put up for any number of excellent reasons by dealers who have been obliged to acquire them in mixed collections in order to secure the pieces they really wanted for their stock. It is perhaps not sufficiently understood that the trade makes up by far the largest numbers of both sellers and buyers at auction sales every year. Reliable and educated dealers have traditionally played an important role in the building up of the great collections all over the world, and have, in this way, provided a dependable provenance for their owners.

A good dealer will be willing, and usually eager, to trade again with his own stock because he has faith in it and because he knows his customers. He will rarely abandon what he regards as his children, and this sense of responsibility is widely appreciated by serious collectors.

Unlike the museum buyer, he has no recourse to murky underground reserve collections well below the threshold of public scrutiny, in which to hide away his mistakes and, unlike the auctioneers, he is not merely an agent.

Appendices

Chronology

1842 Firm established by Gustav Fabergé in Bolshaya Morskaya Street, St Petersburg.

1846 Peter Carl Fabergé (hereafter simply Fabergé) born in St Petersburg on 30th May. Baptised in the Protestant Church.

1870 Fabergé takes control of the firm at the age of 24.
New ground-floor premises taken opposite original basement, now closed.

1872 Fabergé marries Augusta Julia Jacobs.

1882 Fabergé's younger brother Agathon arrives from Dresden to join the firm at the age of twenty.
The House exhibits for first time at Pan-Russian Exhibition in Moscow and wins a Gold Medal.

1884 First Imperial Easter Egg presented to the Empress Marie Feodorovna.
Alexander III grants his Royal Warrant to the House of Fabergé in 1884 or 1885.

1885 House awarded Gold Medal at Nuremberg Fine Art Exhibition for gold replicas of Scythian Treasure.

1886 Michael Perchin joins the firm.

1887 Allan Bowe becomes partner in firm; Moscow branch founded.

1888 Special Diploma received at Northern Exhibition in Copenhagen; the House was *hors concours*, being represented on the jury.

1890 St Petersburg premises doubled in size. Branch opened in Odessa.

1893 Death of Gustav Fabergé in Dresden on his 79th birthday. Art Nouveau movement now launched in Europe.

1894 Death of Alexander III on 1st November.
Marriage of Nicholas II on 7th December.
Eugène Fabergé joins the firm.

1895 Death of Fabergé's brother Agathon at age of thirty-three.

1896 Coronation of Nicholas II.
House awarded State Emblem at Pan-Russian Exhibition at Nijny-Novgorod.

1897 Granted Royal Warrant by Court of Sweden and Norway.

1898 Premises bought at 24 Morskaya Street (now Herzen Street), for a million roubles and reconstruction, for the same sum, was started. Fabergé entrusted the work, which was distinguished by the use of Finnish granite, to his nephew, the architect Carl Schmidt.

1899 *Kokoshnik* adopted as State mark for gold and silver throughout Russia.

1900 Removal to Morskaya Street.
Imperial Eggs exhibited for first time at the Paris 'Exposition Internationale Universelle'. Carl Fabergé, member of jury, acclaimed *Maitre* and decorated with Légion d'Honneur.

1901 Death of Erik Kollin.

1903 Arthur Bowe sent from Moscow to London to start up business for Fabergé from Berners Hotel.
Death of Michael Perchin; workshop taken over by his chief assistant, Henrik Wigström.
Death of August Holmström, succeeded by his son Albert.

1904 Birth of Tsarevitch.
Fabergé invited to visit King Chulalongkorn of Siam. London branch removes to Portman House, Duke Street, Grosvenor Square. Objects by Fabergé exhibited for first time in England by Lady Paget at an Albert Hall bazaar in aid of Royal Hospital for Children.

1905 Branch founded in Kiev.

1906 London branch removes to 48 Dover Street under Nicholas Fabergé and H. C. Bainbridge.
Beginning of business connections with Siam, India and China.

1907 Artists working at Sandringham finish models for stone animal carvings.
Baron Foelkersam's *Inventaire de l'Argenterie* published, in which he writes: 'This firm (Fabergé), which is one of the best and most famous in the world, is renowned above all for its *objets d'art*. Articles made in Fabergé's workshops are known for their technical excellence, especially as regards enamelling, stone polishing and engraving.'

1908 Fabergé arrives in London from St Petersburg to see Dover Street premises on 29th January, and leaves hurriedly the same day for Paris when informed that he would be expected to seek an audience with Queen Alexandra.

1910 Kiev branch closes.

1911 London branch moves to 173 New Bond Street.
Nicholas II commissions Fabergé to carve miniature stone figures of Empress's Cossack Bodyguard.

1913 Tercentenary of Romanov rule brings about revival of Russian Mediaevalism in applied arts known as 'Old Russian Style'.

1915 Bond Street shop closes down. Death of August Höllming.

1916 Death of Julius Rappoport.

1917 Russian Revolution.
The House closes for a short period at beginning of Revolution.

1918 Firm finally closed down by Bolsheviks.
Fabergé escapes in September via Riga, Berlin, Frankfurt and Bad Homburg to Wiesbaden as a courier attached to the British Embassy.

1920 Fabergé arrives at Lausanne in June.
Dies on 24th September at the Hotel Bellevue, La Rosiaz.

1929 Eugène brings his father's remains from Lausanne Crematorium to Cannes and buries them in the grave with those of his late mother.
He sets up tombstone in black Swedish porphyry bearing this inscription:

CHARLES FABERGE
joaillier de la Cour de Russie
né 18 mai 1846 à St Petersbourg
décédé 24 septembre 1920 à Lausanne

AUGUSTA FABERGE
née Jacobs
née 25 decembre 1851 (vieux style) à Tsarskoé Selo
décédée 27 janvier 1925 (nouveau style) à Cannes

Select Bibliography

A chronological list of noteworthy material which has appeared since the Bibliography given in *The Art of Carl Fabergé* was published in 1953.

Carl Fabergé Special Coronation Exhibition including selected items from the Royal Collection at Sandringham, Foreword by Sacheverell Sitwell, Wartski, London, 1953.

Paul Guth: 'Carl Fabergé' in *Connaissance des Arts*, Paris, February 1954.

A. Kenneth Snowman: 'The works of Carl Fabergé, The English Royal Collection at Sandringham House, Norfolk', in *The Connoisseur*, London, June 1955.

Ernle Bradford: 'Gift-maker to Fairyland' in *The Tatler and Bystander*, London, 8 November 1957.

Parker Lesley: 'Handbook of the Lillian Thomas Pratt Collection, Russian Imperial Jewels', The Virginia Museum of Fine Arts, Richmond, Virginia, 1960.

The Art of Peter Carl Fabergé, A loan exhibition for The Manhattan School of Music, A la Vieille Russie Inc., New York, 1961.

A. Kenneth Snowman: *Easter Eggs and other precious objects by Carl Fabergé*, The Corcoran Gallery of Art, Washington, D.C., 1961.

A. Kenneth Snowman: 'A group of virtuoso pieces by Carl Fabergé' in *The Connoisseur*, London, June 1962.

'Fabergé: Catalogue of an exhibition at the M. H. De Young Memorial Museum San Francisco', Published by the Museum, 1964.

C. G. L. Du Cann: 'The Famine in Fabergé' in *Collector's Guide*, August 1964.

Marvin C. Ross: 'The Art of Karl Fabergé and His Contemporaries' in *The Collections of Marjorie Merriweather Post*, University of Oklahoma Press, Norman, Oklahoma, 1965.

Beverley Nichols: *The Art of Flower Arrangement*, William Collins, London, 1967.

A. Kenneth Snowman: 'Palace Ephemera' in *The Antique Dealer and Collector's Guide*, London, March 1967.

Henry Hawley: *Fabergé and his Contemporaries The India Early Minshall Collection of the Cleveland Museum of Art*, The Cleveland Museum of Art, Cleveland, 1967.

The Art of the Goldsmith and the Jeweller, A Loan Exhibition, A la Vieille Russie, New York, 1968.

A. Kenneth Snowman: 'Carl Fabergé, Decorator Extraordinary', A lecture to The Society of Silver Collectors, London, December 1970.

A Thousand Years of Enamel, Introduction by Sir Francis Watson, Wartski, London, 1971.

Irina Rodimseva: *Jewelled objects by the firm of Fabergé,* Moscow, 1971.

Howard Ricketts: *Objects of Vertu,* Barrie and Jenkins, London, 1971.

Hugh Honour: *Goldsmiths and Silversmiths,* Weidenfeld and Nicolson, 1971.

William A. Fagaly and Susan Grady: *Treasures by Peter Carl Fabergé and other Master Jewellers The Matilda Geddings Gray Foundation Collection,* New Orleans, Louisiana, 1972.

Fabergé at Wartski : The famous group of ten Russian figures composed of carved stones of colour designed by Carl Fabergé, Wartski, London, 1973.

Hermione Waterfield: *Fabergé, The Forbes Magazine Collection,* The New York Cultural Center, New York, 1973.

Kenneth Blakemore: *Snuff Boxes*, Frederick Muller Ltd, London, 1976.

Parker Lesley: *Fabergé A Catalog of the Lillian Thomas Pratt Collection of Russian Imperial Jewels*, Virginia Museum, Richmond, Virginia, 1976.

A. Kenneth Snowman: *Fabergé 1846–1920*, Catalogue for an international loan exhibition assembled on the occasion of the Queen's Silver Jubilee at the Victoria & Albert Museum, London, June 1977.

A. Kenneth Snowman: 'Carl Fabergé in London' in *Nineteenth Century*, Christopher Forbes, New York, Summer 1977.

A. Kenneth Snowman: 'Carl Gustavovitch off the beaten track' in *The Connoisseur*, London, June 1977.

Objects of Fantasy; Peter Carl Fabergé and other Master Jewellers, National Geographic Society, Washington, D.C., 1977.

Dr. Geza von Habsburg: *'Carl Fabergé: Die glanzvolle Welt eines Königlichen Juweliers'* in *Du-Europäische Kunstzeitschrift*, Zürich, December 1977.

Victor Houart: *Easter Eggs, a Collector's Guide*, Souvenir Press Ltd, London, 1978.

Hermione Waterfield and Christopher Forbes: *Fabergé, Imperial Eggs and other fantasies*, Charles Scribner's Sons, New York, 1978.

Susan Benjamin: *English Enamel Boxes From the Eighteenth to the Twentieth Centuries*, Orbis Publishing, London, 1978.

Index

Numbers in italic indicate references in picture captions; the pages numbers are those of the pictures to which the captions refer.

aardvark *71*
agate 29, 33
A la Vieille Russie (collection) *21, 32, 143*
Alba, the Duchess of (collection) *83, 118*
Albert Edward, Prince of Wales, portrait of *135*
Alexander, Grand Duke, miniature of, *see* Pansy Egg
Alexander Palace Egg *107*
Alexander III, Tsar *147*; Equestrian Egg *109*; Eggs given by 89, *90, 91, 94, 101, 109*
Alexandra Feodorovna, Coronation box given by *122*; Eggs given to 26, 89, *90, 93, 97, 99, 101, 102, 103, 104, 105, 106, 107, 108, 112, 114, 115*; in the gardens at Livadia *96*; lilies of the valley given to *84*; miniature of, *see* Pansy Egg; table clock given by *130*; photograph of *43*
Alexandra, Princess of Wales, portrait of *135*
Alexandra, Queen 76, *81*, 146; miniature portrait of *24*
Alix of Hesse-Darmstadt, Princess, *see* Alexandra Feodorovna
amazonite 29
Andrew, Grand Duke, miniature of, *see* Pansy Egg
Anglesey, Marquis of *124*
animals, satirical carvings of 74
Anne, Princess (collection) 29
Antiquariat Departments of the Soviet Union 116
ape, red jasper *143*
aquamarine, *see* Standart Egg; Swan Egg
Archangelskoe Palace *122*
Art Nouveau movement 52
Art Nouveau objects *53, 57, 62, 100*
automaton elephant *16*
aventurine glass (goldstone) 35
aventurine quartz 29, 33, *58, 63*
Azova Egg *91*

baboon *71*
Bainbridge, H. C. (manager and later biographer) 37, 76, *120*, 124, 128, *129, 143*, 146
Bauer Collection, Geneva, The 74
bear *71*
bear, cigarette-lighter in the shape of a *40*
beaver *71*
bell-push *36*; bowenite *34*; in the form of a crab *44*; in Louis XVI style *36*; surmounted by frog *134*
Benois, Alexandre (designer) 95, *96*
Bentley (collection) *33*
bidet, salt chair designed as *26*, 53
birch wood 37
bird, fantastic *47*, 52; parti-coloured agate *52*
bison *71*
Blair, Mr (collection) *125*
Blakemore, Kenneth (*Snuff Boxes*), quoted 34
bleeding heart, spray of *81*
Blerzy, Joseph Etienne *147*
Bloom, Mr and Mrs J. (collection) *59*
bonbonnière in the form of a slice of crystallized fruit *50*; in yellow gold *27*
border terrier *70*
Bosch, Hieronymus *47*, 52
Boucheron (jewellers) 11, *146*
bourdalou, miniature *52*
Bowen, G. T. 32
Bowen, Mr D. Richard (collection) *138*
bowenite 29, 32, *101*
Bowes Museum, Barnard Castle (collection) *106*
bowl, mustard-coloured pottery *55*; purpurine with gold handle *50*
box with carving of Tsarina and daughters *122*; circular in red gold *27*; egg shaped *134*; egg shaped in rock crystal *39*; green enamel *122*; nephrite, with *fleur-de-lis* motifs *39*; oval in nephrite *31*; with painting of Peter the Great Monument *39*; papier-maché *41*; pink enamel *39*; shaped as a pumpkin *39*; purpurine *39*; rectangular in nephrite *27*; rock crystal *130*;

royal blue enamel *39*; six-sided *57*; with Tsar's portrait *118*
boyarin (nobleman) *72*
Bradshaw, Arthur (collection) *121, 125*
bratina in Norwegian style *57*
brooch in the form of a bow *43*; with Imperial crown *43*; panel *138*; circular *138*
buttercups and cornflowers *127*
buttercups, spray of *82*
Buxhoeveden, Baroness (*Life and Tragedy of Alexandra Feodorovna*), quoted 108

cabochons, precious stones used as 28, 29
Cairo sale 129
Cantacuzène, Prince and Princess (collection) *125*
carnation *86*
carpenter (*plotnik*) *72*
Cartier (Jewellers) 11, *146*
carving, method of 36, 37, 65, 75
casket, oxidized silver *77*
cat with arched back *70*
Catherine the Great, miniature of *142*
catkins *88*
Caucasus Egg *91*
chalcedony *33*; stained (Mecca stone) 29
chameleon *67*
champlevé enamelling 25
Charles of Denmark, Prince, portrait of *135*
chess-set *58*
chestnut leaf *63*
chick, bowenite *46*, 52
chimpanzee with folded arms *71*; looking troubled *71*; seated *143*
Christie's 121
chrysanthemum *81*
Chulalongkorn, King *124*
cigar box *48, 53*
cigarette box, green enamel *55*
cigarette case with match compartment *123*; in nephrite *31*; oval *123*; oyster-coloured enamel *123*; palisander *55*; pink and green ribbed gold *54*; red gold *17*; red, green gold and platinum strips *54*; rhodonite *123*; royal-blue enamel *51*; royal-blue enamel *123*; with scallop pattern *48, 48*; silver *121*; violet enamel *123*; with white-enamelled lines *20*
Cleveland Museum of Art, The 53
clock, bowenite *34*; incorporated in Cuckoo Easter Egg *93*
cloisonné enamel 25
Clover Egg 28, *104*
coach, replica of, *see* Coronation Egg
coachman *72*
collie *70*
Colonnade Egg *95, 96, 105, 121*
coloured gold *17*
convolvulus *134*
copper: added to gold *17*
cornelian *33*
cornflowers *126*
cornflowers and stem of oats *127*
Coronation Egg *97, 122*
covered cup in the Rococo manner *79*
Cowdy, Mr John (collection) *72*
Cox, Lady (collection) *53*
Cox Museum 106
cranberry, spray of *87*
Crosby, Mrs Bing (collection) *142*
Cross of St George Egg *112*
Cuckoo Egg *93*
cuff-links *127*
cup, rouble inserted in handle *134*; striated agate *50*

dachshund *68*
dachshund puppy *70*
daisies in pot *86*
dandelion *126*
diamond, rose-cut or brilliant 29
Diamond Trellis Egg *101*
Dinglinger, Melchior 89, *103*

dish, entwined by a silver snake *60*; jade in Renaissance style *61*; rectangular *63*
donkey *70*
dormouse *71*
Dorofeev (mechanic) *90*
duck, blue-grey *66*; vari-coloured agate *69*
duckling *69*; flapping its wings *69*; mustard-coloured *69*
dvornik (houseboy) *72*, 121

Easter Egg, agate *32*
Easter Eggs, unusual aspects of 74, 89
Edward VII *51*, 76
Edward VII, cigarette case given to *51*
Egg given to Barbara Kelch *115*; with Danish Palaces *95*; with revolving miniatures *90*
eglantine 80, *83*
Ekaterinburg, source of rhodonite 32
elephant, Indian *67*; gun-metal *16*; as a pendant *31, 74*; rock crystal *16*; sardonyx *16*
Elizabeth Feodorovna, Grand Duchess, portrait of *135*
Elizabeth II, H.M. The Queen (collection) *39*, 124, *130, 134, 135*, *see also* Sandringham
Elizabeth, the Queen Mother *136*, (collection), *57, 127*
Emanuel, Harry (jeweller) 106
emerald 28
Empire style, *see* Napoleonic Egg
en plein enamelling 20
enamel 17–28; opalescent *24*; opaque 20; translucent 19
English monuments illustrated on objects 27
Equestrian Egg *109*

Fabergé, Agathon 31
Fabergé, Carl *3*
Fabergé, Eugène *3*, 53, 90, 108, *115*, 124, *143*, 144
Fabergé Exhibition, Wartski 1949 128, *129*
Fabergé Exhibition, Wartski 1953 128
Fabergé jewels, Jubilee Exhibition 42
Fabergé, Kiev branch 41; London branch *143*; Moscow branch 14, 17, *143*; Odessa branch 15, *143*; St Petersburg shop 13, 128
Fabergé objects, acquisition of 116; Cairo sale 129; prices of 121
Farouk, King 129
Feldstein, Mr Irving (collection) 78
Fifteenth Anniversary Egg *112*
First Imperial Easter Egg 90, 121
fish *68*
flamingo *43*
flower studies 80–88
folding screen of six frames *56*
Forbes Magazine Collection *91, 92, 94, 113, 122, 126, 128*
Forbes, Malcolm (head of Forbes Magazine) 128
forgeries of Fabergé objects 145–149
frame, engraved red gold *30*
frame shaped as a Shield of David *30*
Froedman-Cluzel, Boris (modeller) 76
frog, designed as a box *70*; nephrite *65*; red jasper *70*
frogs *70*

Garden of Delights, Madrid 52
garnet 29
Gatchina Palace Egg *101*
Geddings Gray, Matilda (collector) *91, 95, 110*, 128
Gentle, Annie *44*
George Alexandrovitch, Grand Duke, miniature of *91*, *see also* Pansy Egg
George VI (collection) *124*
Getz, Mr and Mrs Oscar (collection) *51*
gipsy woman *32*
Giuliano family *148*
Gloucester, Duke of (collection) *31, 40*
gold, coloured *17*
gold mark, *see* marks and standards
gold and silver standards 17, *141*
goldstone 35

goose 67; standing 67; with outstretched neck 67
gorodovoi (policeman) 72
Grand Duchesses (on board Imperial Yacht) 96
grand feu enamelling 20
grand piano, miniature 121, 134
Grant, Julia, vase given to 62
Griffins (Romanov emblem), see Trans-Siberian Railway Egg
griffon 70
guéridon, silver mounted 22
guilloché enamel 21, 98
gull 66
gun-metal 16, 53

hamster, wax figure of 37
hand-bell in rock crystal 127
hand-seal 50; bowenite 48, 52; in the form of an egg 43; reeded gold mount 34; with trumpet-shaped stem 125; white enamel 134
handle for riding crop 138
Harcourt Smith, Simon 16
Hartley, Mr and Mrs Jack (collection) 55
hawthorn, spray of 85
Helen, Queen of Rumania (collection) 131
hippopotamus 74; bowenite 74; with its mouth open 74; nephrite 74; stylized 74
holly with purpurine berries 88
holly wood 37
Holmström, August W. (workmaster) 92, 144
Honour, Hugh (Goldsmiths and Silversmiths), quoted 92
Horse, Shire 69
house boy (dvornik) 72
Hungerford Pollen, John Ancient and Modern Gold and Silver Smith's Work, quoted 93

icon of Christ Pantocrator 25
Imperial children, miniature portraits of, see Alexander Palace Egg
Imperial Easter Eggs 89–115
Imperial family, miniatures of, see Pansy Egg
India Early Minshall Collection, The (Cleveland Museum) 26
Irina, Grand Duchess, miniature of, see Pansy Egg
Ivan Kalita (Russian folk hero) 78

Jackson, Margaret (Tsarina's former governess) 137
jade guéridon 22
jade 29, 32, 61; see also jadeite, nephrite
jade photograph frame 27
jadeite 32
japonica 88
jar, covered 33; shaped like a pear 134; Tiffany glass 62
jasper 28, 33, 58
jewel casket, see Renaissance style Egg
John, Mr Elton (collection) 43
Joseph, Mr and Mrs Edward (collection) 22
Jubilee Exhibition 16, 42, 133, 136
jug, silver-gilt 57

kangaroo 67
Kelch family, Eggs commissioned by 24, 115
Keppel, Mrs George (friend of Edward VII) 76
Keppel, Mrs, cigarette case given by 51
Kiev 41, 141
kingfisher, bowenite 46, 52; nephrite 46, 52
kitten 70
koala 71
Kokoshnik 43
Kokoshnik (gold mark) 96, 140
Kollin, Erik A. (workmaster) 47, 144, 148
Kortmann firm, George Stein with 97
Koubbeh Palace, Cairo 129
kovsh, bowenite 46; in the form of a swan 33; Imperial 31; miniature silver 57
Kremlin Armoury Museum 92, 98, 102, 103, 104, 107, 108, 109, 114, 115
Krijitski (painter), see Caucasus Egg; Egg with Danish Palaces

labourer (zemlekop) 72
ladle, nephrite 31
lamp, Loetz glass 62
Landsman, Mr and Mrs Richard (collection) 24
Lansdell K. Christie (collection) 122, 123, 125, 126
lapidaries 36, 37
lapis lazuli 29, 108
Latchford, Mr Douglas A. (collector) 124
Le Roy, of Amsterdam 94
Ledbrook, Mr Bryan (collection) 111

letter-opener 137, 137; bowenite 127
lilies-of-the-valley 86; in basket 84; Egg 98; spray of 131
Lindenast, Sebastian (coppersmith) 92, 93, 103
Livadia Palace 116
Loetz glass 62
London branch 143
lorgnette 138
Louise, Princess, portrait of 135
Love Trophies Egg 94, 96, 104
Lutiger, Frank (modeller) 76

macaque 'see no evil' 71
Madonna lily Egg 99
magot, seated 75
makers' marks 141
magpie 66, 75
maquettes 36
Marchetti, Andrea 144
Margaret, Princess (collection) 28
Marie Feodorovna, Tsarina 146; brooch given by 43; collection 118; Easter Eggs given to 89, 90, 91, 94, 95, 98, 100, 101, 109, 110, 111, 112; miniature portrait of 135
marine chronometer 35
marriage cup, Chinese, mounted by Fabergé 29
marks and standards 140–144
Mary, Queen (collection) 117, 121
Masatsugu, Kwaigyokusai (Japanese artist) 65
match-holder in the form of a brick 46; in sandstone 47
match-case in silver 30
Matilda Geddings Gray Foundation collection, The 92
Maud, Princess of Wales, portrait of 135, 135
Maximilian, Emperor 92
Mecca stone 29
medal celebrating the Year of the Pig 124
Metropolitan Museum, New York 128
Michael, Grand Duke (brother of Tsar) 136; miniature of, see Pansy Egg
Miller, Isabella 44
minaudière in Art Nouveau design 53
minerals 28–36
miniature-frame designed as an open fan 134; enamelled translucent aquamarine 135; lilac enamel 135; with photograph of Princess Maud of Wales 135; with portrait of Albert Edward, Prince of Wales 135; with portrait of Alexandra, Princess of Wales 135; with portrait of Grand Duchess Elizabeth Feodorovna as a nursing sister 135; with portrait of Princess Louise 135; with Tsarina as a young woman 135; hinged 135
miniatures of Imperial family, see Pansy Egg
mock-orange, spray of 81
monkey on all fours 71; seated 76
moonstone 29
Morskaya Street 3, 17
Mosaic Egg 115
Moscow 14, 17, 141, 143
mother-of-pearl, paintings on, see Egg with Danish Palaces
mouse 70
mujik (peasant) 72
Murano lapidaries 35
musical box 122
Mystic Apes, Three 65, 74
Mullaly, Terence 16

Napoleonic Egg 110
neo-Louis XVI pieces 47
nephrite 32, 60, 63, 107
netsuke 64, 65, 65, 70, 71, 74, 75
Nevalainen, Anders Johan (workmaster) 141, 144
Nicholas II, Tsar 89; Coronation box given to 122; Eggs given by 89, 90, 93, 95, 97, 98, 99, 100, 101, 102, 103, 104, 105, 106, 107, 108, 109, 110, 111, 112, 114, 115; miniatures of 118, 119, 122; see also Cross of St George Egg, Lilies of Valley Egg, Pansy Egg, Steel Military Egg
Nicholas II and the Tsarevitch in Tsarskoe Selo 96
Nicolson, Sir Harold 128
nickel: added to gold 17
niello 53; cigarette case 36
Nobel, Alfred 123
Nobel, Emanuel, cigarette case designed for 123
nobleman (boyarin) 72, 76
Norfolk terrier 70
notebook, leather 24
Nuremberg 92

obsidian 33
Octopussy (Ian Fleming) 136
Odessa 15, 141, 143
Olga, Grand Duchess (sister of Tsar), miniature of, see Lilies of the Valley Egg; Pansy Egg
olivine 29
onyx 33
opera glasses 142
Orange-tree Egg 112
orletz (rhodonite) 32
ostrich 75, 143
oxidized silver 18, 25

paillons 21
palisander 37, 55
palladium: added to gold 17
Pamiat Azova cruiser (Azova Egg) 91
Panina, Vara (gipsy model) 32
pansy 87
Pansy Egg 100
paper-clip, purpurine 50
parasol handle 138; in the form of a frog 131
Peacock Egg 90, 106
peasant (mujik) 72; playing balalaika 72; Ukrainian 72
pekinese 68
pelican 67
pencil-holder 138
pendant with portrait of Alexandra Feodorovna 43
Perchin, Michael (workmaster) 97, 143, 144, 148
Peter the Great Monument, miniature of 119
petit feu enamelling 20
Petouchov, discoverer of purpurine manufacture 35
Petroff, Nicolai (workmaster) 20
photograph frame in Siberian jade 27
pianoforte, miniature 38
pig, bowenite 46; orange-brown 70; pink agate 70; purpurine 70; scratching its ear 70; seated 70
pigeon, agate 66
piglets, litter of 70
pine tree in bowenite vase 86
platinum, see Alexander III equestrian Egg; Swan Egg
platypus 71
pliqué à jour enamel 25, 28, 104
Plomer, William 117
plotnik (carpenter) 72
poodle 68
Poliarnaya Svesda (Royal Yacht), see Danish Palaces Egg policeman (gorodovoi) 72
pottery 53
pottery bowl with two silver handles 44
powder box 51
Prachov (miniature and ikon painter) 26
Pratt, Lillian Thomas collection (Virginia Museum of Fine Arts) 91
presentation box 118; Coronation 122, 125; with diamond trellis 122; with painting of Peter the Great Monument 119; with profile portraits of Tsar and Tsarina 117; with Tsar's portrait 119
Prince of Wales (collection) 127
Property of a Lady, The (James Bond story) 136
purpurine 35, 50

quatre-couleur technique 17, 95, 99

rabbit, amethyst 68; crouching 70; lapis lazuli 68; purpurine 68
Radlauer, Dr Edwin I. (collection) 36
Rappoport, Julius (workmaster) 141, 144
raspberry plant 87
raspberries, spray of 126
Rasputin 122
rats 70
reading glass 127
Red Cross Egg 26
Reimer, Wilhelm (workmaster) 139
Renaissance style Egg 94
Renaissance style objects 90
Resurrection Egg 90, 121
revolution, Russian 14
rhodonite 29, 32, 123
riding crop with jade handle 29
rock crystal 29, 32, 111; see also flower studies; 108, 109
Romanov Tercentenary Egg 114
Rose with diamond dew drop 80, 86
Rose Trellis Egg 101
rosebuds 86
Rotary Clock Egg, see Colonnade Egg
roulette wheel, miniature 45

rowan tree with purpurine berries *88*
ruby 28
Rudolf, Archduke 89
Ruel, Jürg (Nuremberg goldsmith) *108*
Rush, Mr Robert (collection) *47*
Russian national figures 72, 75, 76, 147

St Petersburg *13*, 128, 141
salt chair in Louis XVI style *26*, 53
samovar 18
Sandringham animal series 76; flower series 80,
 86; Royal Collection *16*, 24, 27, *34*, 37, *39*, *46*,
 51, 64, 65, 66–71, 73, 74, 74, 76, *81*, 86–88, 117,
 119, 129, *130*, *134*, *135*
Sandoz, Maurice (collection) *106*
sapphire 28
sardonyx 33
Sawabhapongse, Queen 124
scent bottle in the form of a lyre *130*
scent flacons, Chinese style *64*
Schaffer, Alexander (late owner of *A la Vieille
 Russie*) 125
Scythian Treasure 48, *49*
sea lion 71, 75
sedan chair, miniature *38*, *142*
Seeds, Sir William 136
Seeds, Sir William (collection) 72, 121
serpentine 32
sheep 70
Shishkina, Elena (designer) 75
silver-gilt *18*, 22, 57
silverware 17
Sitwell, Sir Sacheverell *104*, *111*, 128, *129*
snail *71*
snake, hissing *71*; coiled *64*, 74; vari-coloured
 agate 70
Snowman, Emanuel (author's father) 116, 124,
 129
Snowman, Kenneth at Cairo sale *132*; collection
 37
snuff box ordered by Alexander III 147
snuff boxes *34*
soldier, Preobrazhenski Regiment 72
Solomon, Mr and Mrs Bernard C. (collection) *93*
sow, chalcedony 70
spaniel *70*
spaniel, King Charles 70
sparrow, pecking *64*
sparrows, netsuke style *64*
spoons, silver-gilt 23
stallion, wax figure of 37
stamp box *138*; nephrite *39*
Standart Egg *108*
Standart (Royal Yacht) 62
Star of Bethlehem, *see* Pansy Egg
Steel Military Egg *115*
Stein, George 97
Stolitza y Usadba (Town and Country), quoted
 113
stones, precious and semi-precious 28–36, 75, *111*
Strogonov, Count Gregory 48
strut clock, enamelled sunburst field *59*;
 rectangular *30*; red gold *19*; rose diamond
 numerals *59*
strut frames *18*, *24*, *27*, *127*
surtouts-de-table 18
swag 17
swallow 66
swan, delving among its feathers 66
Swan Egg *106*
swan, life-size *106*; swimming 66
swivel-seal in the Persian manner *48*, 48
swizzle-stick, carved bowenite *50*

table-bell, silver *134*
table clock of hoof form *34*; rock crystal *130*
table lighter in the shape of a monkey *40*
Talbot de Vere Clifton, Henry (collector) *124*
Tatiana, Grand Duchess, miniatures of, *see* Lilies
 of Valley Egg; Pansy Egg
tazza 49
teapot, miniature 26
temperature in enamelling 19, 20
Thornton, Mr and Mrs Peter (collection) 50
Tiffany glass *62*
Tiffany (Jewellers) 11, 146
toads *70*, 71
toilet bottles in crystal 28
Trans-Siberian Railway Egg *102*
Trassack (enameller) 21
Trepoff, General *119*
Troubetskoy, Prince *109*
Truman, Charles 148

Tsarevitch 95, 96, *96*; miniatures of, *see* Cross of
 St George Egg, Steel Military Egg
Tsarskoe Selo, *see* Alexander Palace; *116*
tureen in the form of a cabbage 56
Twain, Mark (*The Innocents Abroad*), quoted 106
Twilight Egg 147
Tyrannosaurus, nephrite *33*

Uspensky Cathedral Egg 92, *103*

Van der Elst, Mrs Violet (collector) 125
vase showing Fabergé Moscow shop *21*; Tiffany
 glass 62
Victoria & Albert Museum *118*, 136
Victoria Melita, Grand Duchess Cyril *51*
Victoria, Queen, table clock given to *130*
vodka cup in the form of a helmet *45*

Wäkewä, Alexander (workmaster) 144
Wäkewä, Stephan (workmaster) 141, 144
warthog *71*
Wartski 29, *30*, *31*, *33*, *41*, *43*, *44*, *52*, *72*, *97*, 121,
 128, *129*, *138*
watering-can *126*
Weininger, Salomon 148
Wernher, Lady Zia 136
Wigström, Henrik (workmaster) *81*, *97*, 143, 144
wild cherries with blossom *86*
wild rose *87*
Wilhelmina, Queen, dish presented to *61*
wine glass *130*
Winter Egg *111*
Winter Palace, St Petersburg 128
Wood, Mr Charles R. (collection) 72
wood, use of 37, 53
Woolf, Madame Josiane (collection) *18*, 72, 73, *85*
workmasters and their marks 144
Wortham, Hugo 136
writing-block cover *130*

Youssoupov family residence, St Petersburg *122*
Youssoupov, Prince Felix 25, *122*, 128
Youssoupov, Princess, *see* Grand Duchess Irina

Xenia, Grand Duchess, miniature of, *see* Pansy
 Egg

Zehngraf (miniaturist) miniatures in Egg with
 Revolving Miniatures, Lilies of the Valley Egg
zemlekop (labourer) 72
zolotnik 17, 141
Zuiev, Vassily (miniaturist) *110*, *113*, *114*, *115*,
 118, *119*, *122*